RED-BLOODED AMERICAN MALE

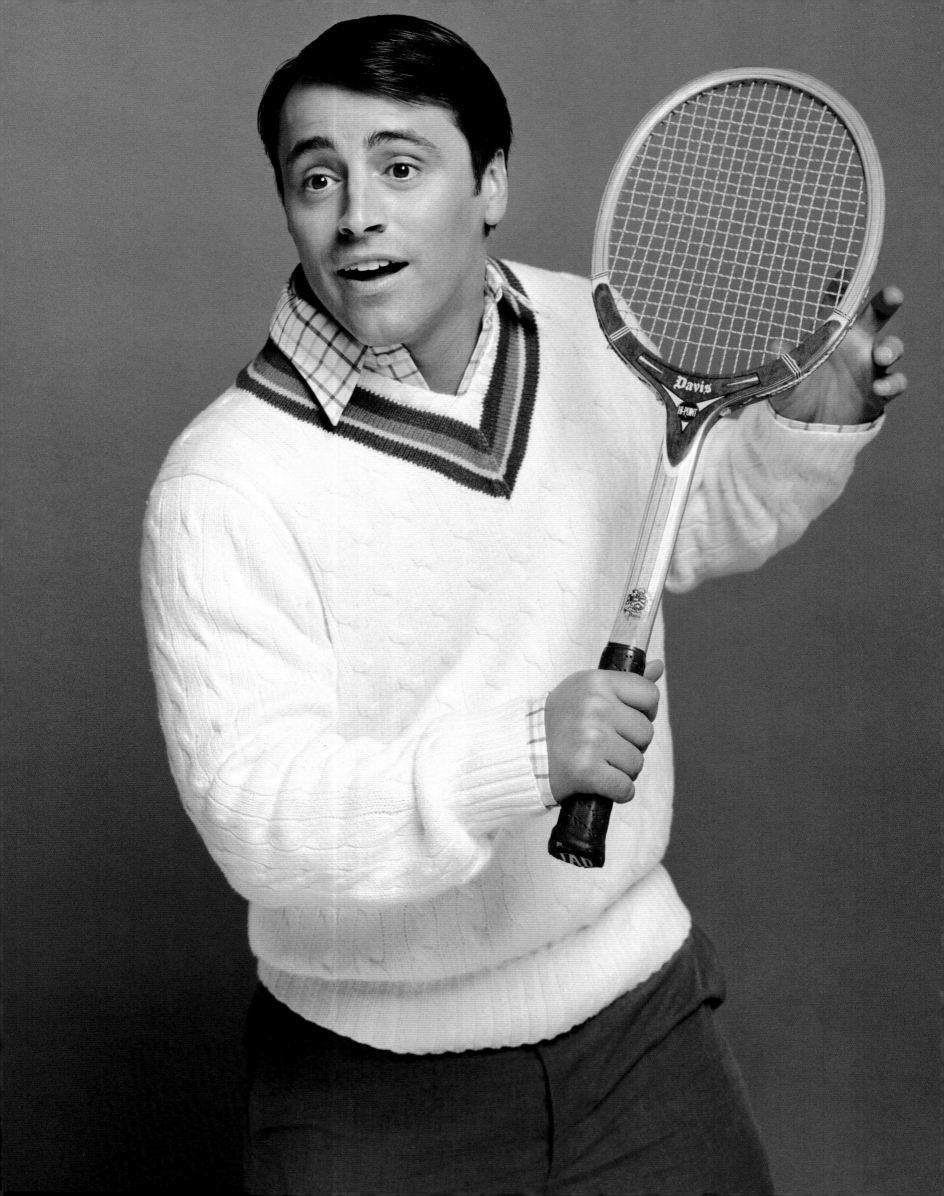

RED-BLOODED AMERICAN MALE

Photographs

Robert Trachtenberg

AMPHOTO BOOKS
Berkeley

CONTENTS

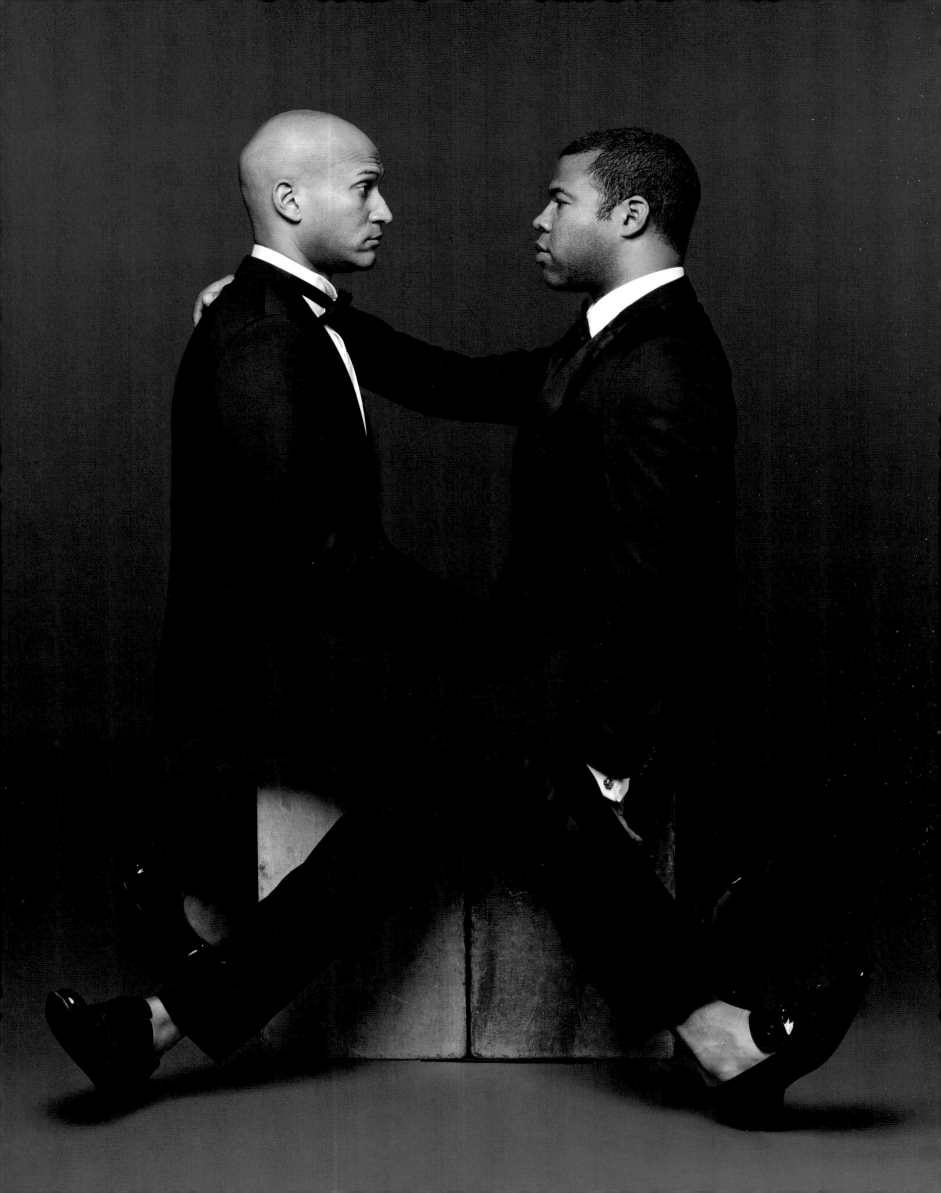

Never . . . be mean in anything;

never be false; never be cruel.

Avoid those three vices . . . and

I can always be hopeful of you.

—Charles Dickens

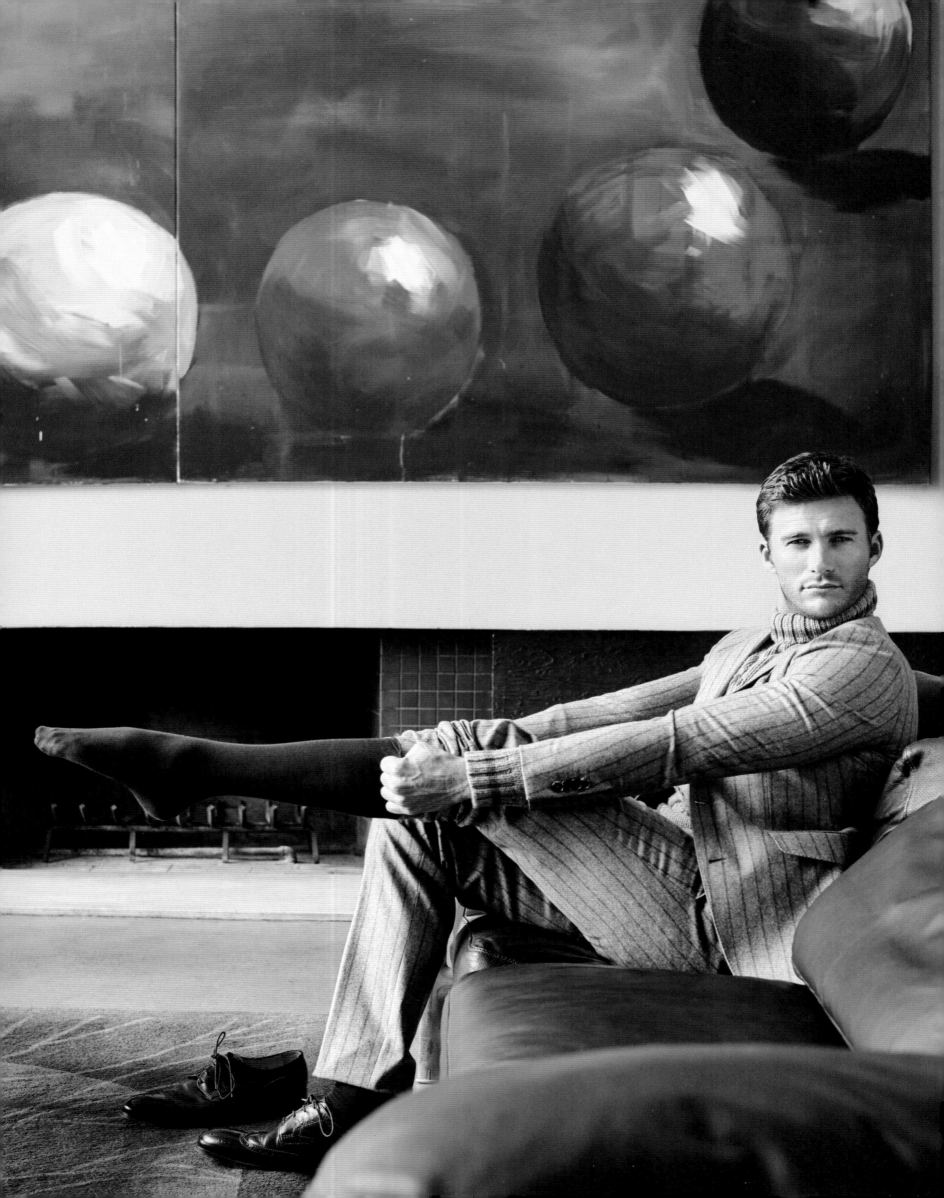

INTRODUCTION

Jess Cagle is the editorial director of both *People* and *Entertainment Weekly* magazines and a longtime friend, so it seemed smart to ask him to interview me for the introduction rather than writing what would surely have read like a bad term paper. Initially he asked for a huge sum of money, depilatory cream, and a new set of luggage, but we were able to negotiate down to a Honey Baked Ham and eyelash extensions. I can't thank him enough for taking the time to do this.

Robert, let's get the most important question out of the way first: you're aware of the fact that despite the title, there are several Canadians in this book, including one on the cover, right?

Yes, but it was too late by the time I realized it. Those people are like chameleons. I asked the publisher to put an * after *American* on the cover, but they said we couldn't afford it, so in the spirit of unity and fulfilling my contract, I'm including all the Americas—North, South—I've even got a photo of America Ferrera in my wallet I could show you.

Maybe later. Second most important question: Why should anyone pay good money for this book?

Wait . . . is there such a thing as bad money?

You've got a point.

If viewed properly, this book will act as a spiritual guide, a lifestyle guide, a DIY guide, so we really should be charging at least double. In fact, it's my dream that down the road the book will eventually be marked up instead of marked down. I fully expect a sort of Dutch-tulip-bulb-mania-of-1637 situation. Google it. By the way, I suppose this is as good a time as any to say that I've seen your apartment, and I expect you to pay full retail for your copy.

Where did you get the idea for the book? Or did you just wake up one day and think, I shot Andy Cohen taking a leak off a skyscraper for *Entertainment Weekly*, and a picture like that simply can't be published too many times?

I've been up for jobs where the client wanted to see my men's portraits, and when we'd group them together, it would always come as a surprise to me that I'd gotten the guys in (mostly) unconventional settings doing (mostly) unconventional things. When it surprised me for the fortieth time, I decided to call a publisher.

And the images play off stereotypes in unexpected ways. What story are these photos telling?

That at this point in our culture, everyone is in on the joke—so if we're going to the beach, you can't just stare off at the water like it's your first album cover or you're selling anti-blood-clot medication. You have to be willing to play a little, because it's cooler, more endearing, and more enduring if you don't take yourself too seriously.

Most of these shoots were assignments for various magazines, so a lot of them are tied to themed issues or a specific project someone was promoting. The challenge was always, how do I add my own sensibility to it?

In the course of your career you've also shot a lot of women (some of whom are included here). Why focus on the men?

It seemed more interesting for the book to have a specific theme, rather than just be a gaggle of photos. When they were gathered together, it became clear that tweaking conventional notions of masculinity had unwittingly become a specialty of mine.

How did you come up with the title?

It came late in the process and stems from a running joke I have with friends. A typical example is: I call my friend Scott and ask if he wants to go to dinner. He says, "Don't start with me—I'm rolling out dough for an apple pie, I've got a load of laundry to iron, and *Mildred Pierce* starts in ten minutes." To which I reply, "Of course—what red-blooded American male *wouldn't* be doing all that on a Friday night?" So the title is meant in a completely tongue-in-cheek, take-none-of-this-too-seriously, nationality-neutral way.

Speaking of red-blooded American males, what kind of little boy were you?

In retrospect, odd. For the first four years, I was raised in an aquarium with a small heat lamp. I'm kidding. Years ago there was an interview with Martin Scorsese, and they asked him about playing sports as a kid, and he said, "Anything with a ball: no good." Same here: Zero interest. I could not see the point. So I watched a lot of TV: Warner Bros. cartoons, The Three Stooges, and, especially, old movies. I realized early on I wasn't going to get by on looks or athletic prowess, so I'd better figure out something else. Sarcasm turned out to be a good fit. My eldest brother used to bring me out to the middle of the street and have me get into an insult showdown with his friends—it was like a Friars Club Roast. And I'd win. I was ten.

Could any of the photos in the book be considered autobiographical?

Only the photo of Scott Eastwood on the previous page. My dad traveled a lot for work and wasn't around much, so it wasn't until years later that I realized this was not the usual way guys put their socks on. Coincidentally, it was the same for my oldest friend: his dad was out of the house every morning by 6 a.m., so we had pretty much only seen our moms putting on their hose in the morning. Thank God I at least saw my dad shave.

Do you think being gay has any impact on your work or on your relationship to male subjects?

I believe I know what you're asking, and I never laid a hand on one of them.

Thank you, that is exactly what I was getting at.

Truly, I don't think it has.

Besides being beautiful, your work has a lot of humor and your subjects always seem to be in on the joke. How do you make them comfortable on set and get them to play ball with your ideas?

Growing up in Los Angeles, I've been around actors my whole life. I've stood in line at the supermarket next to Cary Grant; I've sold books, magazines, and stationery to Greta Garbo, Andy Warhol, and Katharine Hepburn. I'm pretty comfortable around celebrities, and that probably makes it easier for them to be comfortable around me.

But this fascinates me: how photographers bond—or attempt to bond—with their subjects. I was speaking at an event once, and another photographer was up first. He went into this whole speech about how he makes them a pot of tea, how they sit and talk and get to know each other before they begin, and I thought, *What the fuck is he talking about?* There are images in this book that were done in eight minutes from the time the person walked in the door. I'm always aware that this is commercial photography, and they come to me because they're promoting something. They're not there to make a new pal. Sometimes that's a happy by-product. I have ended up bonding with subjects over our mutual love of a particular brand of chewing gum. But I've never tried to force it.

I hear other stories of photographers pressuring subjects into poses or situations that are uncomfortable, which can cause tension on set. My feeling is: Do it or don't do it. If you don't, I'll come up with another idea. Somehow, some way, I'm going to get the shot. But you can't just stand there; I'm not taking X-rays. The first documentary I directed was on the great filmmaker George Cukor, who had the best quote about coddling actors too much. He said, "After the age of twelve, no one really cares how you are except your mother." This pops into my head all the time, because I get that you're tired, I get that you don't have a character to hide behind, I *sort* of get that you hate having your photo taken, but when someone is paying good money at a 7-Eleven to buy a magazine with your face on the cover, they don't give a crap that you were in a bad mood the day of the shoot. They want their money's worth, so suck it up, dammit. I take it seriously, and I expect them to as well.

Calm down.

I think I'm okay now.

Weirdest situation on a shoot?

Oh, someone came a day after having a chemical peel on their face and neck. It looked like they'd been in a fire. The makeup artist had to send out for—I'm not kidding—mortician's makeup because that was the only stuff thick enough to cover all that raw skin.

I need to know who that was. I want the name, and I want it now.

You know I can't tell you that in print. Call me on my cell immediately.

All right then, at least tell me who most surprised you?

Actually, George W. Bush at the White House. Really good sense of humor.

Why isn't he in the book?

Boring photo. With the wife. Stiff.

Your photography is very often informed and inspired by pop culture, especially films, and occasionally a sense of the ridiculous. For example, the photo of Chris Colfer and gang is almost like a postmodern Norman Rockwell.

The ability to set up and (hopefully) land a joke in one frame, or convey the story without having to rely on a headline, is the Rockwell Challenge, isn't it?

Is that actually a phrase?

It is now.

When you're about to embark on a shoot, deciding how to approach a subject, where do you go for inspiration? And don't say "the Ethel Merman episodes of *The Love Boat*" unless you have to.

God, she's good in *It's a Mad, Mad, Mad, Mad World*, isn't she? All the things I mentioned—the cartoons, the movies, working in bookstores for years and thumbing through endless art and photo monographs, a certain color of paint, a piece of fabric—all of that hopefully sticks in your head to draw from. It's like a deep freezer you pull stuff out of and defrost as needed. I've still got a frozen tri-tip and two frames from a Jacques Tati movie I'm waiting to use.

As mentioned previously, you've also written, produced, and directed a handful of documentaries and other TV shows that are all Hollywood themed. In fact, you won the Emmy for directing a film about Mel Brooks. Has directing had any impact on your still photography or vice versa?

Good question. I've gone on meetings to get an agent to move into feature work, etc., and I always hear the same concern: "We don't know if you can tell a story." It's hard for them to wrap their heads around the discipline and economy the still work requires. I finally said to one of them, "If I can tell a story in one frame, I think I can do it in two hours." On these documentaries we're pulling in an average of six hundred to eight hundred historical stills to use alongside the clips, so all that imagery goes into the freezer to inform the photography, and vice versa, absolutely.

What photographers do you most admire?

Food photographers, because they're not taking jobs from me.

Do you remember the first picture you ever took?

I remember the first published picture I ever took. The photographer I worked for was on vacation, and *GQ* called to hire her for a portrait. I told them she was in Hawaii, and they asked me if I would do it, assuming I was her first assistant and should be about ready to go out on my own. In reality, I was her studio manager and de facto in-house stylist/producer/prop guy and had only just begun to toy with the idea of shooting. Quite frankly, I didn't know how to plug the light in, but I did know where it should go. I'm no idiot, so I said yes. It all had to come together very fast, and this was pre-Internet, so I couldn't see whom I was shooting beforehand—he was not a celebrity. I went to the location, and I can say with absolute certainty he was the most unattractive man to ever appear in that magazine. Bangs *and* a unibrow. It was unreal.

Do you remember the first good picture you ever took?

That *was* the first good picture! It was well lit, it was well composed, they were happy—I wasn't going to mess up this opportunity.

How have your photographs evolved over the years?

As you know, the whole nature of not only celebrity but photography itself has radically changed since we started. I can't stress the word *radically* enough. Can we make it bold and in a bigger font size?

Radically.

Thanks. It used to be really hard to be a photographer. There were chemicals and science involved, not to mention hundred of rolls of film to cut, sleeve, and edit by hand. It was expensive as hell just to get a portfolio together. The whole process — and I'm including myself — is now leaner and faster, in part, of course, due to digital.

A lot of the time, you have to do things you've never done before that you'll never do again, and you've got one chance to get it right. It's only when you're on a scissor lift over an Olympic-sized pool that you realize that synchronized swimmers can't really hold a pose long enough since they're treading water, for example. This is an insane business, based on mutual need that ebbs and flows in the most unpredictable ways. I always cite the example of John Travolta. His career was in a dip, and *InStyle* magazine had just started and they needed people for the magazine because they had no track record and hadn't taken off yet. They called and asked if I would shoot him on his private jet, with his family. I had to be talked into it, but I went. The magazine came out the same month as *Pulp Fiction*, and overnight Travolta was once again the biggest, coolest movie star. And the resale of those images around the world paid off my college loans. But for every one of those miracles, there are drawers full of photos of people who were going to be the next big thing.

All that said, it's an incredible profession. The camera is the key that's unlocked the door to people and places I would have never been exposed to. How else was I going to get to the private quarters of the White House or be the first to see Elon Musk's new Tesla or spend the day at Highclere Castle with the *Downton Abbey* cast or just spend a few hours with incredibly dedicated people like Afghanistan war veteran Cameron Kerr?

So with all that mileage, do you have any advice on how to take a great portrait/get a signature look?

Yes. Use oil or acrylics; there are too many goddamn photographers. In reality, most everyone is a pretty decent photographer at this point. What they'd do under pressure at a cover shoot, I have no idea, but phone cameras are sickeningly good. If I have a signature look, it's subconsciously thematic rather than anything technical, since I assess lighting and filters and all that on a case-by-case basis. The legendary photographer Cecil Beaton said, "I still consider myself an amateur so that I have the amateur's freshness and spontaneity and willingness to learn." I like that.

Getting back to the book, what are your thoughts on today's modern man?

I believe it should be a misdemeanor to wear flip-flops more than twenty feet away from a body of water without a pedicure. I believe road rage is for sissies. I believe most men buy their shirts a size too big. I believe you shouldn't cheap out on haircuts or eyeglasses, it's your head, everyone is looking. I believe getting wasted should be a right of passage, not a hobby. I believe you should do unto others as you would have them do unto you. Is that any kind of an answer?

It's a kind of an answer, yes. Just one more question: Is there a male, living or dead, you wish you had shot?

Yes. Joan Crawford. He really knew how to take a good picture.

5

PAUL RUDD

2006

"Since they didn't make enough Paul Rudds to
go around, the rest of us have to date."
—Isaac Oliver, *Intimacy Idiot*

This was for *Rolling Stone's* "Hot" issue. It
seemed absurd to do anything where we tried to
make Rudd look deliberately "hot." His "hotness"
(I'm going to keep using quote marks because
I can't bring myself to use that word in context
legitimately) comes effortlessly. He agreed we
should mock the whole notion of "hot." He agreed
to get in the bed. He agreed the boxers were
getting in the way and dropped them. Months
later, he sent me a nice note saying friends had
seen the photo on the walls of gay bars across
America and he couldn't be more proud.

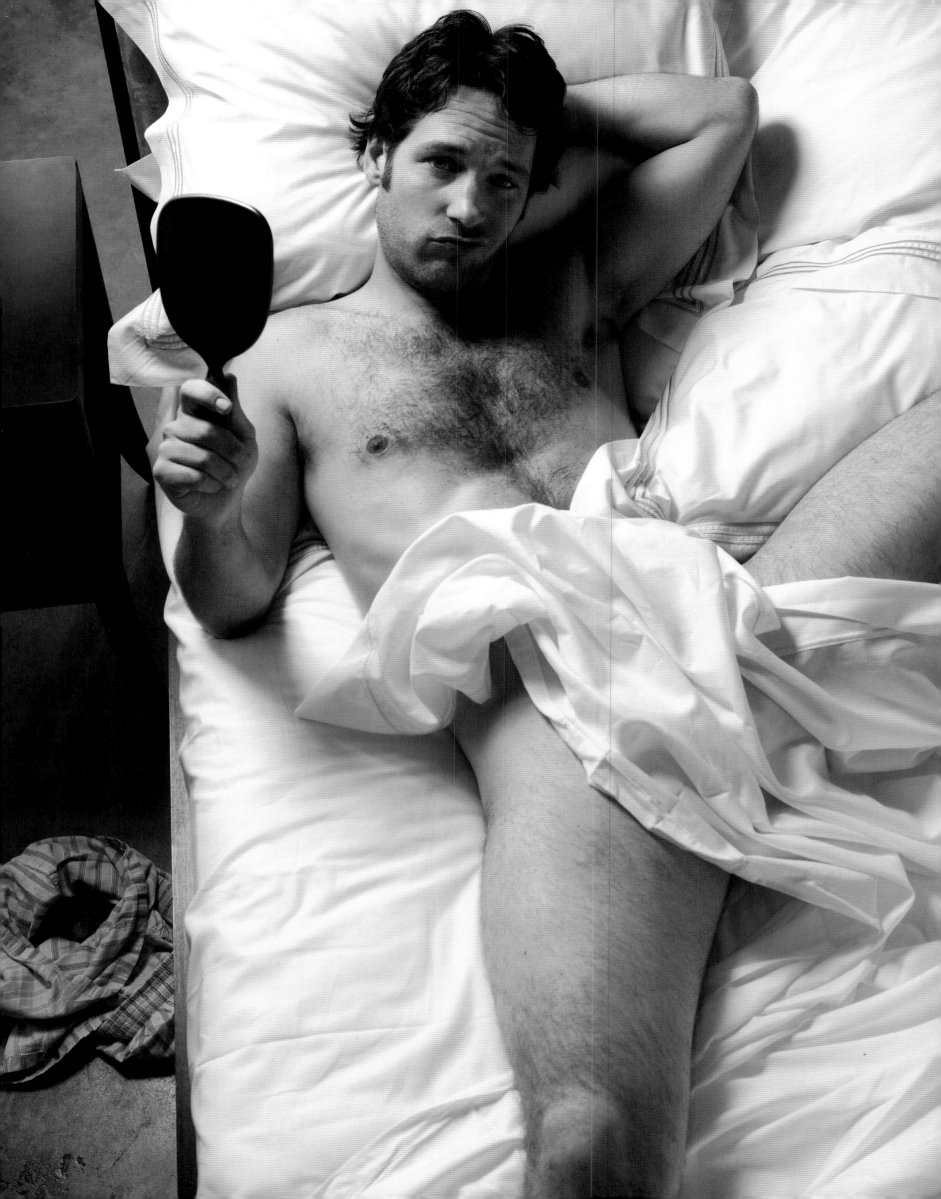

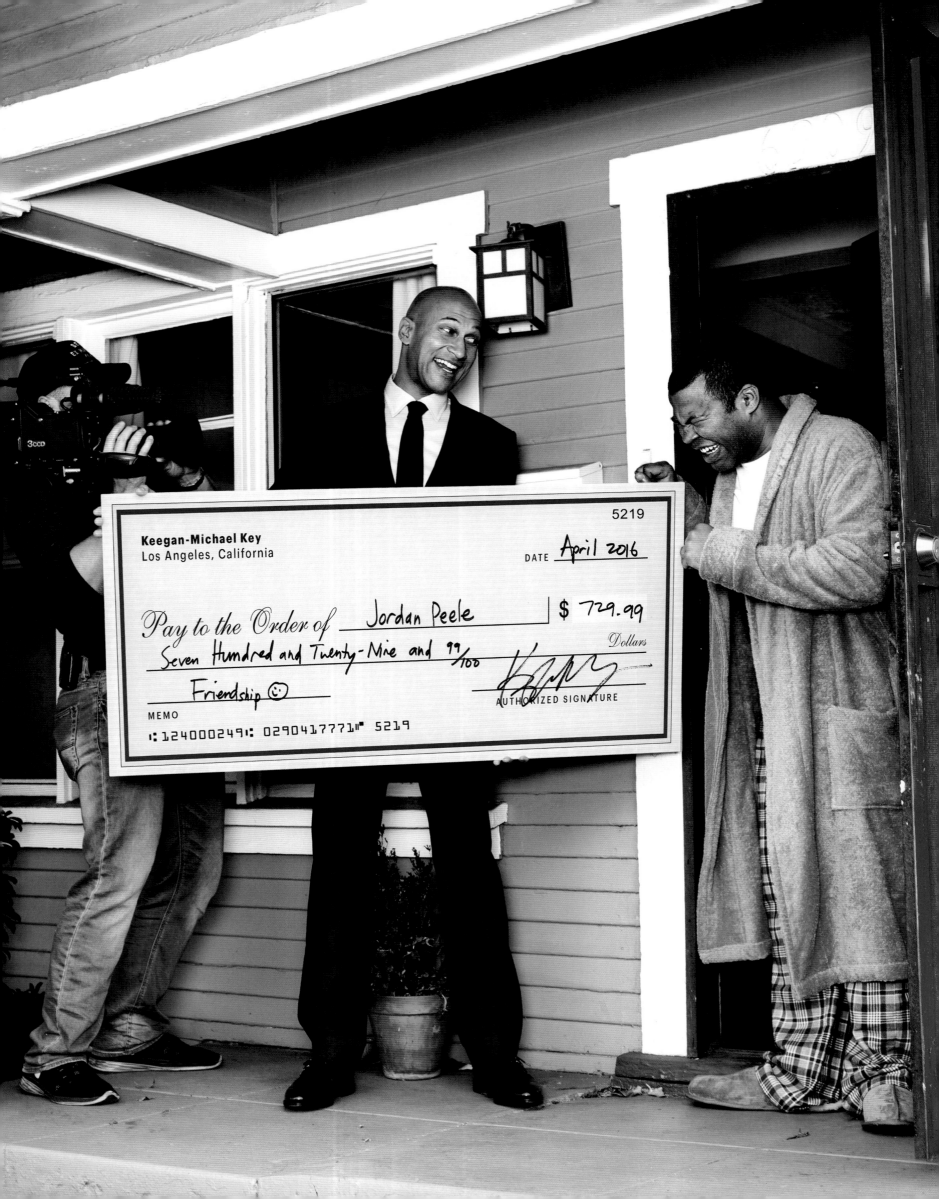

KEEGAN-MICHAEL KEY and JORDAN PEELE

2016

Sometimes you're really lucky and get to see two masters of improvisation go at it for eighty-six frames. And you wish you were recording sound as well—because this was hilarious.

JASON SCHWARTZMAN

2016

(overleaf)

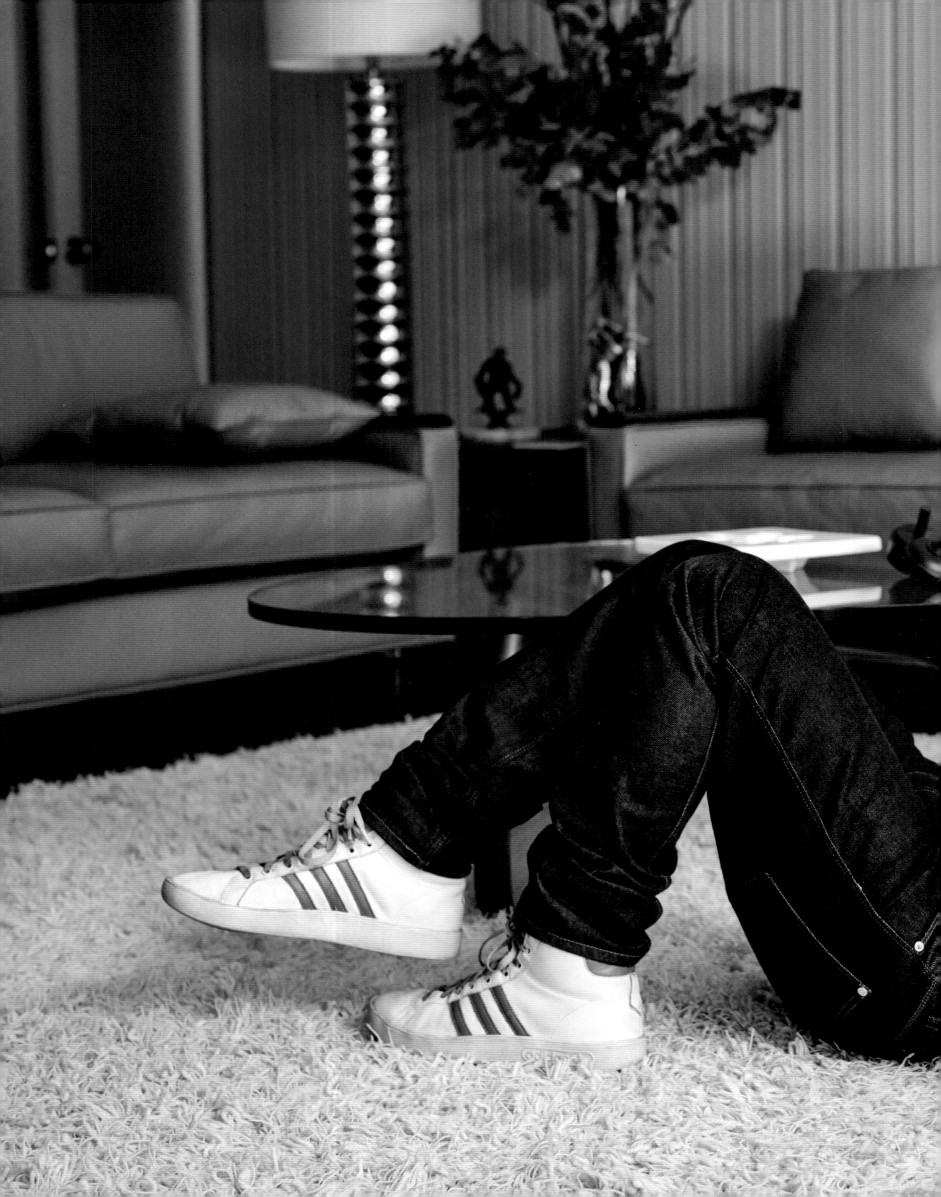

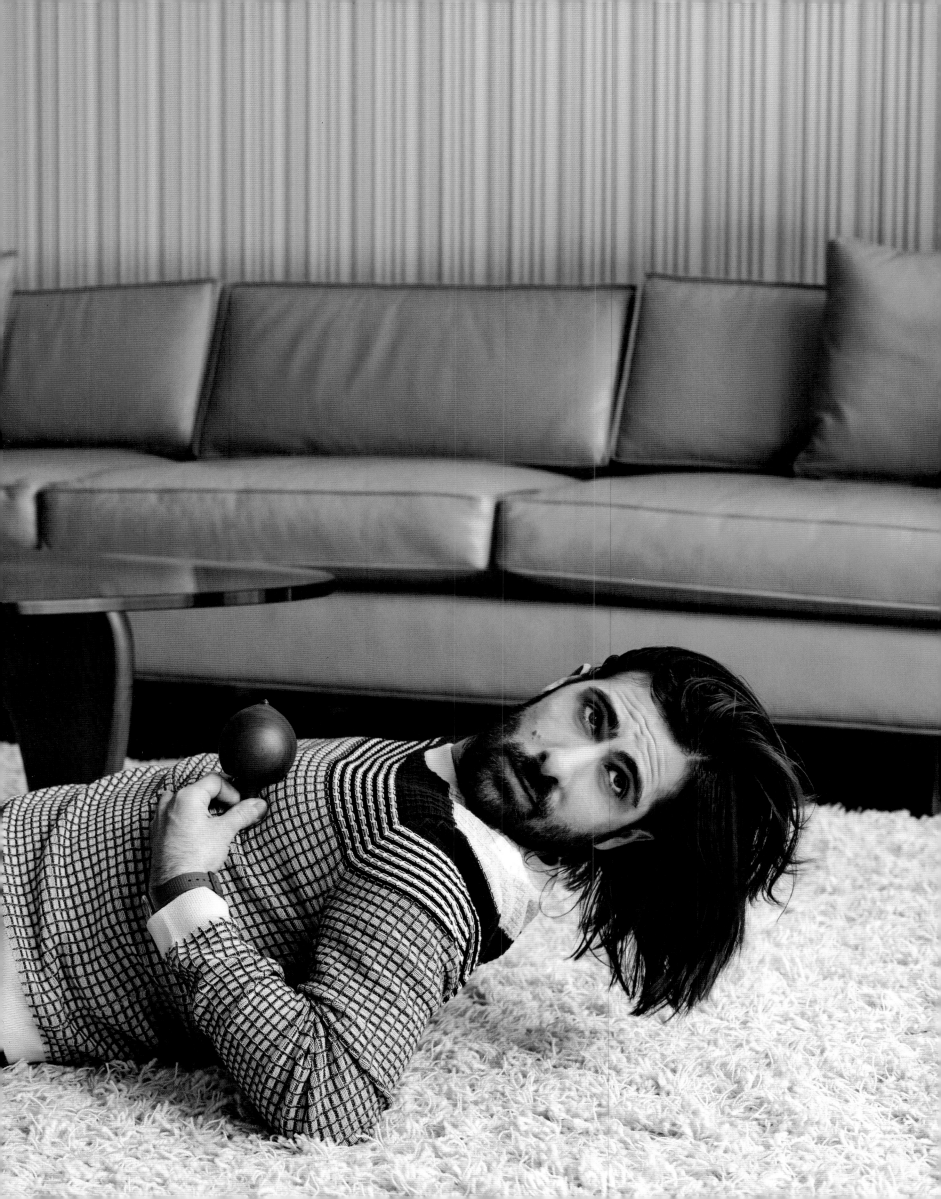

BRADLEY COOPER
and SIENNA MILLER

2015

I loved these two because we had around twelve
minutes to shoot and I started to show them
a couple of ideas I had, and Cooper turned to
Miller and said, "Let's just do these exactly."
Now I'm a fan for life.

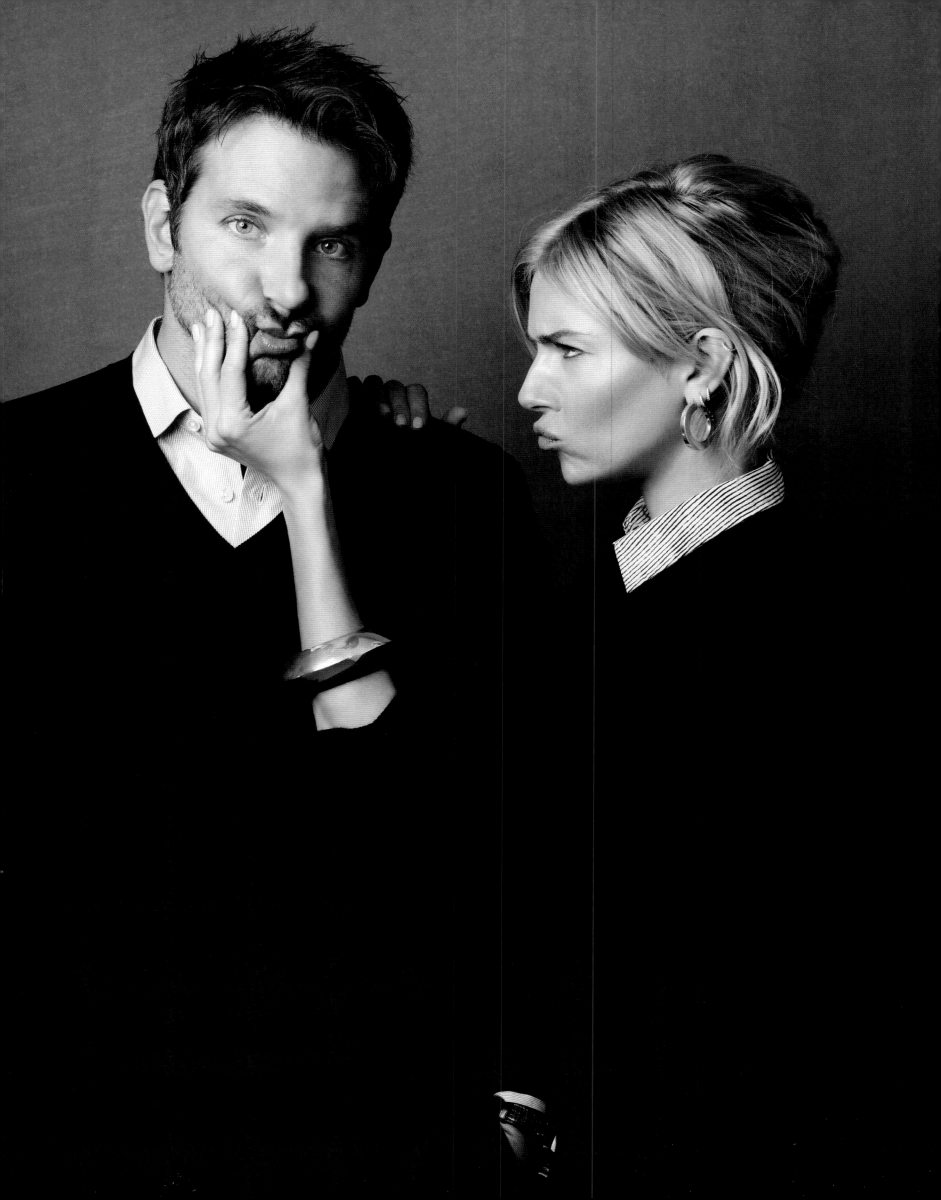

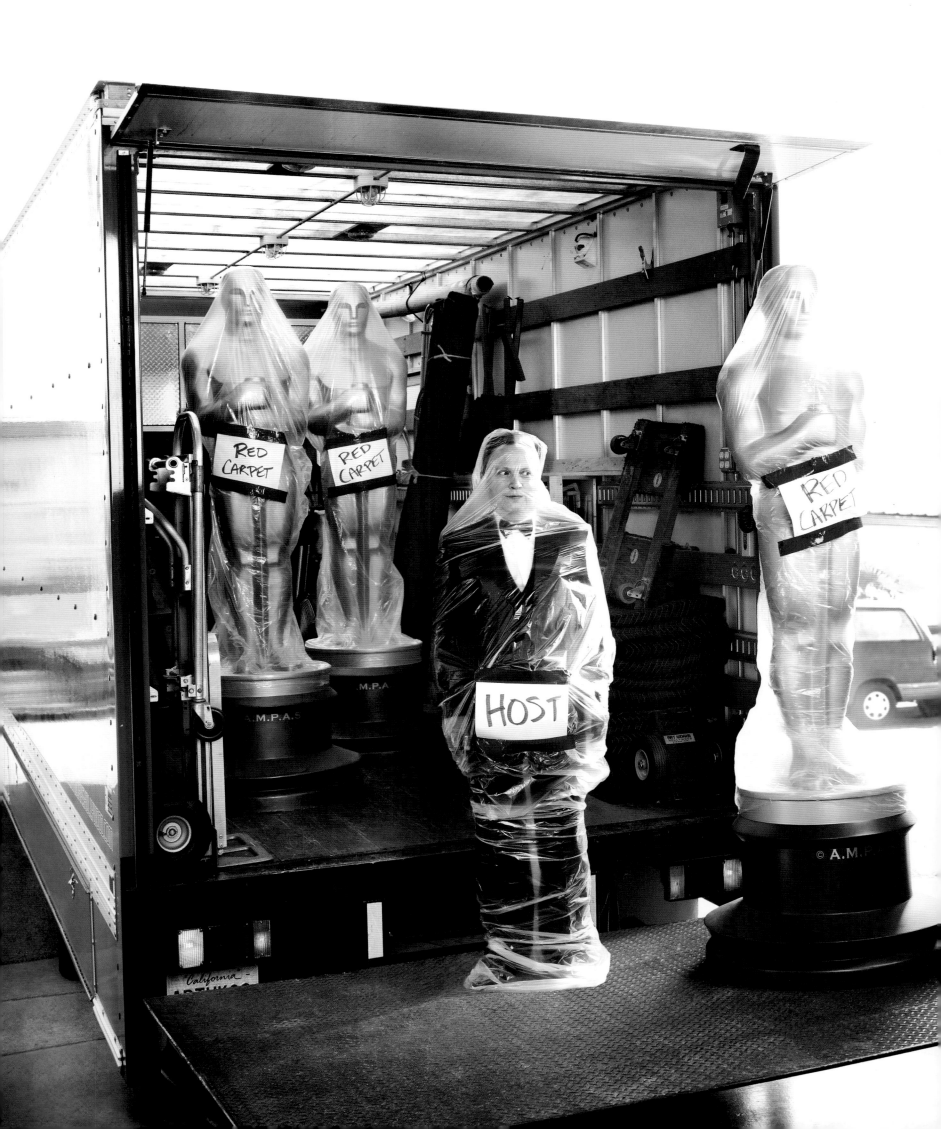

BILLY CRYSTAL

2012

It's not easy to come up with a new gag when shooting the Oscar host. The actual statue is a beautiful object, but its features aren't very defined, and the base is big and heavy, so doing anything playful quickly becomes awkward. Luckily, we had some of the big boys brought in. Billy is looking fondly at the prop guy whose idea it was to wrap him in plastic on an especially warm Santa Monica day.

JERRY SEINFELD and LARRY DAVID

2010

It's a very rare celebrity who actually wants to have their photo taken. They've already done the work—the movie, the TV show, the album—this is just more work on top of it. They get that they have to promote, but it's usually not their favorite thing. My only request here was that someone attempt a spit-take. At the end of the shoot, this was my exchange with Seinfeld:

Me: "Thanks for doing this."

Seinfeld: "Oh, it was my pleasure."

Me: "Really?"

Seinfeld: "No, not really."

Me: "I didn't think so."

(overleaf)

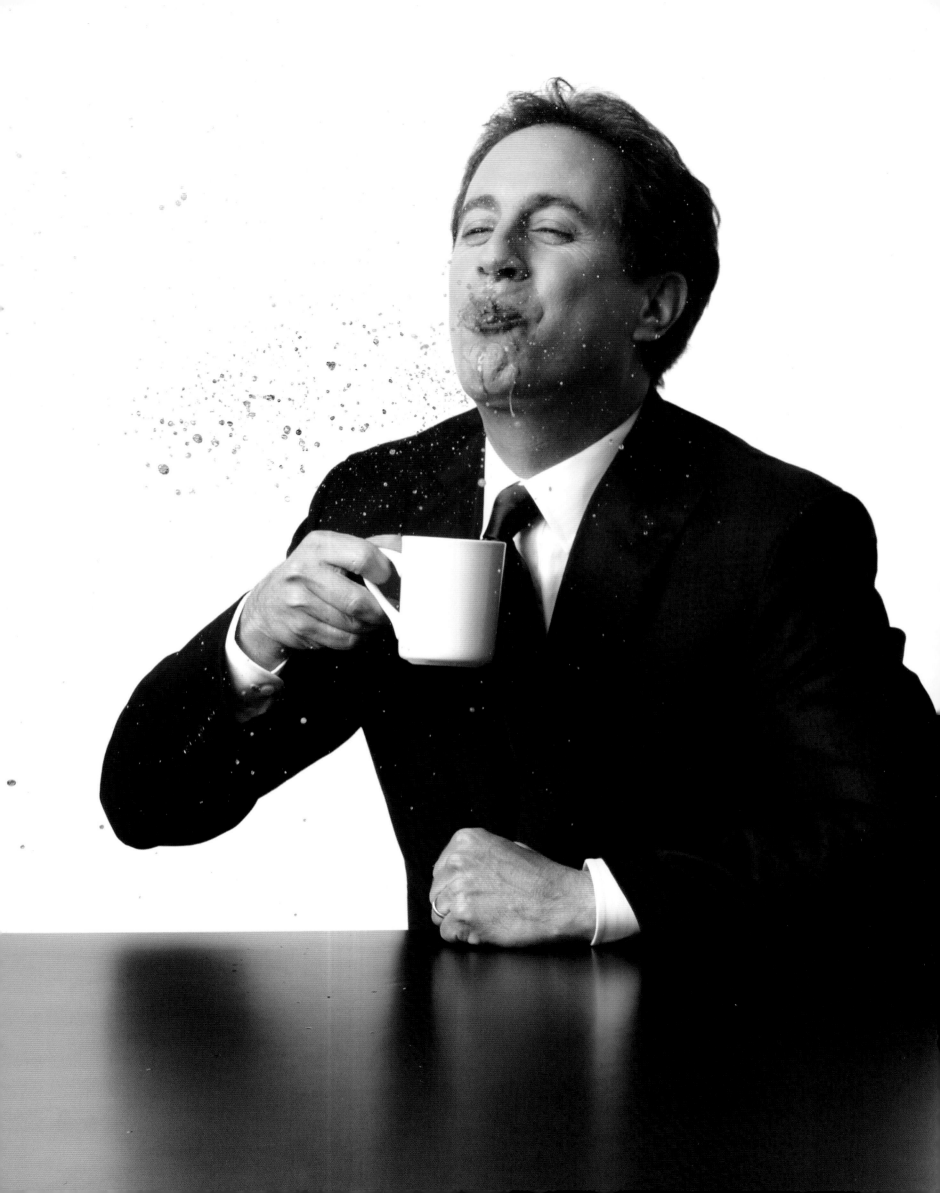

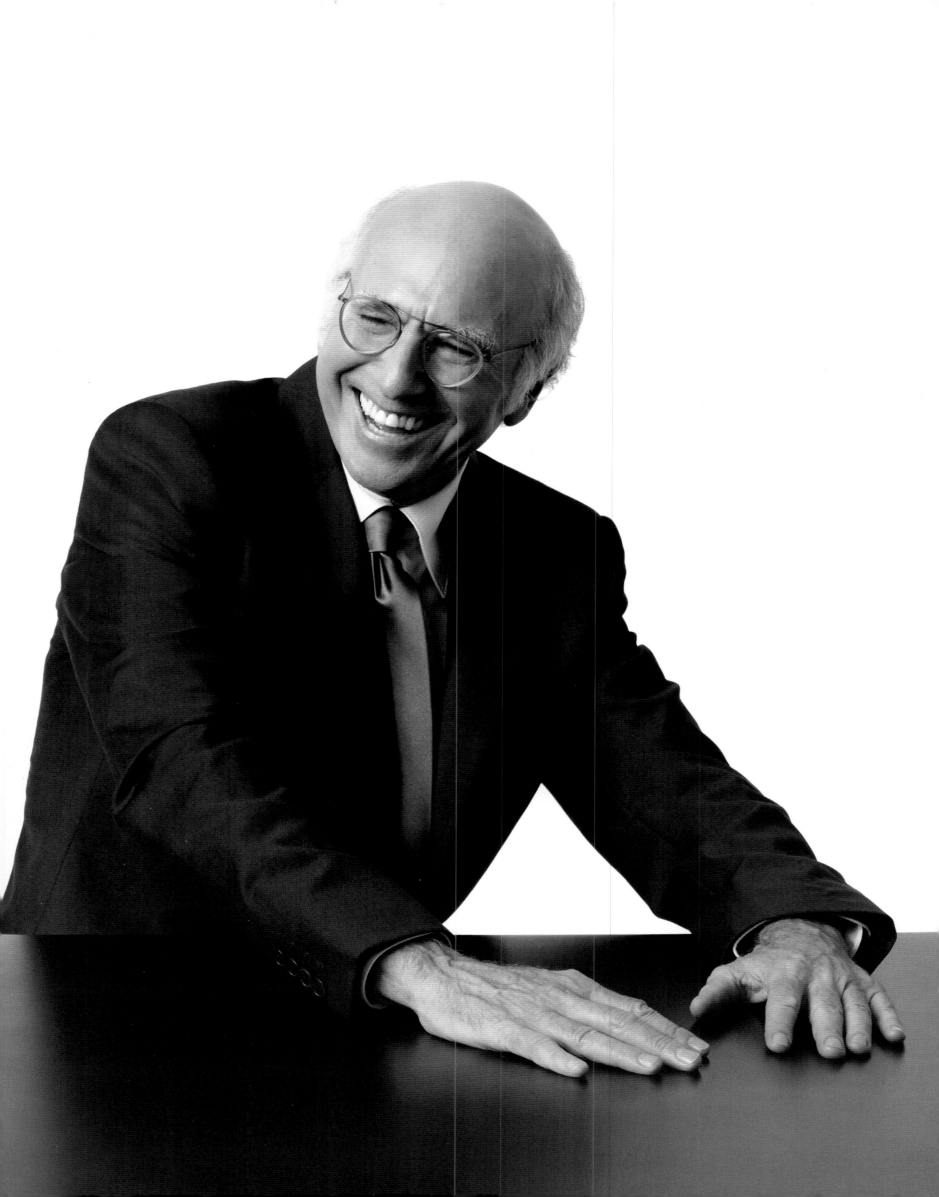

CONAN O'BRIEN

2011

Turns out, hanging from a real helicopter
approximately fifty feet off the ground requires
an enormous amount of core strength. These are
the things you don't realize until you show up and
it's time to shoot. Luckily O'Brien has abs of steel,
so he was never in any real danger. Though as a
safety precaution we kept his hair, makeup, and
wardrobe team close by at all times.

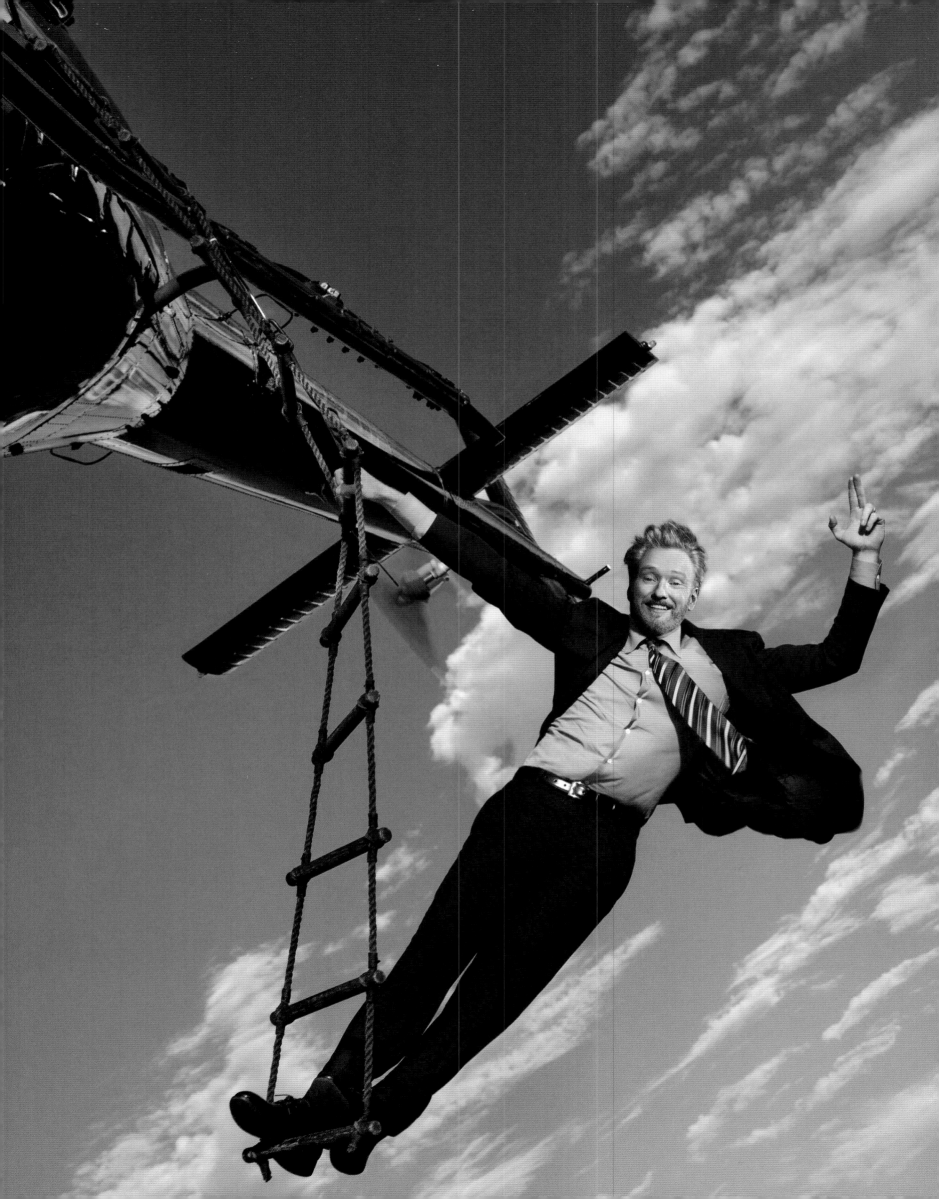

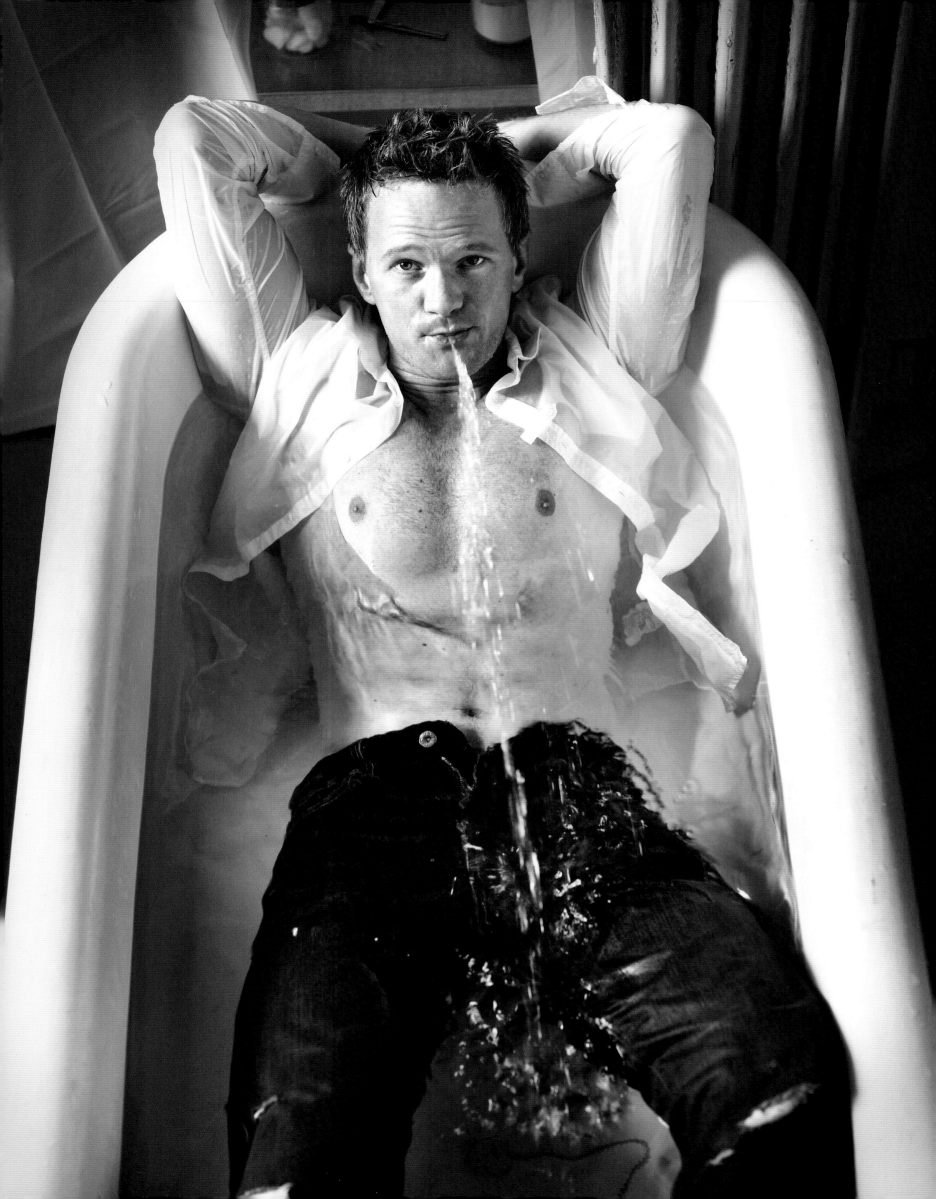

NEIL PATRICK HARRIS

2009

Another "Hot" issue shoot (see Paul Rudd, page 7) where, luckily, Harris couldn't take things too seriously either. And I got to keep the jeans afterward.

GENE KELLY

1994

When Hal Rubenstein was the men's fashion editor of the *New York Times Sunday Magazine*, you could call up, pitch a story, and he either said yes or no on the spot. He worked off pure instinct. I wanted to do a story on Gene Kelly's classic American style and re-create some of his famous movie scenes using a model. Rubenstein said yes but asked me to try and get Kelly for an interview and photo to front the piece. Amazingly, Kelly agreed. I went to his house in Beverly Hills, we hit it off, and it was the first of many photo sessions I did with him. He'd lived at the same address on Rodeo Drive since the 1940s. He'd tell me how there used to be a bridle path going down the street, and how, when he did the incredible roller-skating number in *It's Always Fair Weather*, he just stopped off at the hardware store on Beverly Drive and bought a pair of fifty-cent skates on his way to MGM. In the *Times* piece, "An American in Style," he is quoted: "When I was growing up, dance in movies was a means of expression for the wealthy. But I didn't want to wear rich people's clothes and become a victim of the shiny-floor syndrome. I wanted to dance like the man in the street, like the ones I met while working my way through college, pumping gas in Pittsburgh." This was one of the last photos taken of him. I just couldn't get how cool he was out of my head. A few years later I wrote, produced, and directed the documentary *Gene Kelly: Anatomy of a Dancer* for the aptly titled PBS series *American Masters*.

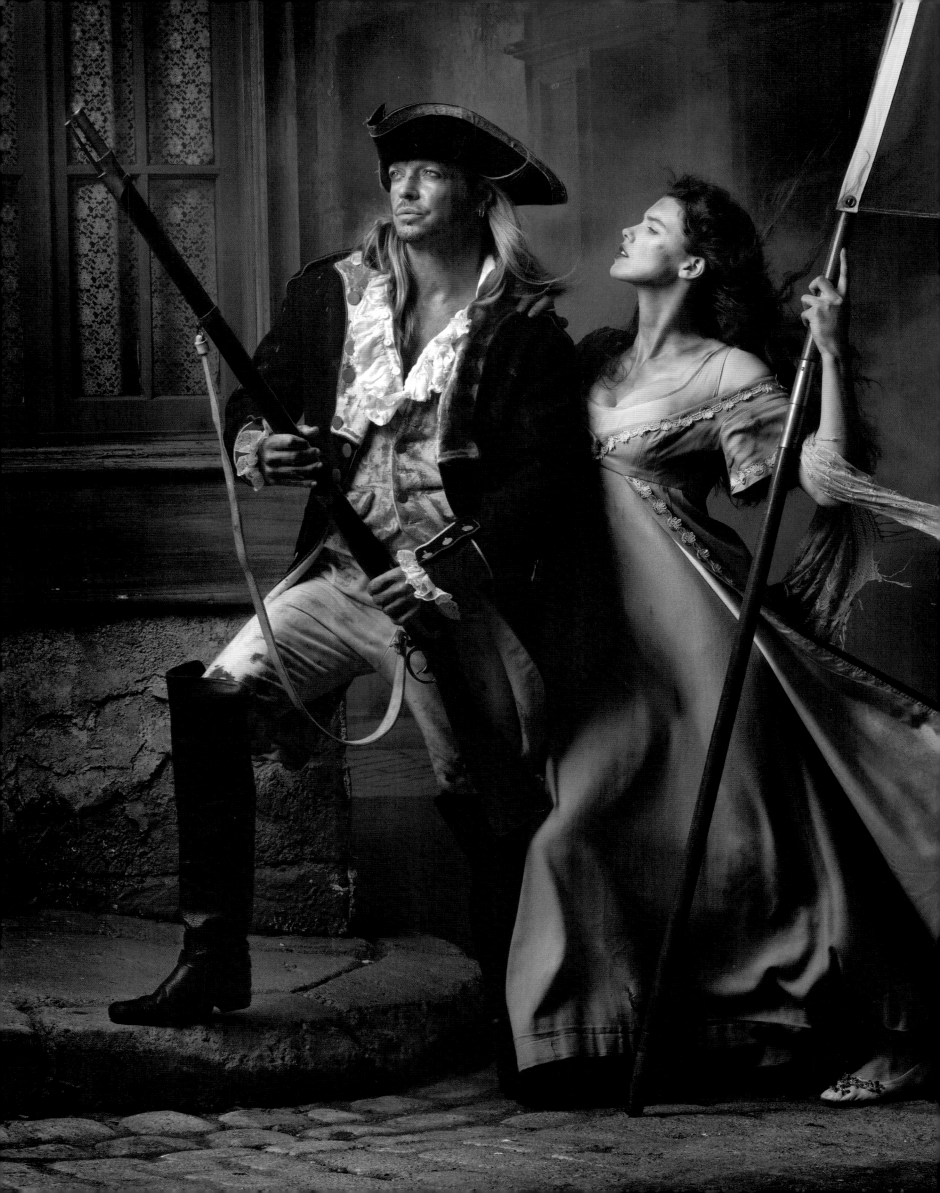

BRET MICHAELS

2009

TOMMY LEE JONES and MERYL STREEP

2012

You try to think of the simplest thing they would be willing to do, so they're not just posing, standing shoulder to shoulder. And then you get out of their way.

(overleaf)

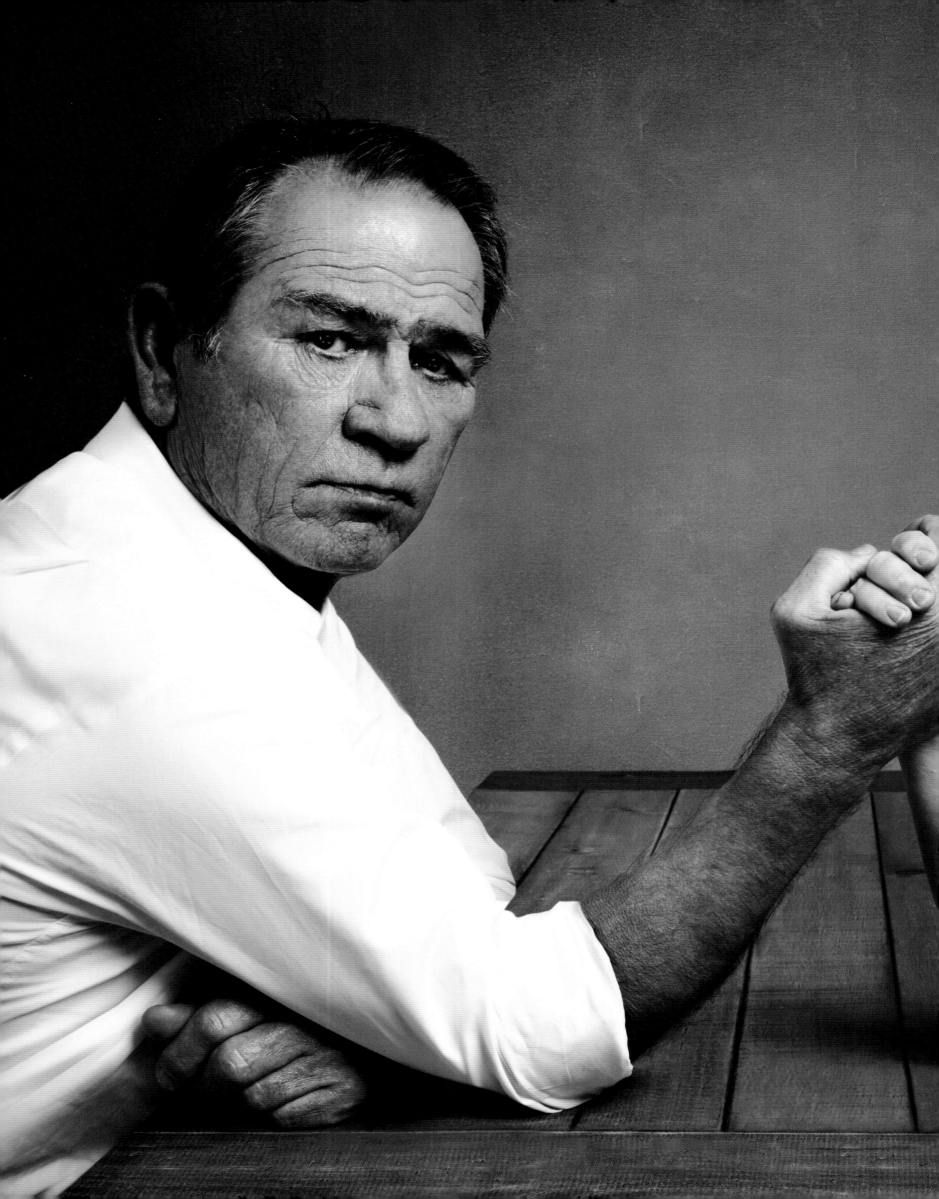

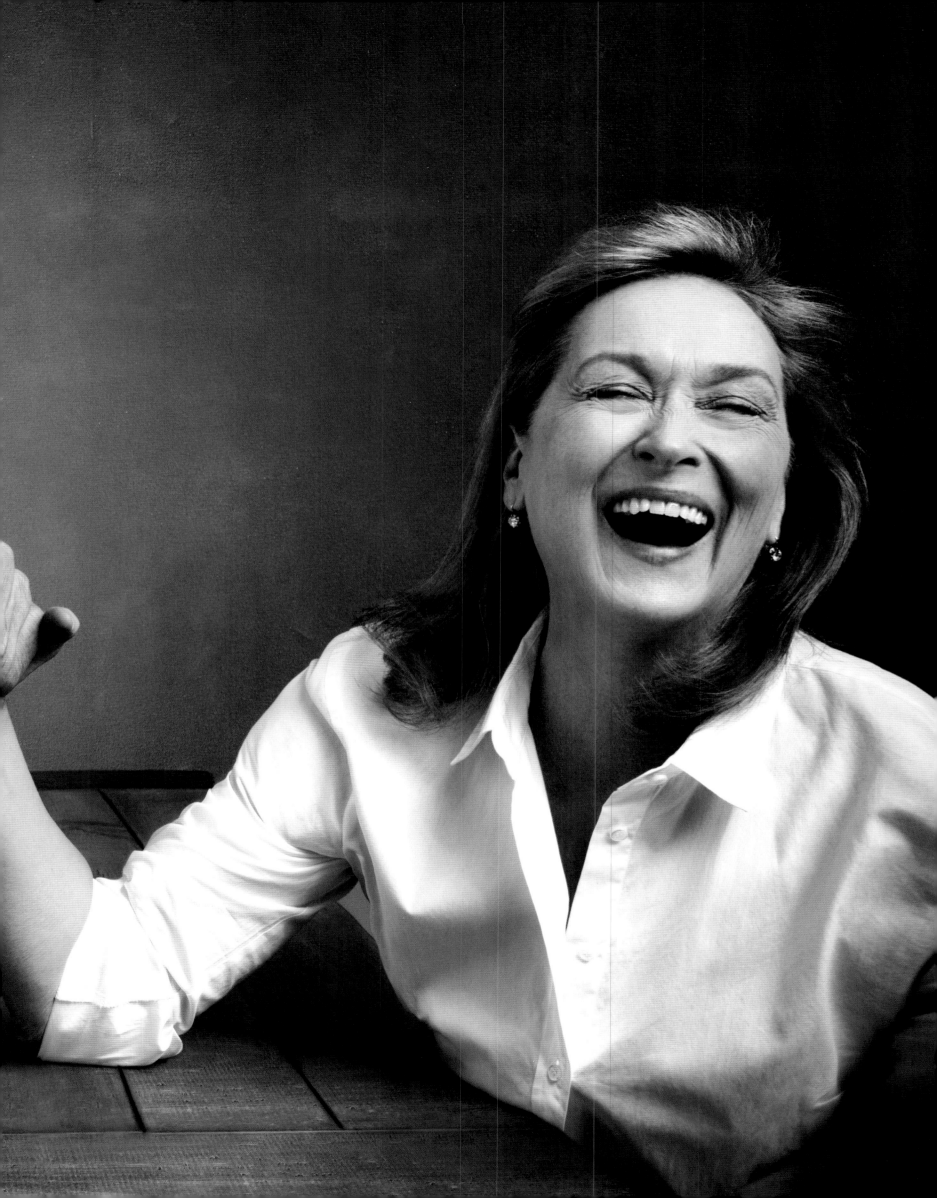

JIMMY KIMMEL

2012

Why is Kimmel dressed up like Daenerys
Targaryen in *Game of Thrones*? The easy answer
is, "Because it was Tuesday." In reality, this was
part of a series where Kimmel portrayed some of
television's most popular characters. This is a great
example of "high concept/low tech," meaning the
entire set consists of two walls in a studio. The
effect is all lighting, and, well, that wig is working
pretty hard too.

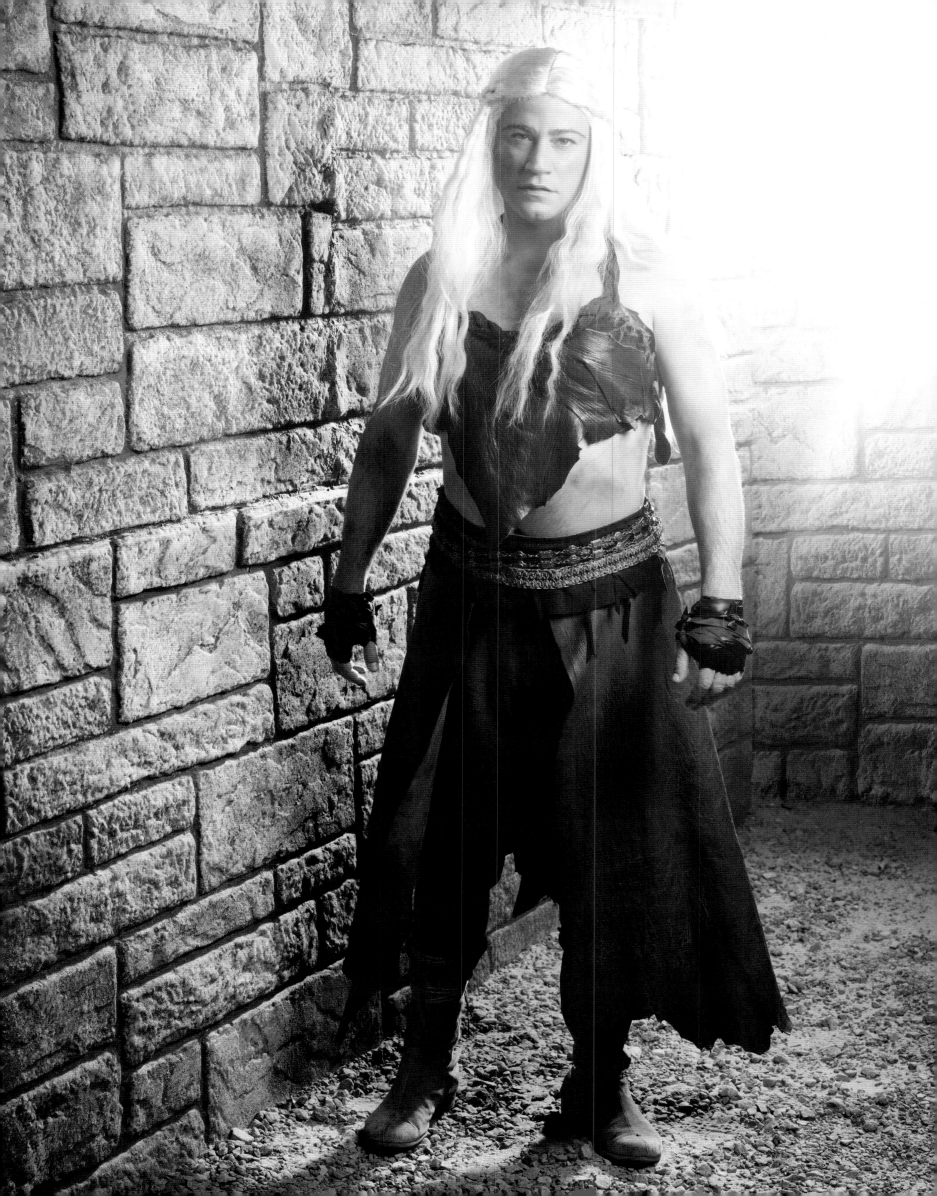

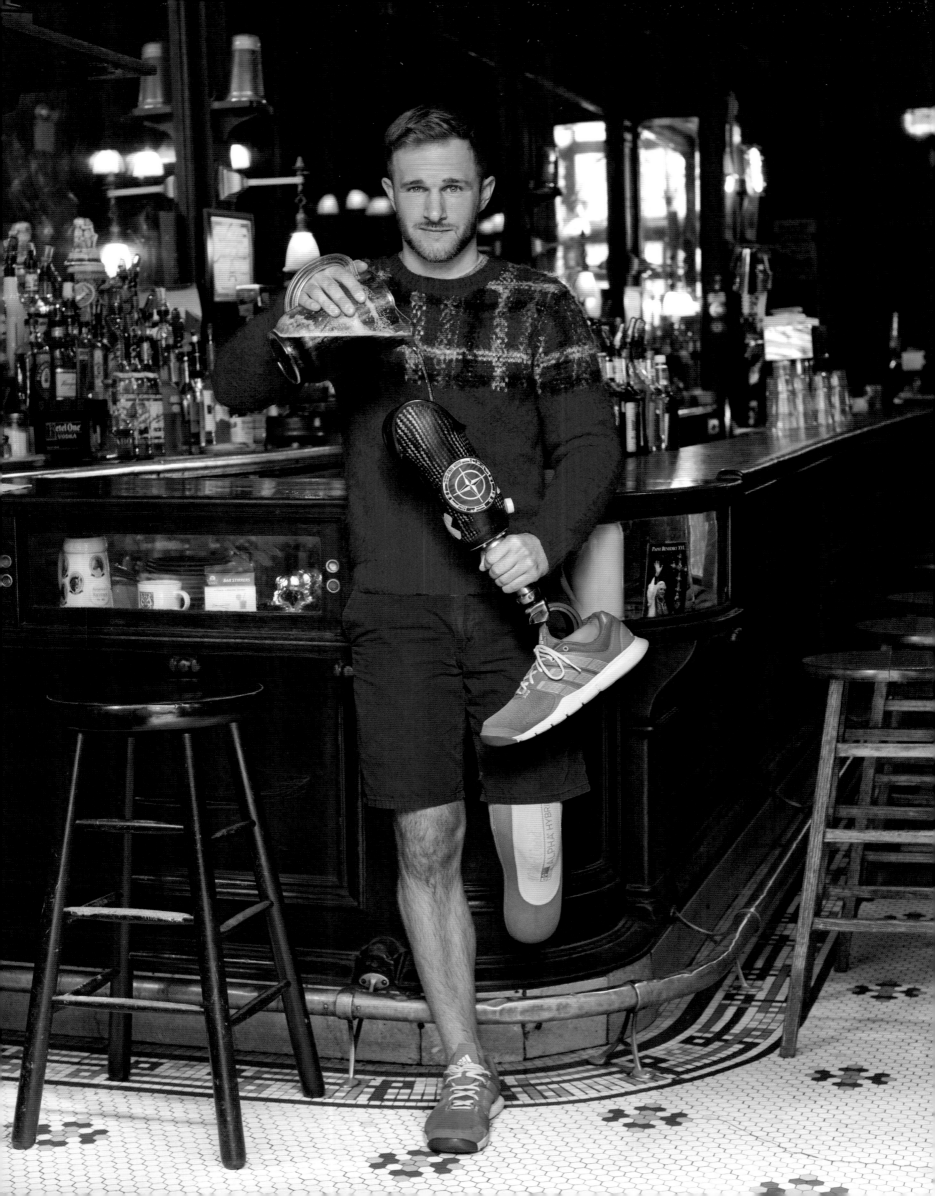

CAMERON KERR

2015

The horror of war injuries sustained by our armed forces has been well documented. I wanted to photograph a war vet a little bit differently. When I found Kerr, I asked if I could shoot him getting a pedicure. He said sure, but he told me that it's typical when the men who've sustained these types of injuries get together to drink, they use their prosthetics as beer steins. Much better.

SETH ROGEN

2012

I had a strong desire to use a live baby lamb in a shot. I think I had seen a spread in *Italian Vogue* with baby animals and was smitten. I'd ask every photo editor who gave me an assignment, "Can we rent a baby lamb?" until I finally got a yes. One thing I had not counted on was how incredibly loud a baby lamb can bleat. It was ear splitting, unbelievable. Rogen had definitely suffered hearing loss by the end of the shoot. At one point I turned to my assistant and said, "But look how cute it is!" His reply: "Listen, everything is cute when it's small. Except a dick."

MARK WAHLBERG and FAMILY

2014

We shot in the driveway of Wahlberg's home. The garage was filled with boxes of the protein powder he manufactures. I wanted to try the chocolate flavor but felt bad asking after cramming his family into a car with no AC for thirty minutes.

(page 34)

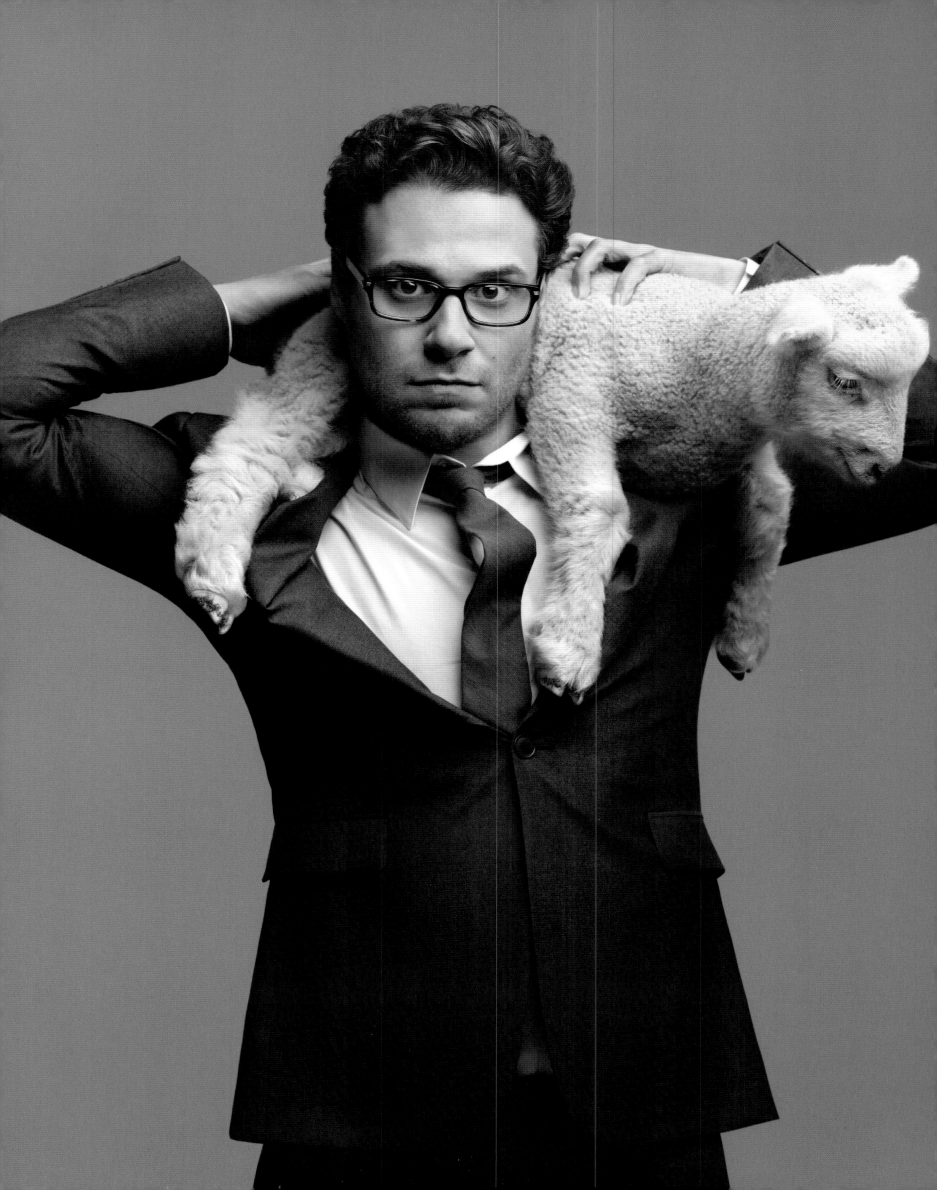

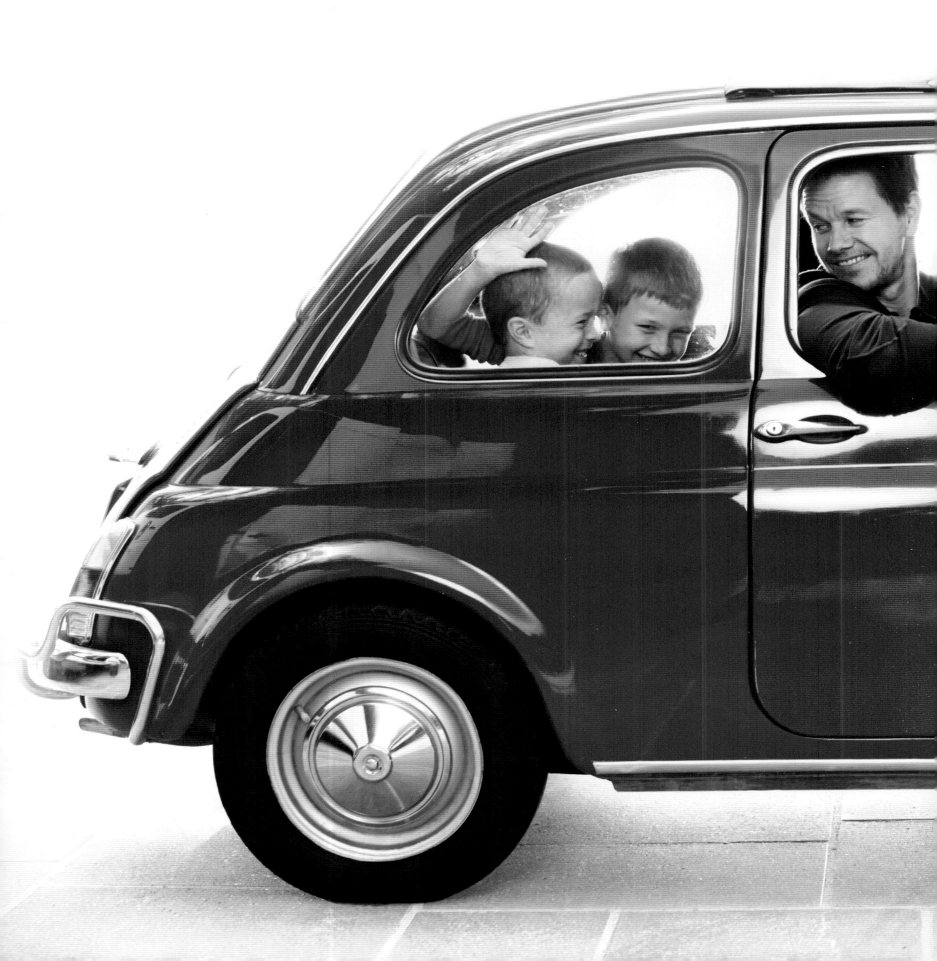

VINCENT KARTHEISER

2013

No one had told us Kartheiser shaved his
hairline back six inches for his role on *Mad Men*,
which he was still shooting when he showed up.
#ilovedigitalretouching

BRYAN FULLER

2015

Producer, writer, and director Bryan Fuller has
carved a unique place for himself in television
by creating such cult shows as *Pushing Daisies*
and *Hannibal*, as well as the upcoming *American
Gods* and a new *Star Trek* reboot. A true master
of the macabre with an unerring sense of color,
style, wit, and the ability to gross me out, when he
casually told me what he wears to bed every night
(eye mask, moisturizing gloves, ear plugs, Paul
Smith pajamas, the dogs Henry and Lou), I said,
"When can I shoot?" This was our text exchange
a few weeks after:

Me: "Hey—I just thought of something: Do you
want to email me a quote about what you wear
to bed and why?"

Fuller: "You mean how it's about restoring
sensations first felt in the womb, that sort of thing?"

Me: "Ummm . . . Let me get back to you."

(page 38)

36

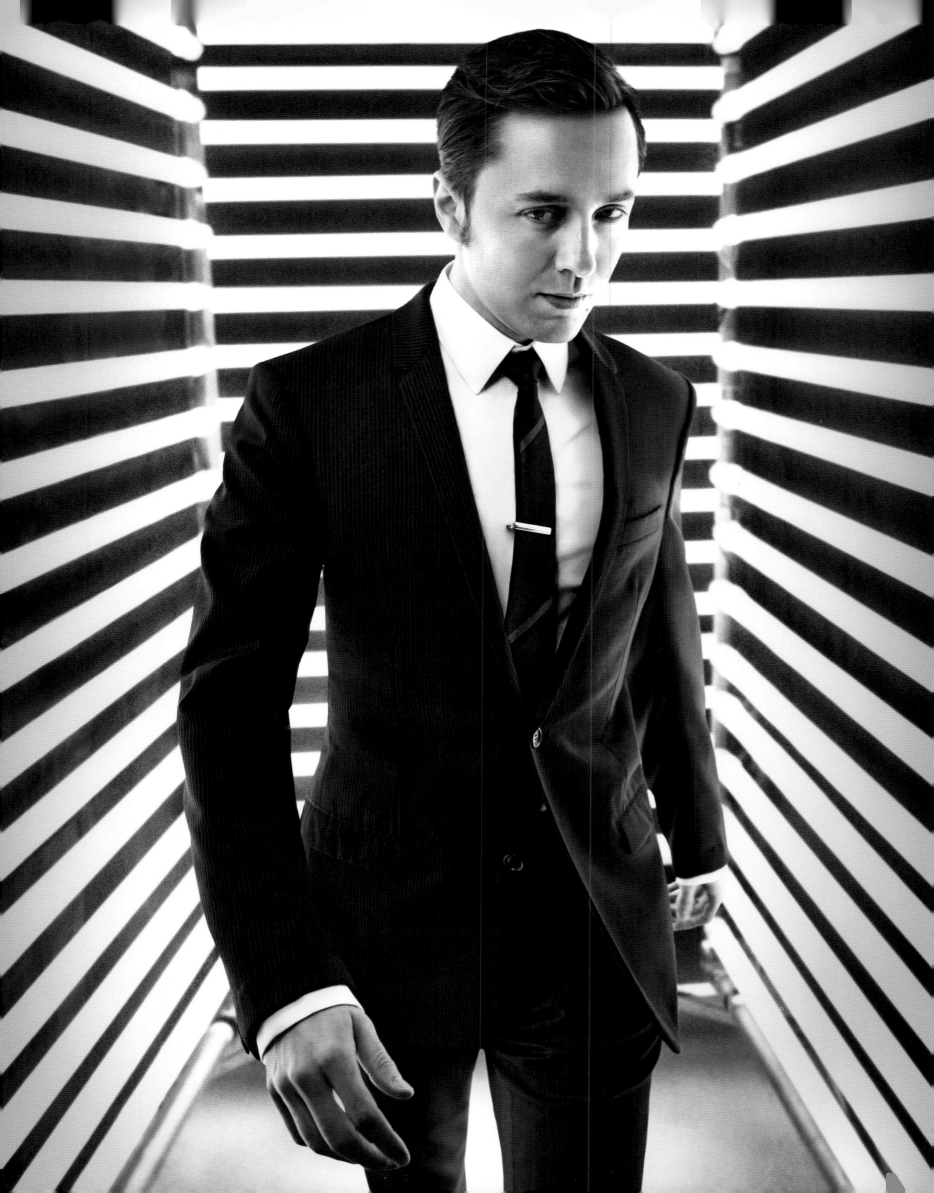

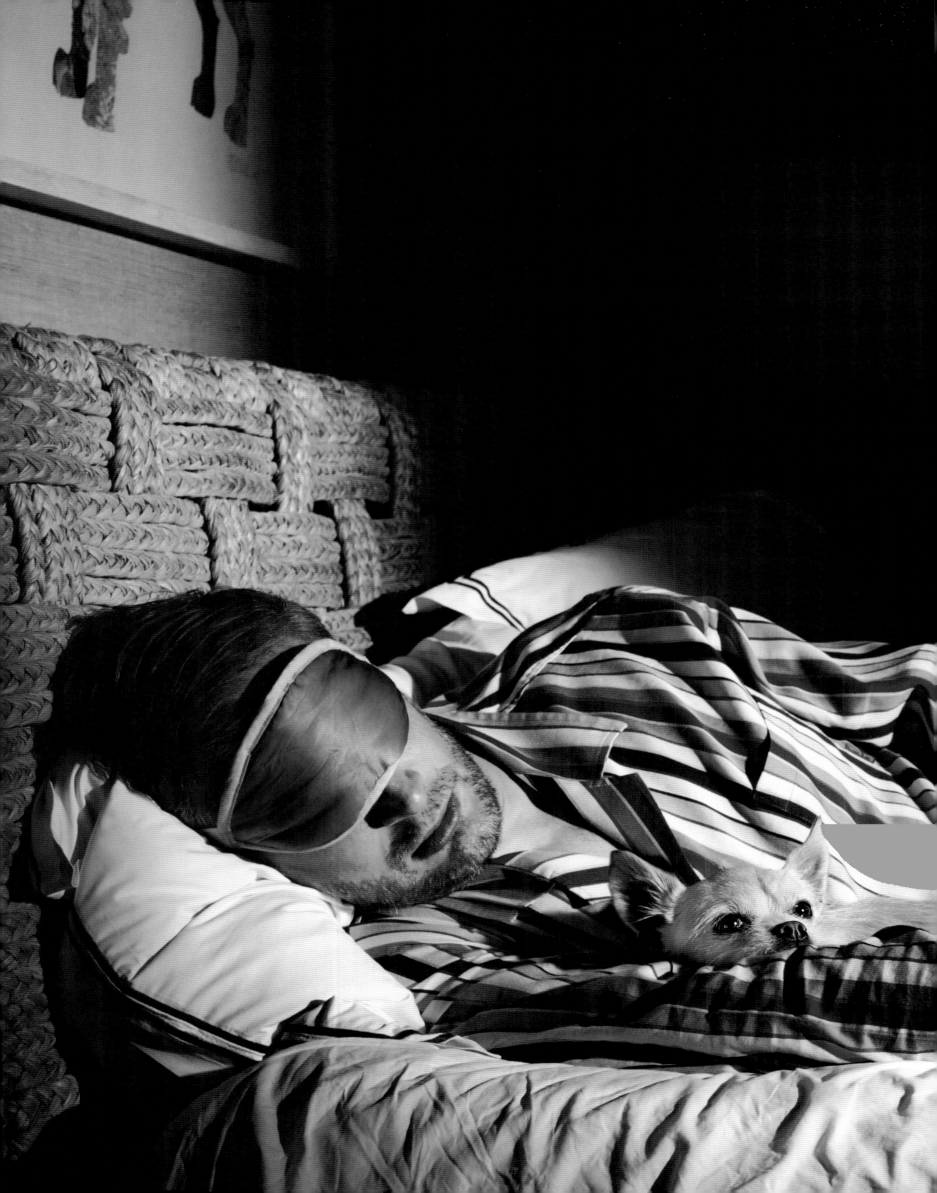

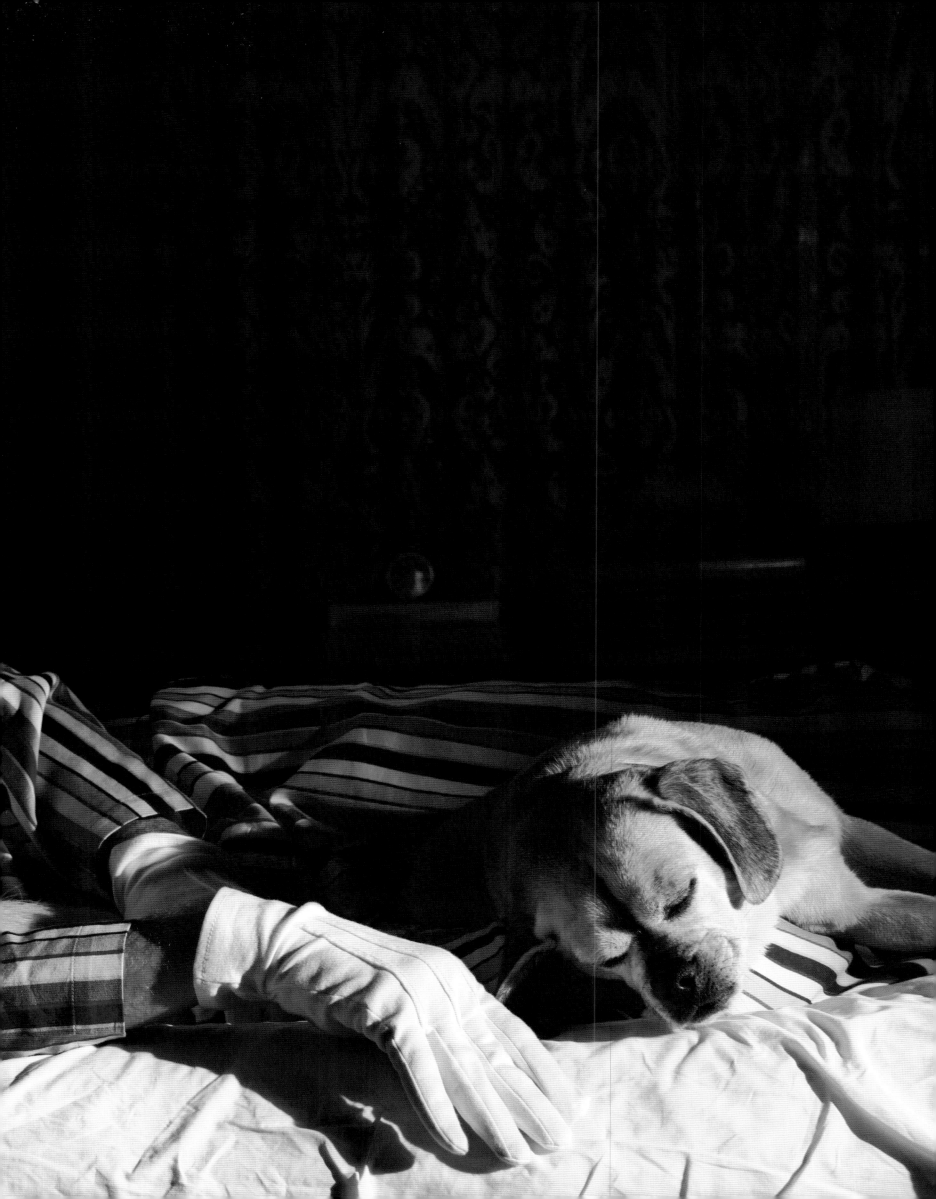

BILL HADER

2014

40

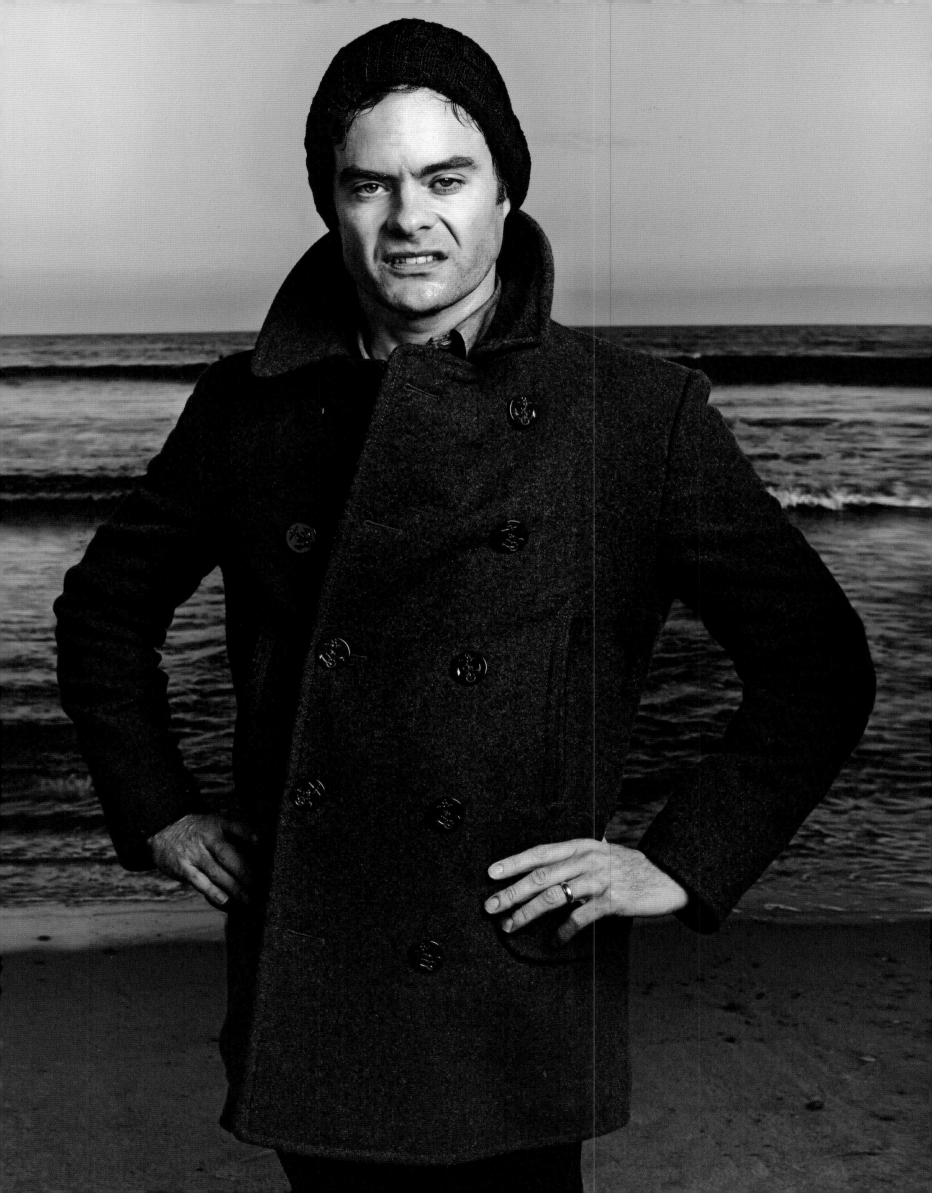

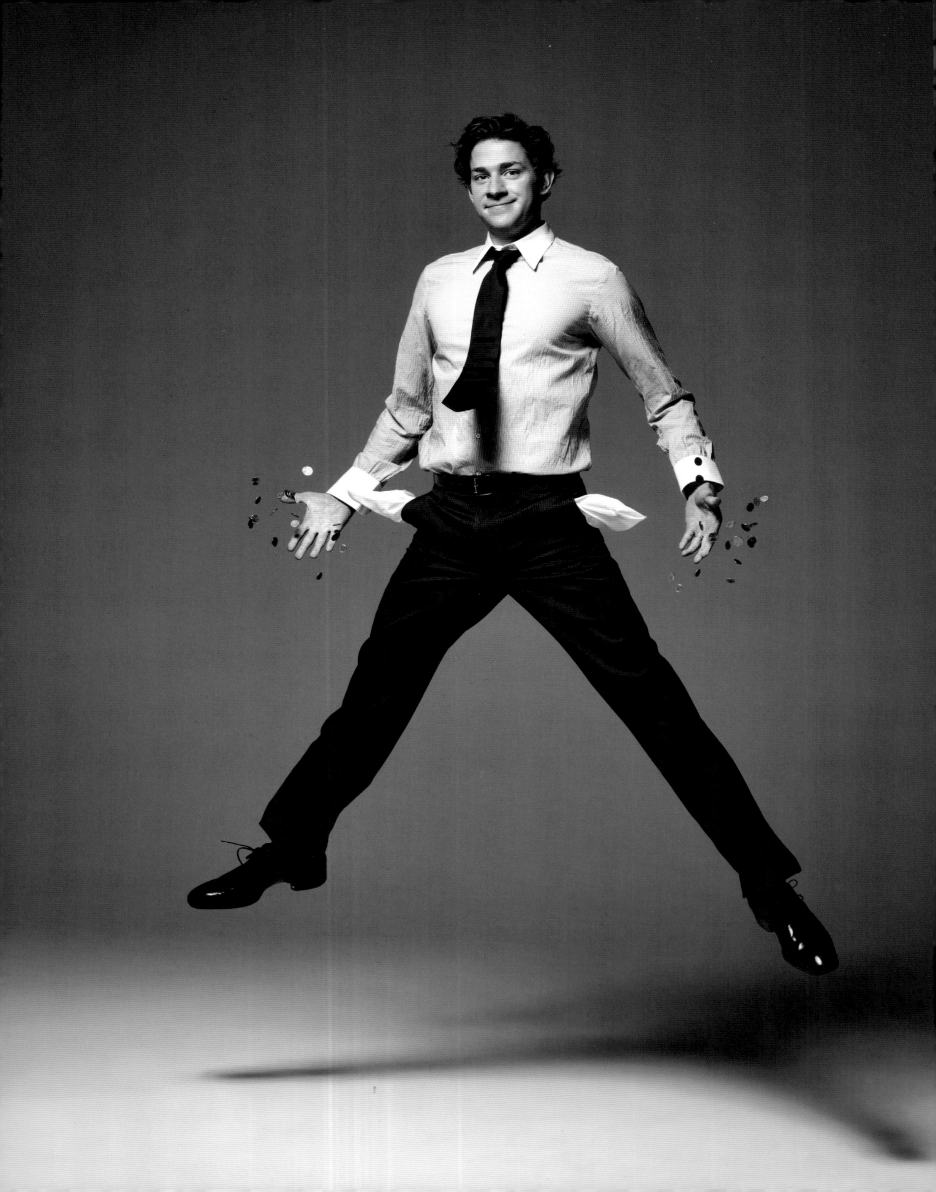

JOHN KRASINSKI
2008

BRYAN CRANSTON

2012

Years ago, when Bill Murray was the movie critic on *Saturday Night Live*, he ran through a list of actors and said, "They're not acting; they're just behaving." I feel like I've sat through a lot of "behaving" before I got to Bryan Cranston. He infuses everything—including sitting still in a fake diner—with gravitas and intelligence.

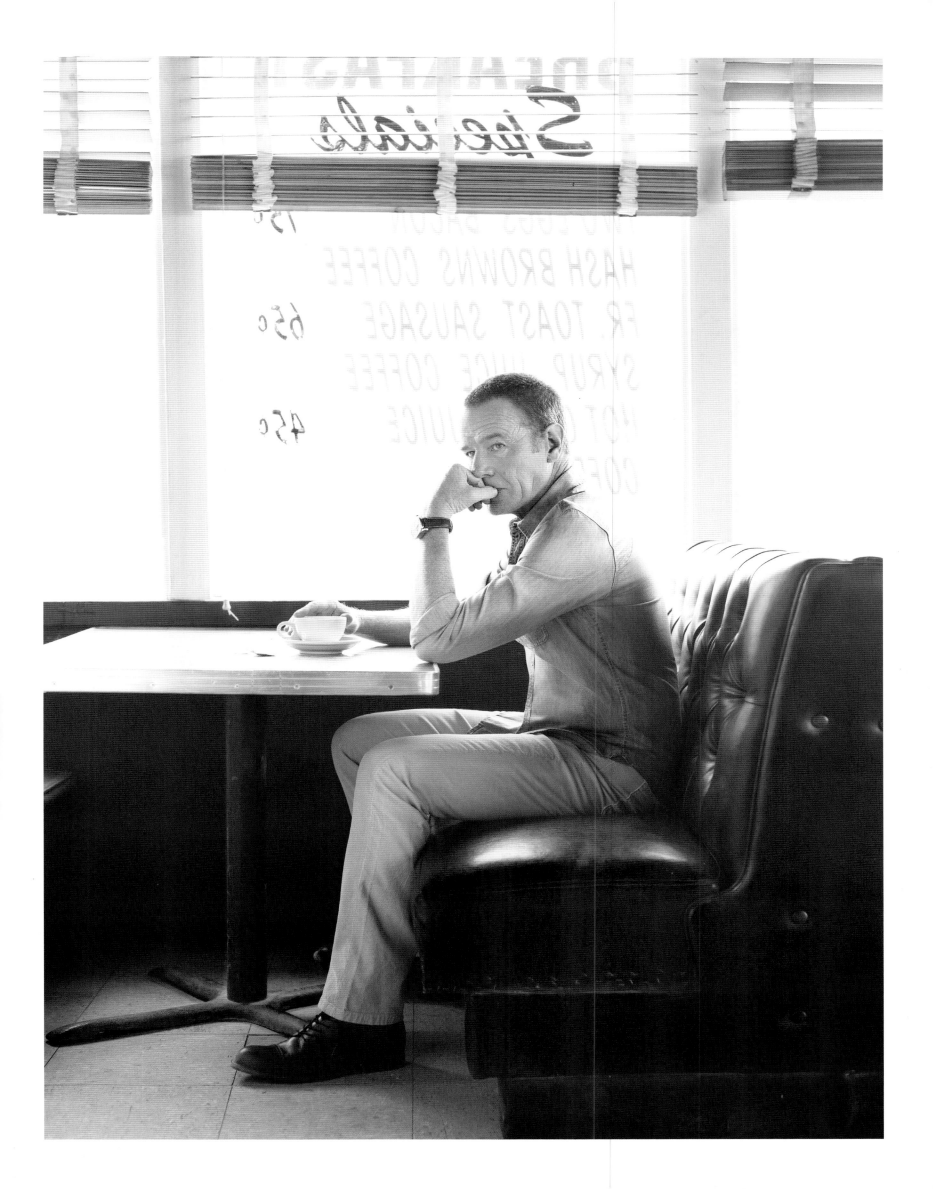

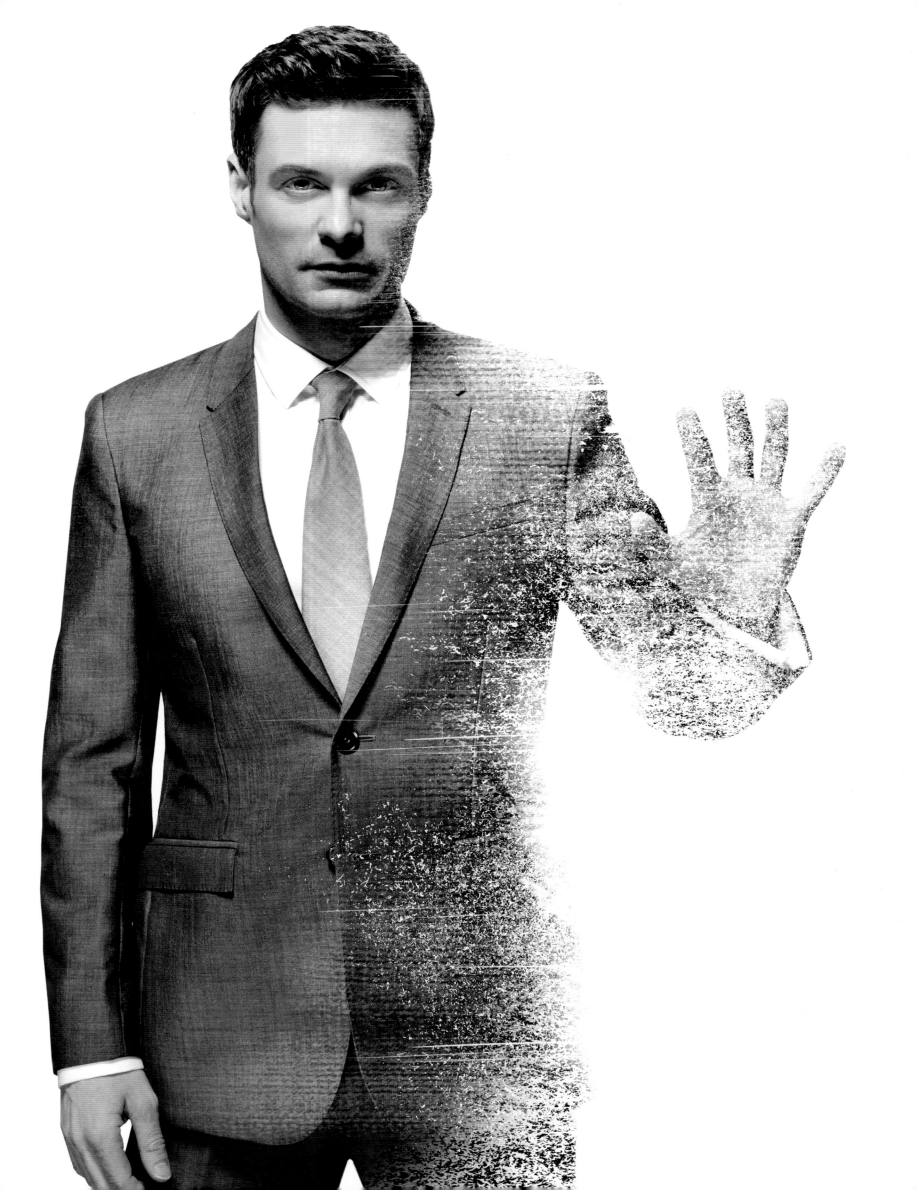

RYAN SEACREST

2011

Producer, radio and TV host, and probably the busiest guy in Hollywood, Seacrest was shot for a story on the future of media. When he told me his daily schedule, I almost puked.

DIEGO LUNA, GÉNESIS RODRÍGUEZ, and WILL FERRELL

2012

This was shot to coincide with the release of their film *Casa de Mi Padre.* In one of those odd, only-in-Los-Angeles situations, the old house we rented on a nondescript street in a suburban neighborhood just happened to have a chapel in it. We tossed the pew out onto the lawn, and voilà, we got our saloon.

(overleaf)

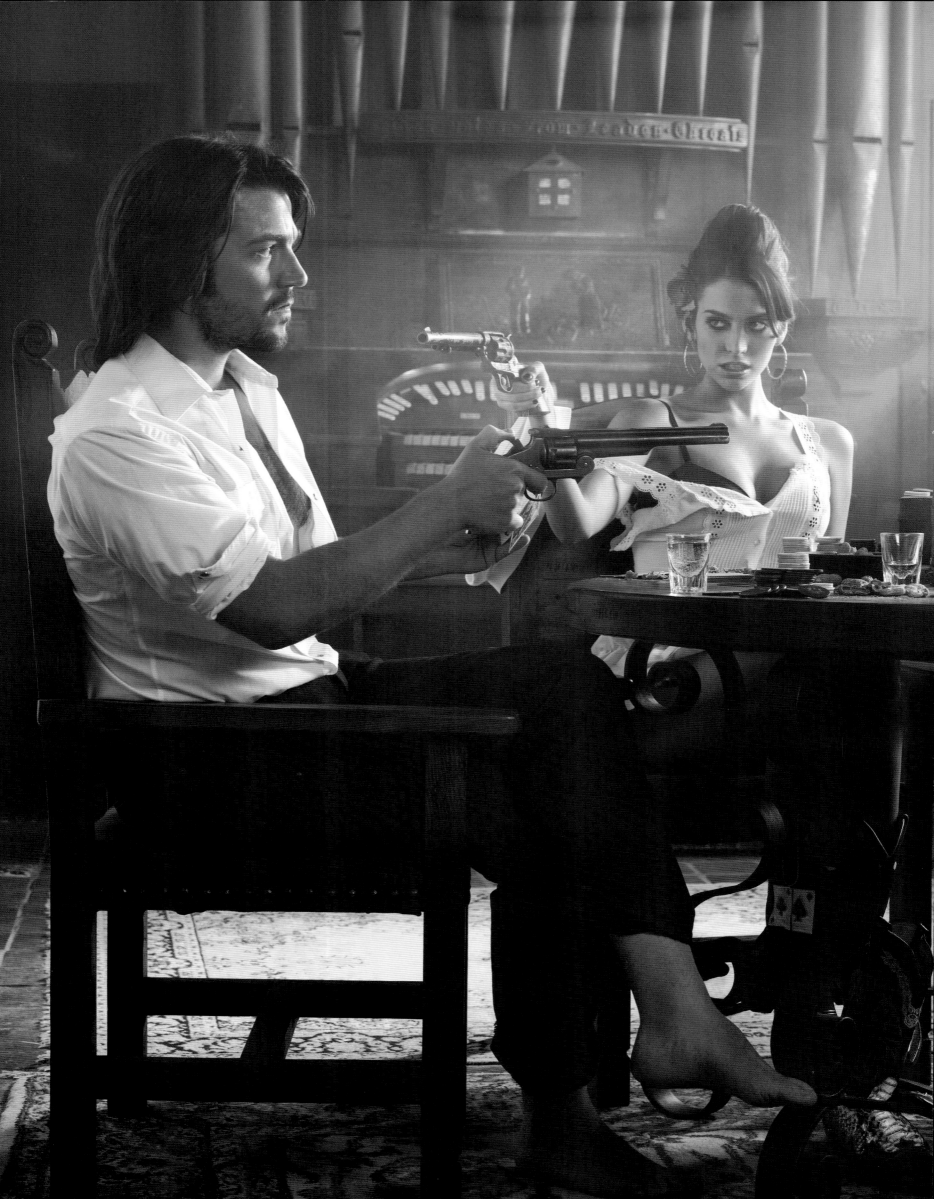

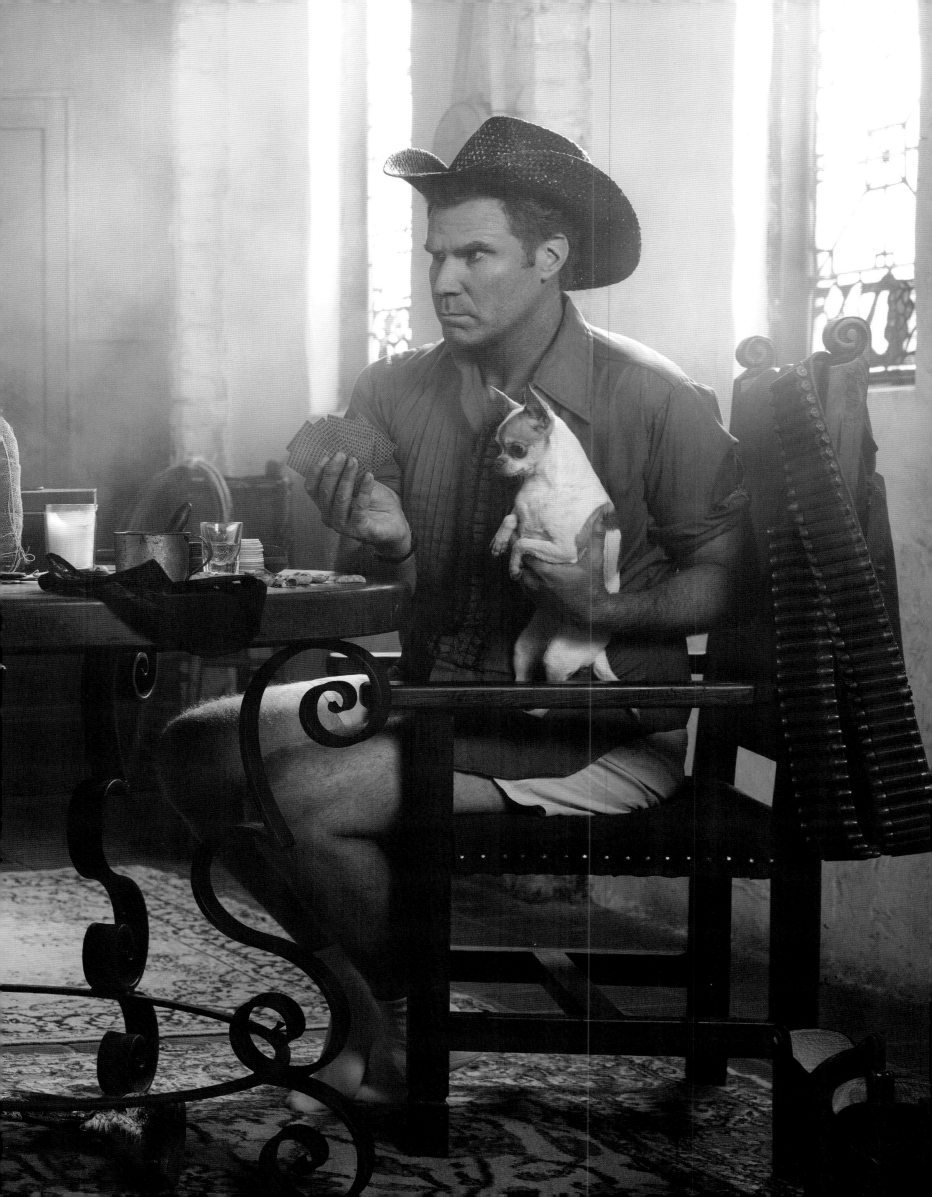

JUDD APATOW

2011

Apatow was promoting his film *Knocked Up* and
told us if we ordered a few cheeseburgers from
room service, he could make himself look pregnant.
We were shooting this when his wife and very
young daughters walked in to visit. I remember
the youngest taking one look at him posing and
burying her head in her mother's neck, saying,
"No, Daddy, no. . . ."

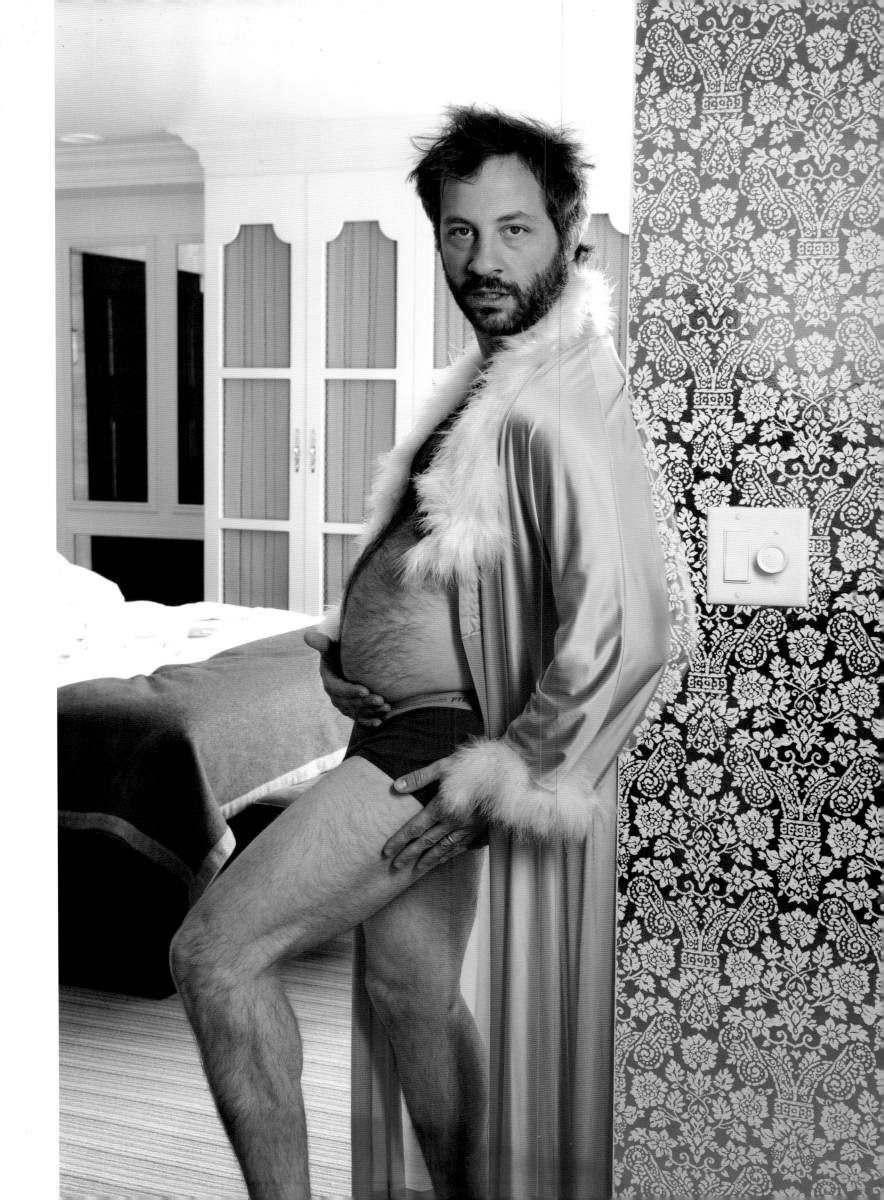

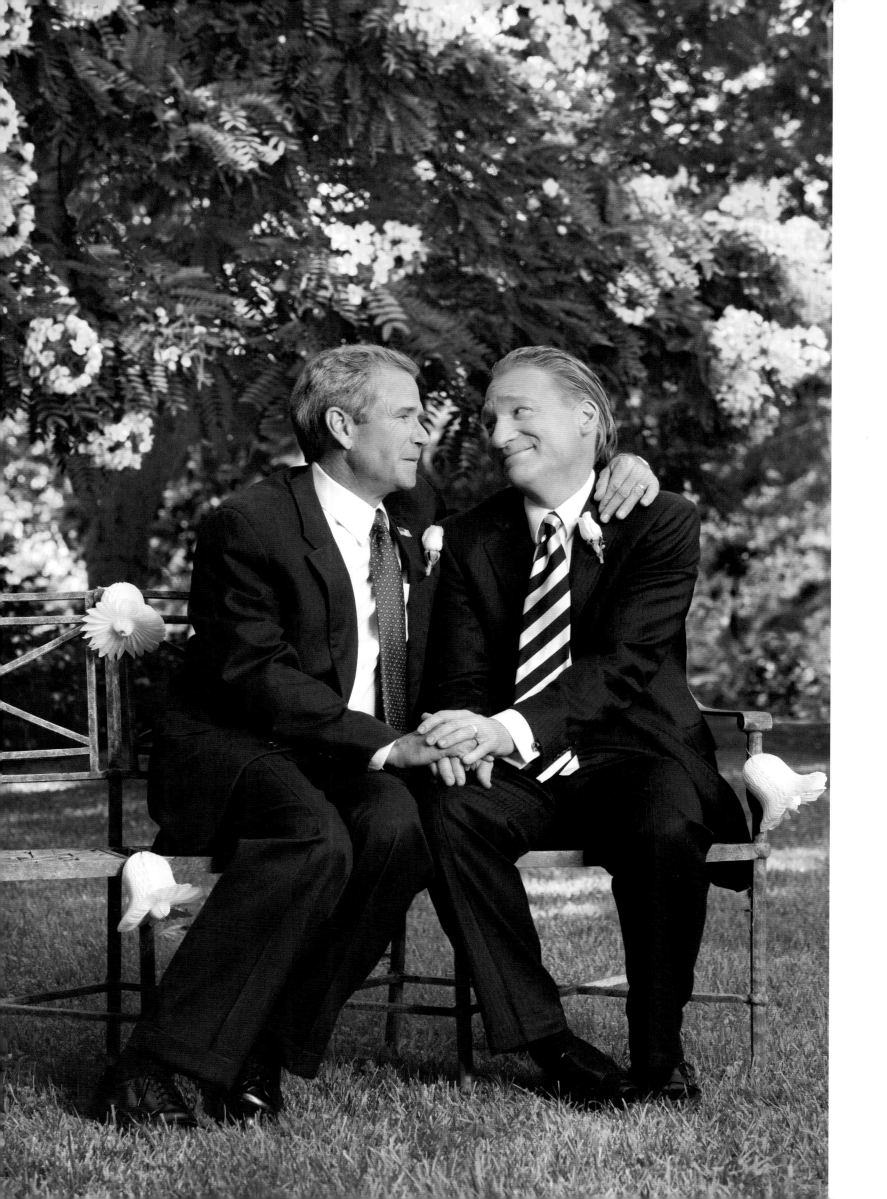

BILL MAHER

2006

A very good Bush impersonator. Almost too good. Maher and I were both a little unnerved. Maher probably more so because this was being photographed in his backyard.

TAYLOR MAC

2015

To quote the *New York Times*, "Fabulousness can come in many forms, and Taylor Mac seems intent on assuming every one of them." An acclaimed playwright, actor, singer-songwriter, performance artist, director, and producer, Mac was in the development phase of *A 24-Decade History of Popular Music* when we shot this. The concept called for him to perform American songs dating from 1770 to 2016. Backed by twenty-four musicians at the start, Mac would stay onstage for a full calendar day, devoting one hour to each decade (with costume changes) and losing one musician per hour until he was finally alone on the stage. Audience members would be required to sign an agreement committing them to stay for the entire event. Visionary in concept, ambitious in scale, daunting in execution, my first question when Mac told me the plans was, "But where are you going to pee?"

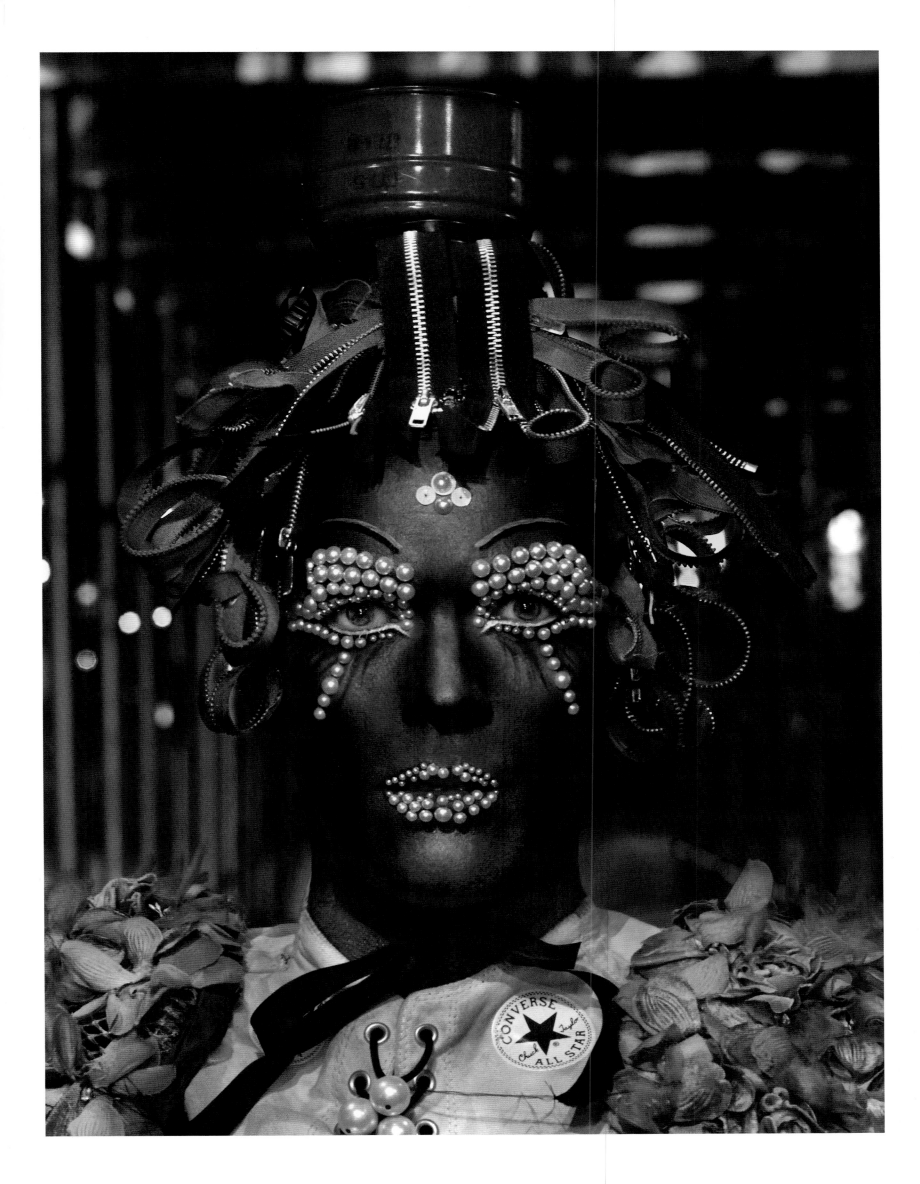

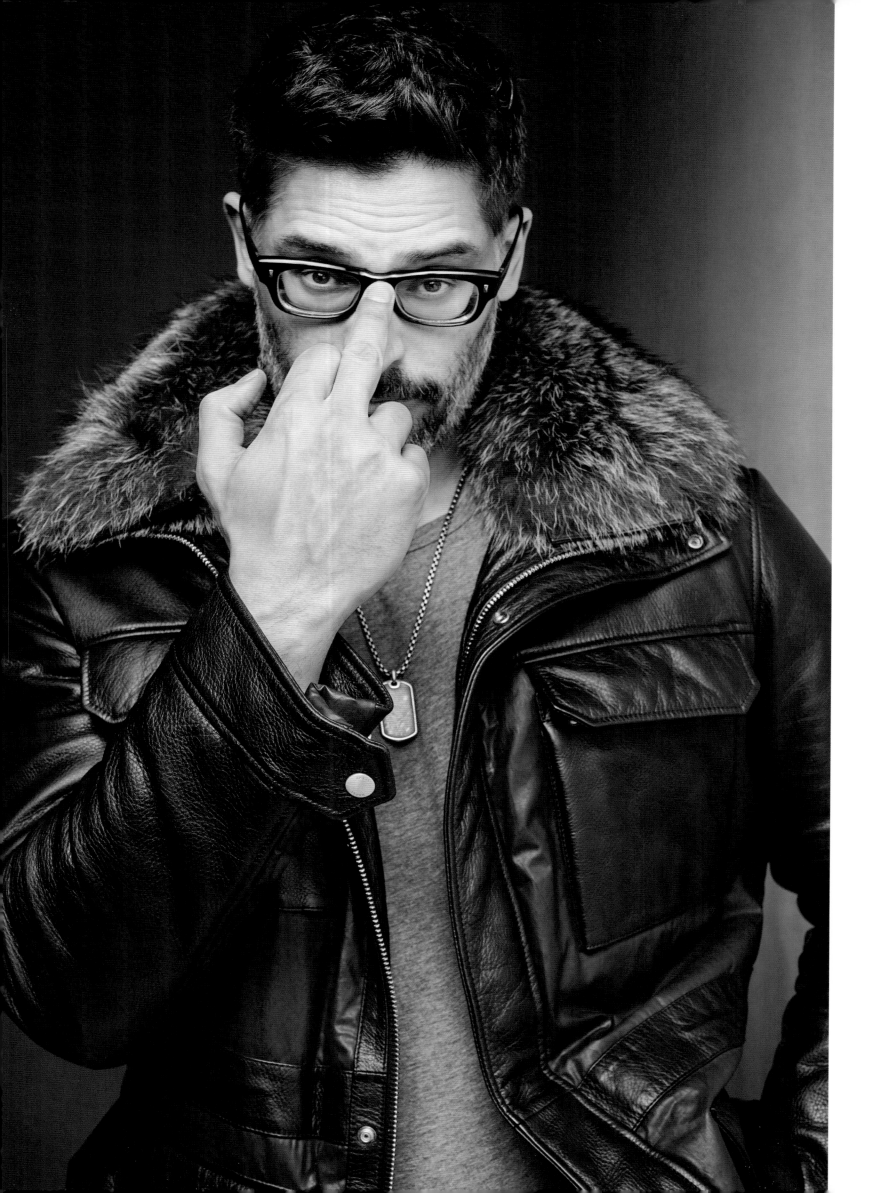

JOE MANGANIELLO

2015

I kept trying to give him simple props to work with, but he wasn't buying it. Finally he said, "Wait, I have a coup for you—I'm going to wear my glasses for a shot!" I said, "*That's* your idea of a coup? Riding a tricycle naked smeared in strawberry jam is what I would consider a coup." And then he did this.

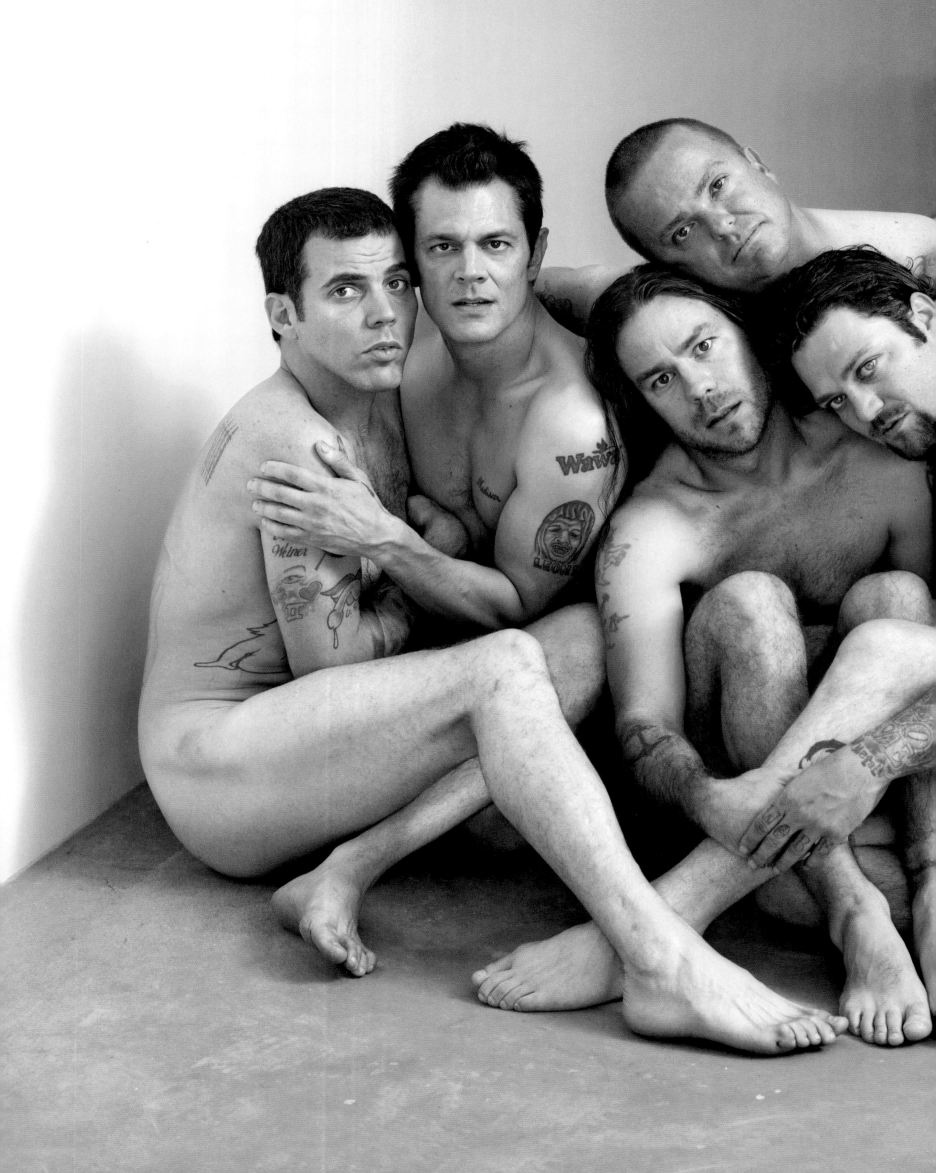

STEVE-O, JOHNNY KNOXVILLE, CHRIS PONTIUS, WEE-MAN, and BAM MARGERA (Cast of *JACKASS*)

2010

I'm usually opposed to re-creating famous photos, but *Rolling Stone* came to me with this idea in place, and the guys were all onboard. It's based on a photo of supermodels taken by the legendary Herb Ritts. Easily the most awkward direction I've ever had to give any group: "Please tuck in your balls."

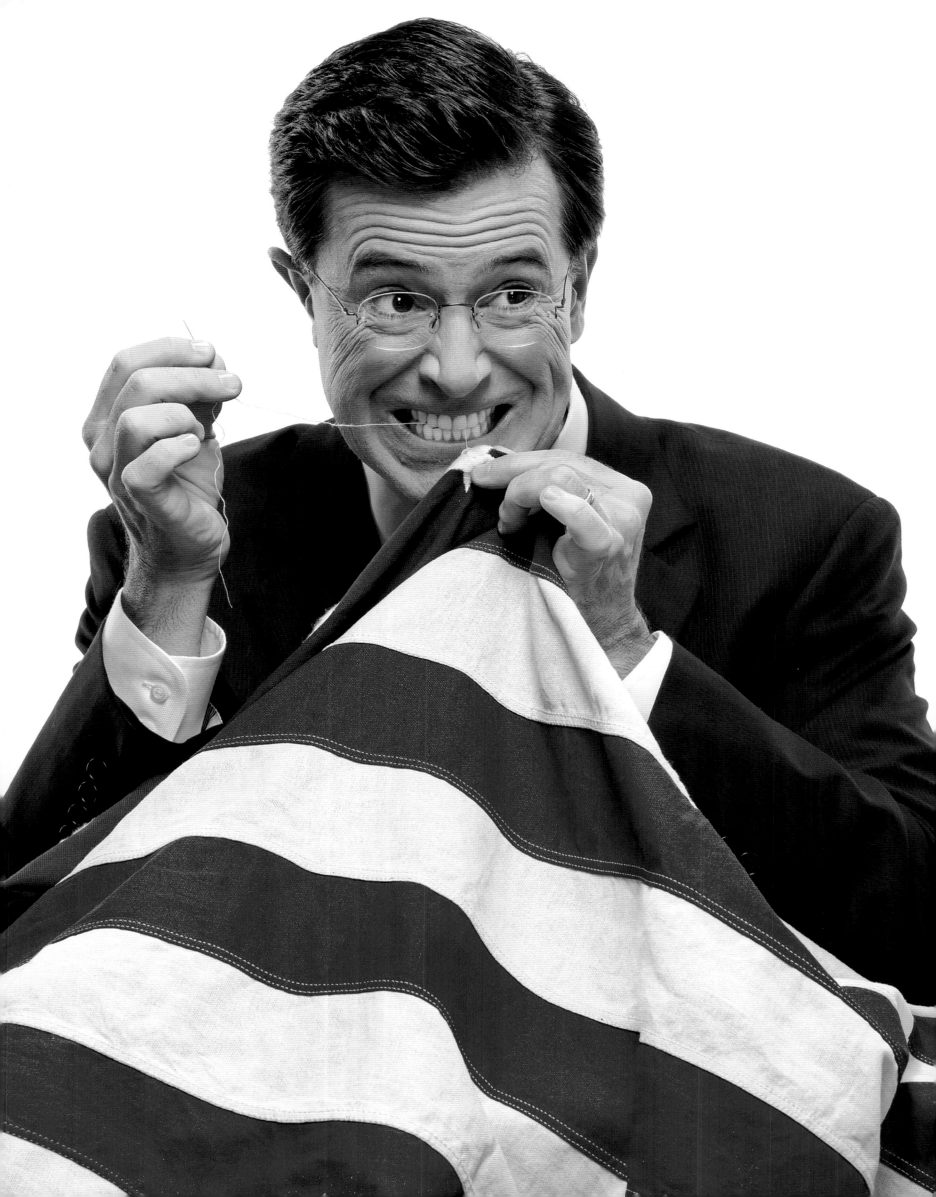

STEPHEN COLBERT

2006

His idea. Came up with it right on the spot.

JON STEWART

2006

The Terror Alert Milkshake. His idea.
Came up with it right on the spot.

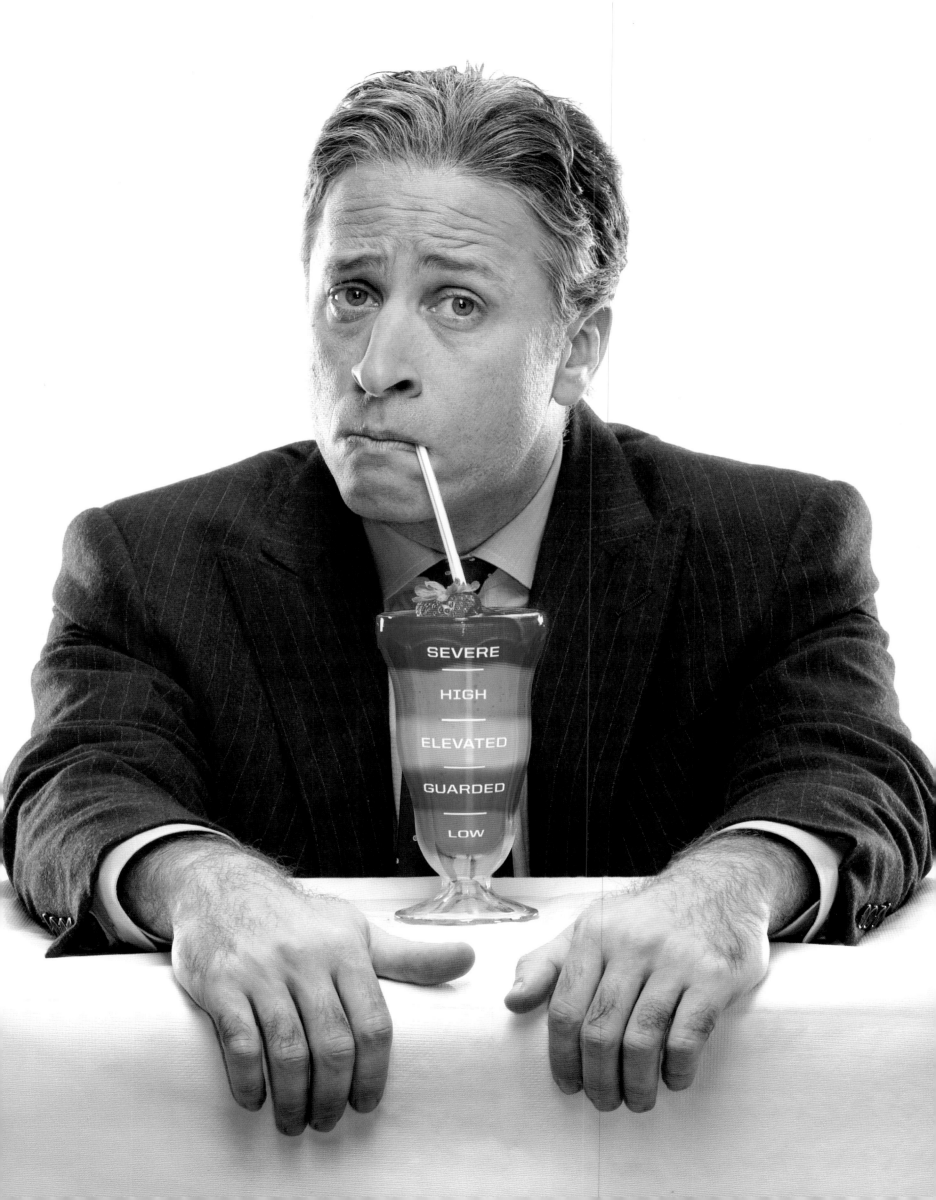

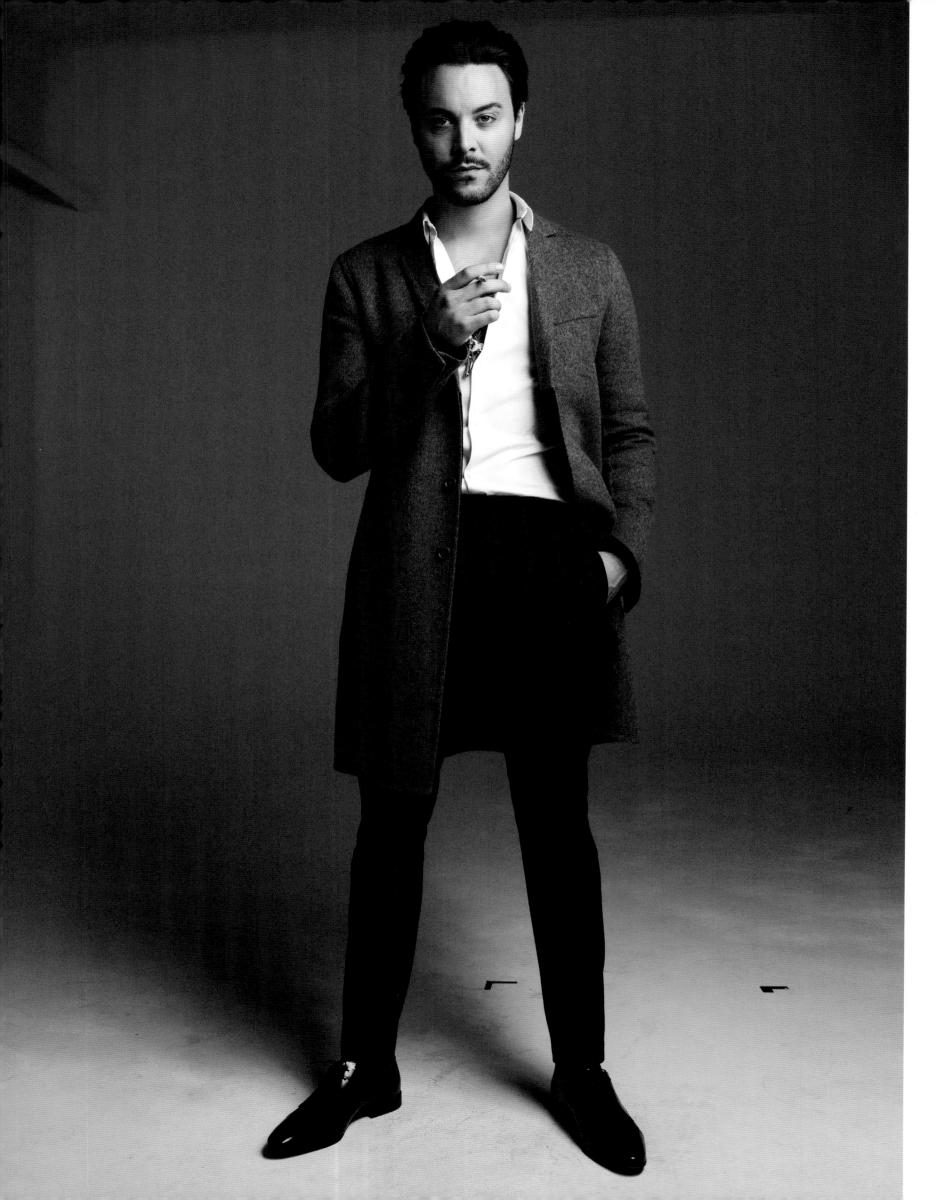

JACK HUSTON

2013

Huston was born and raised in England, but he makes the cut two ways: he descends from Hollywood royalty (his paternal grandfather was legendary film director John Huston) and he can do an American accent really well.

WOODY HARRELSON

2012

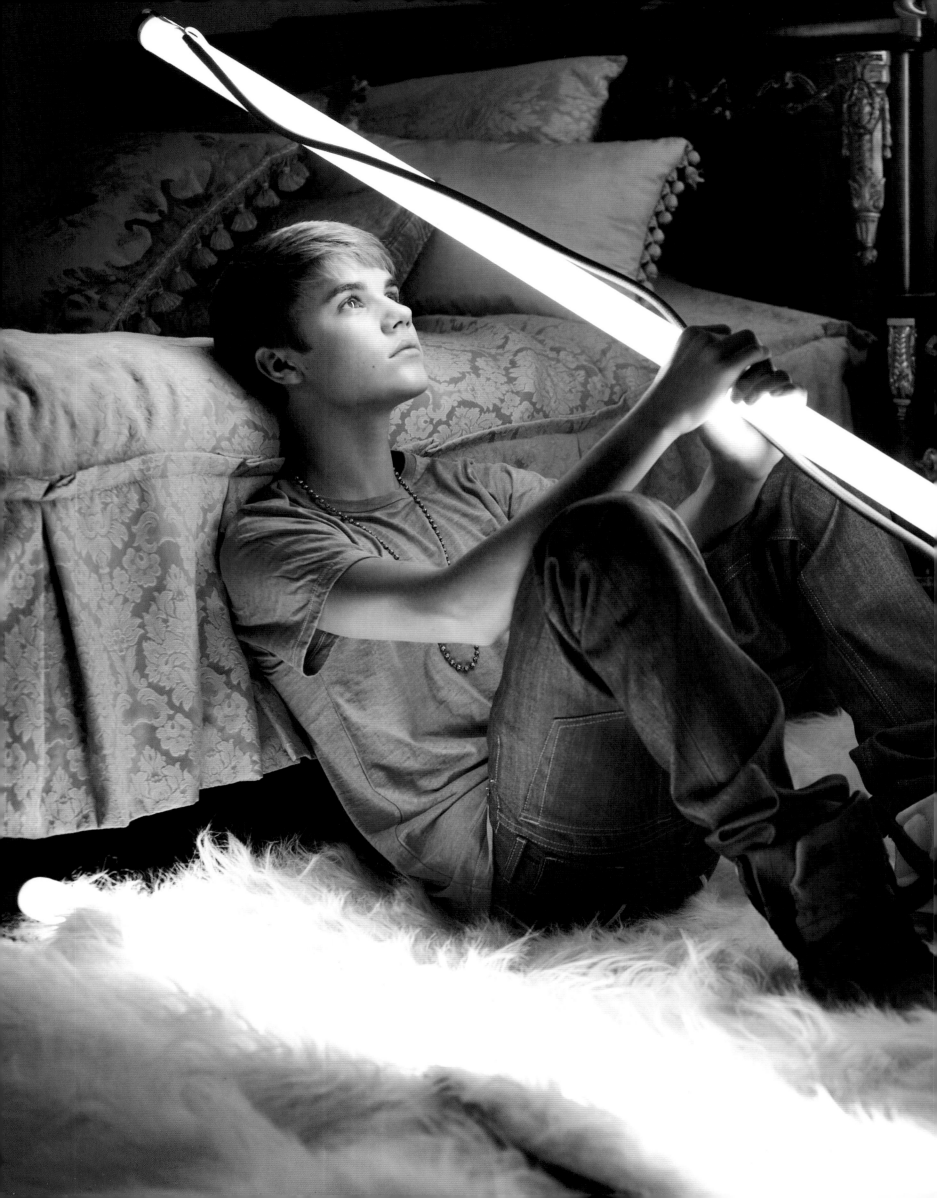

JUSTIN BEIBER

2012

I know, Canadian.

MARK WAHLBERG
and WILL FERRELL

2015

The night before the shoot, I came across a
random photo of Elizabeth Taylor fiddling with
her hair while her dresser held the mirror for her,
and I thought, "Would they?"

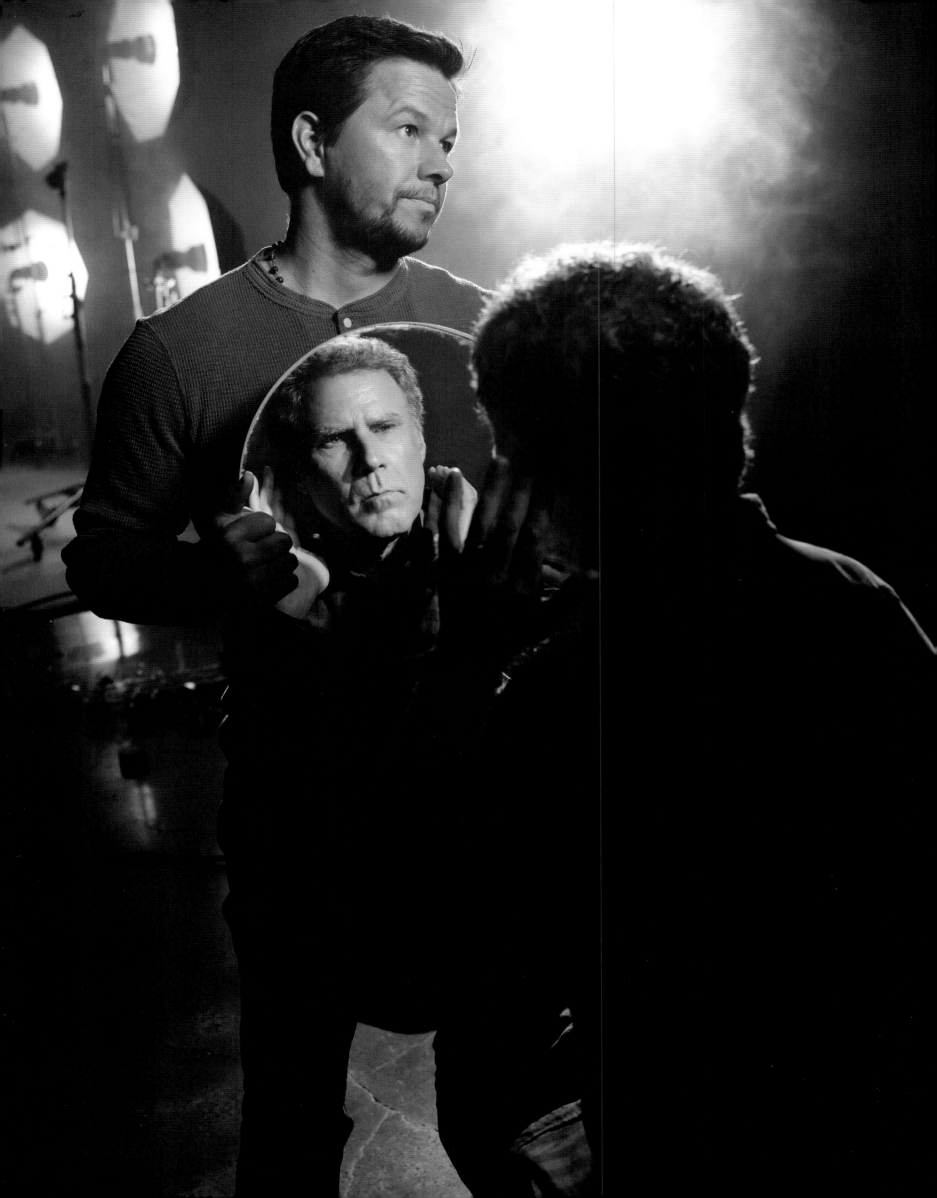

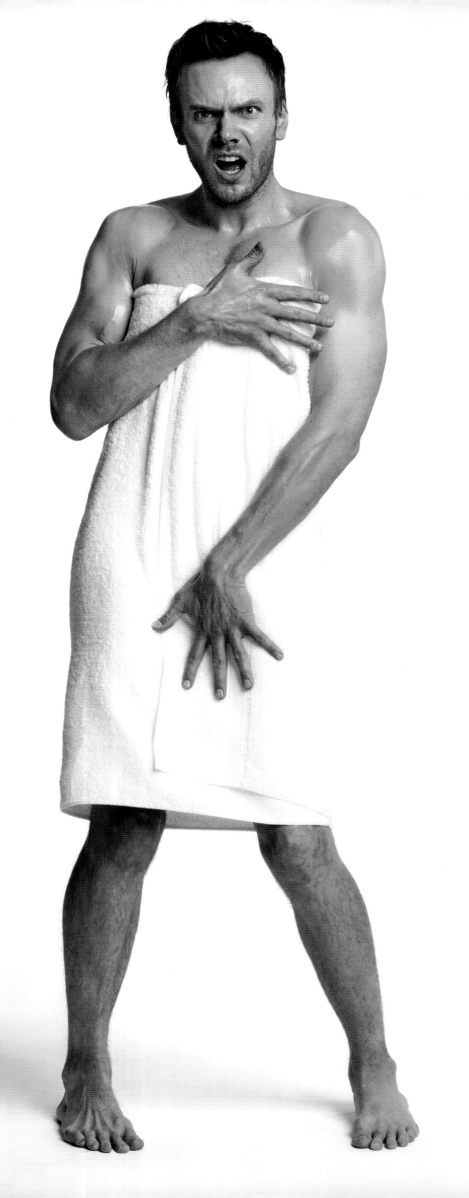

JOEL MCHALE

2012

RYAN MCCANN

2015

McCann, a former quarterback for the UCLA
Bruins and Cincinnati Bengals, had his athletic
career cut short due to a shoulder injury. That's
when, to quote him, "I started lighting things
on fire." McCann essentially paints with flame,
a technique known as pyrography. Most often
the images are accompanied by satirical text,
though he also creates the occasional sculpture
(see body in left of frame) as well as oil painting
and photo work.

Me: "Was it strange going from the daily
camaraderie of practice and play to the solitude
of an artist's life?"

McCann: "I can't say I was uncomfortable in
a team atmosphere, but I'm definitely someone
who is comfortable alone."

Me: "Have you ever had to call the fire
department?"

McCann: "No, it hasn't gotten that out of
hand yet."

Me: "What's your insurance policy look like?"

(overleaf)

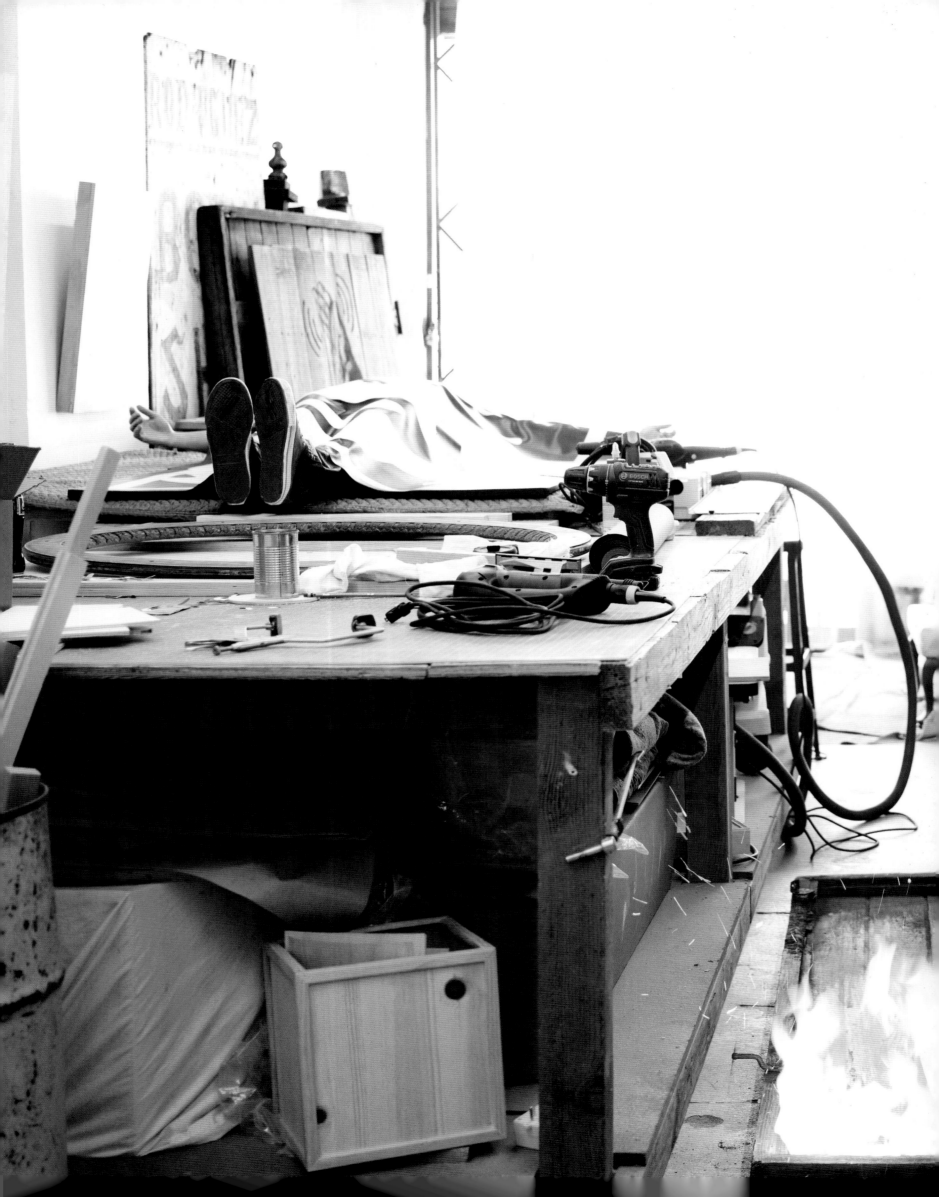

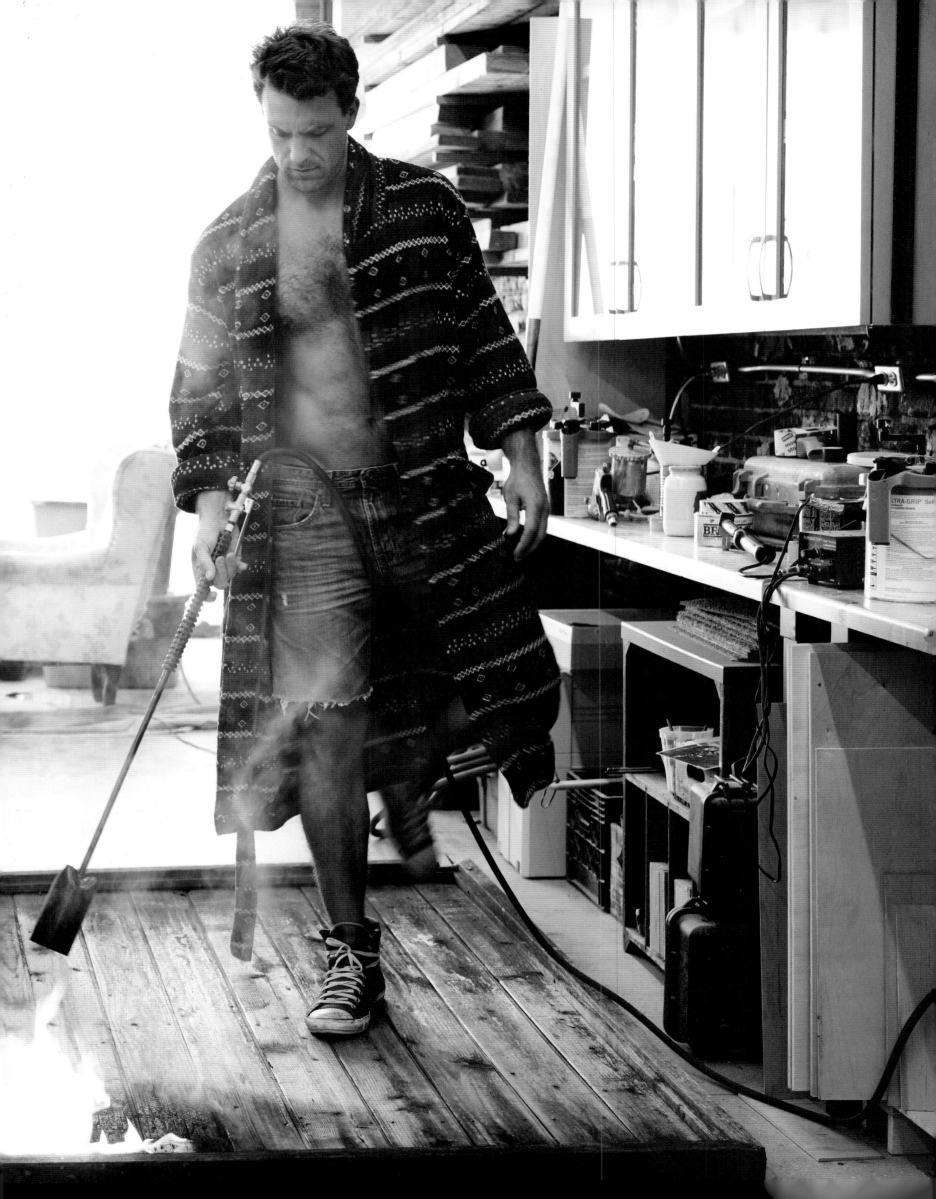

BOB SAGET

2005

I was able to talk to Saget on the phone before the shoot about what I wanted to do: "A hooker dressed as a giant rabbit is passed out next to you in a cheap motel bed. There's booze, condoms, lube, cash, and the pitiful realization of what you've just done." Without a moment's hesitation he replied, "Sounds good. Do you need me to bring any of that?"

JUSTIN THEROUX

2015

A writer, actor, and producer, he couldn't be a nicer guy. We shot this in the front yard of his beautiful, serene home. It's not easy to do a burnout on gravel. We did take after take, and when it was over, he got off the bike, looked at the deep ruts dug into the gravel, and sighed, "My wife is gonna kill me."

(page 78)

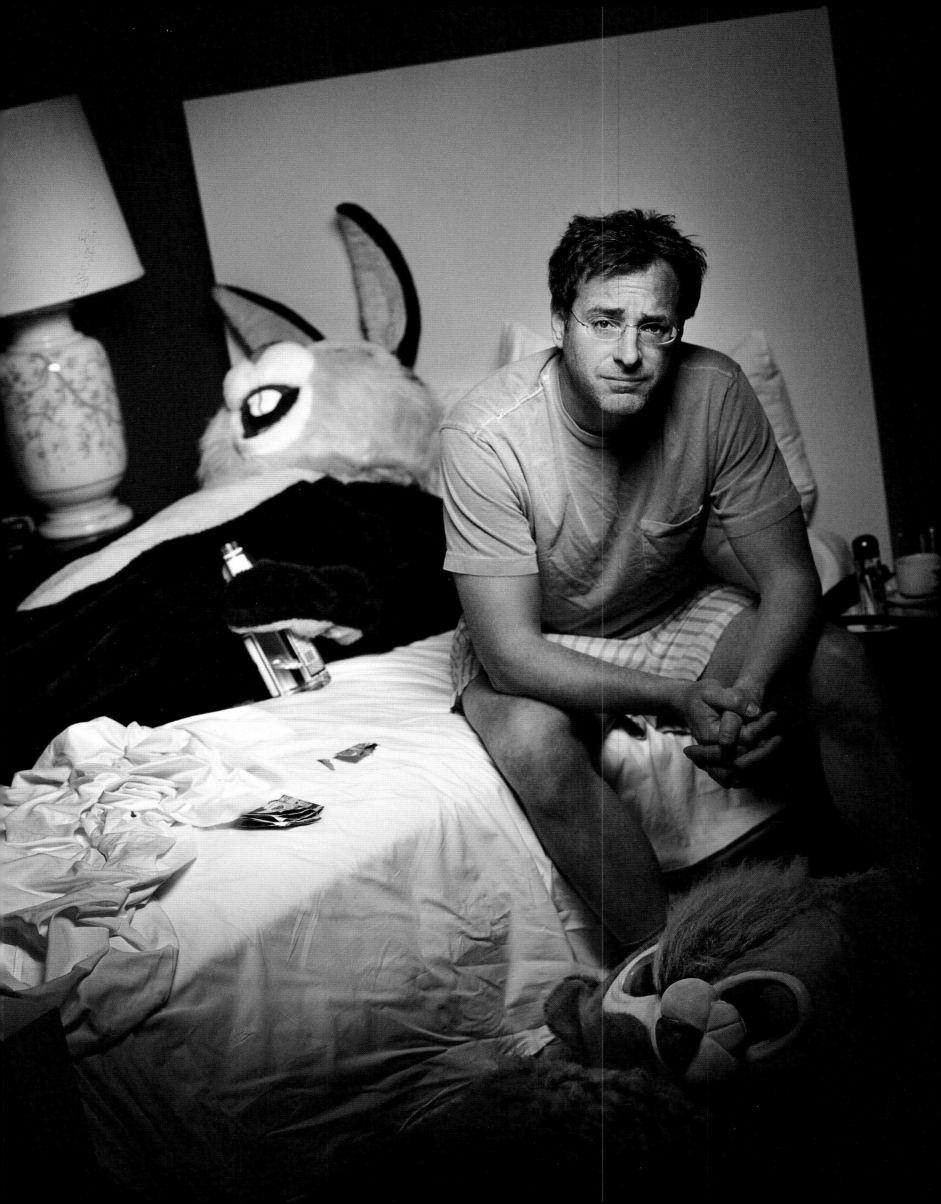

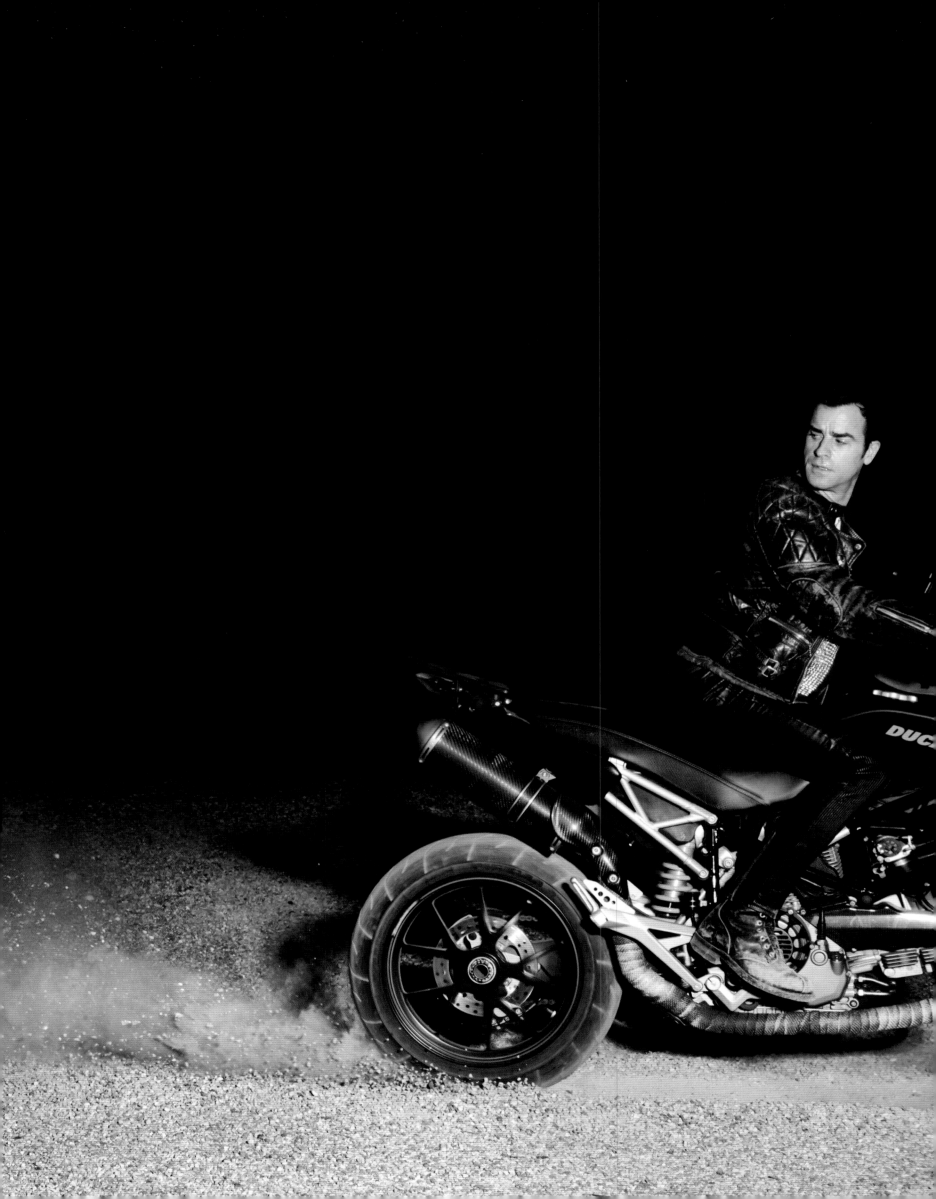

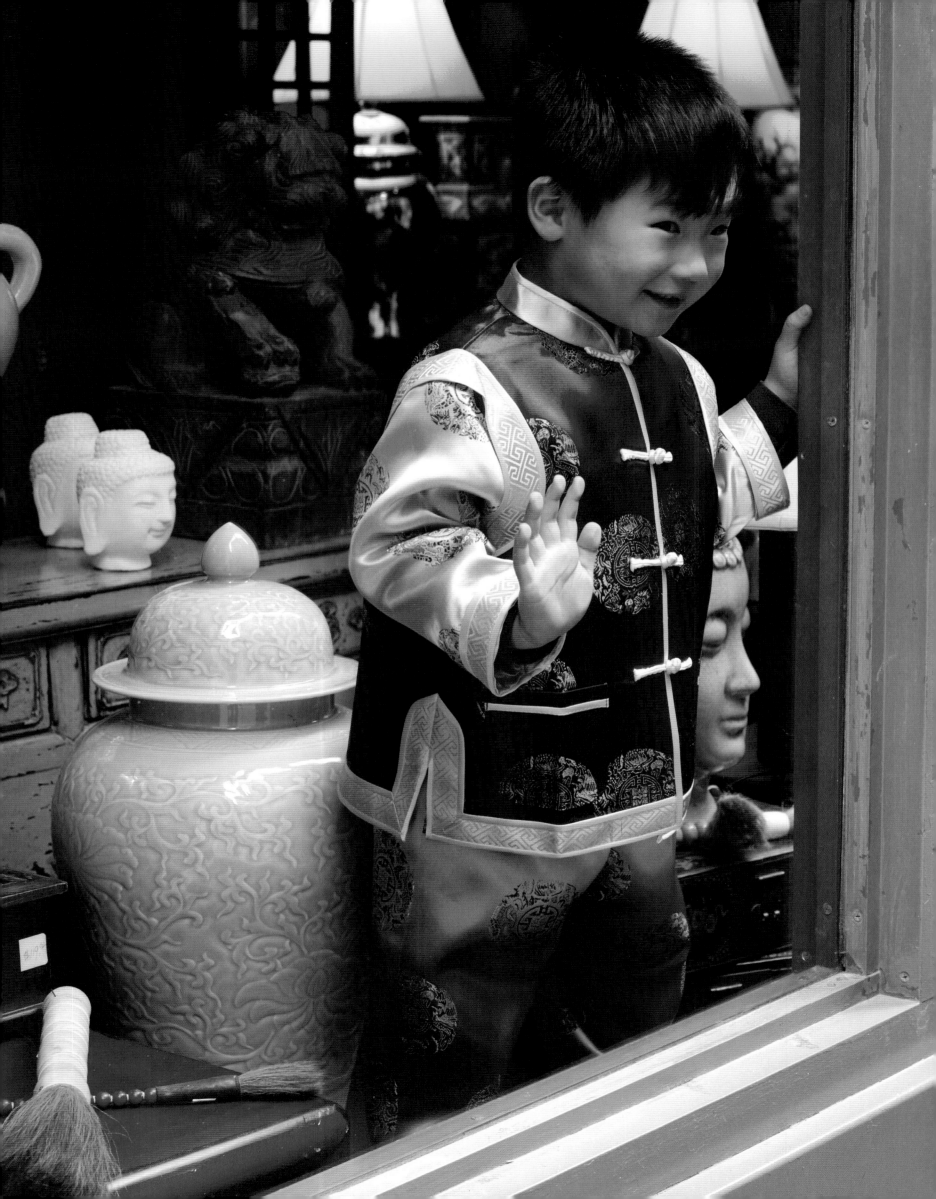

LIAM QUILL KONG

2015

Three-year-old Kong was born in New York City, where this photo was taken. Kong's heritage is Irish, Chinese, Welsh, and Korean. The e-mails between his mother and me trying to figure out which way to dress him were endless.

DEBRA MESSING and ERIC MCCORMACK

2001

I photographed them many times during the run of *Will and Grace*, and they were always game for anything. This shot was done at the end of a long day where we had dressed them as Lucy and Ricky and then Sonny and Cher. The great thing about editorial photography is that you can take a notion to its absurd extreme. In this case, I thought, *What if one of Will and Grace's fights got really out of hand?* They loved it, the magazine loved it, but these images have never been published. In the weeks leading up to press, 9/11 happened. I got a call from the magazine telling me that, given the circumstances, they couldn't show people being hurt, even in a comical way. It took a long time before you could show someone getting their ass kicked again.

(overleaf)

MESSING, DEBRA
AKA 'GRACE'
2 4 6 0 5 7 S

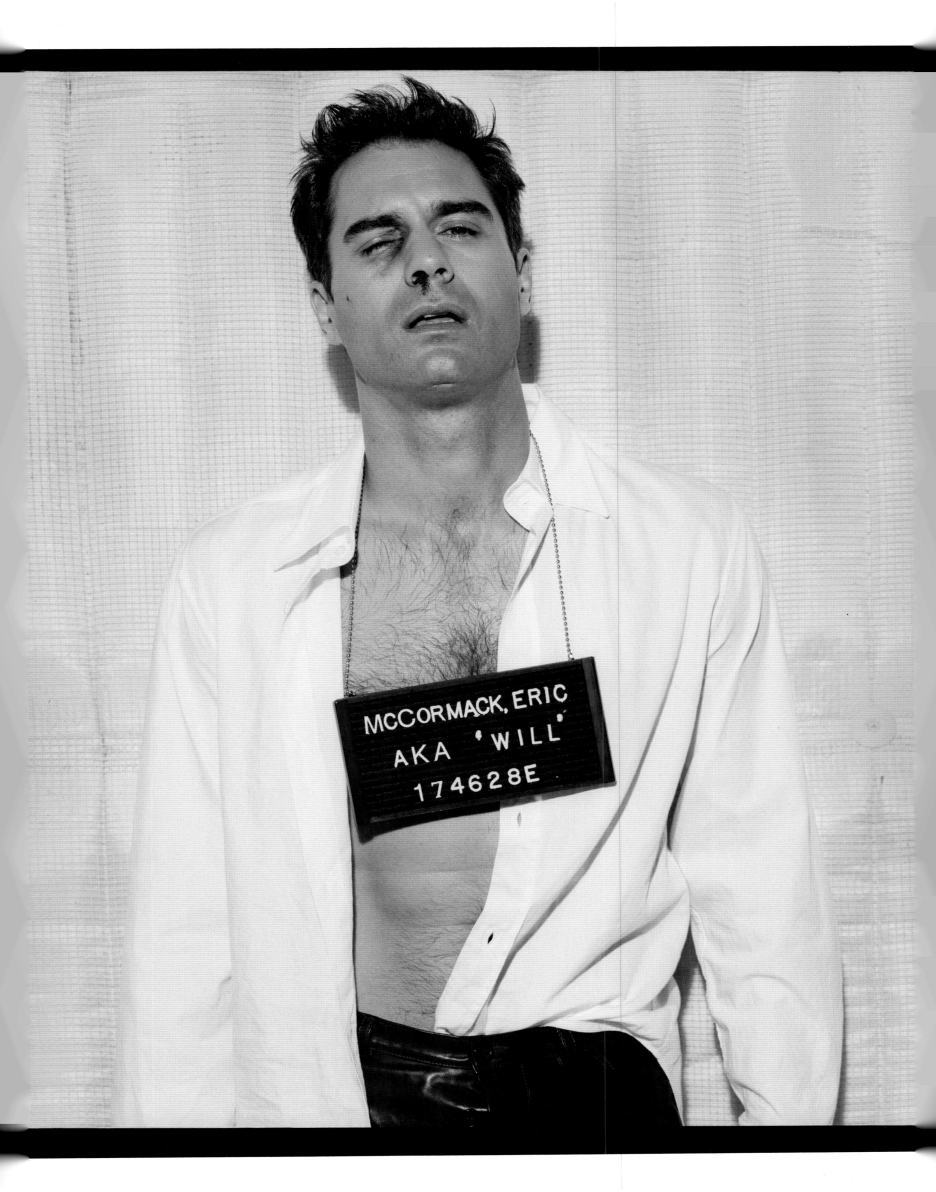

WILL ARNETT

2008

Though you're only seeing the one shot, here's how my day with Arnett broke down:

Shot One

Me: "Will you put on this strapless gown?"

Arnett: "Yes."

Me: "Thanks, the color really works with your eyes."

Shot Two

Me: "Will you cry at a window with mascara running down your face?"

Arnett: "Yes."

Me: "More hysterical, please."

Shot Three

Me: "Will you put on these fishnets?"

Arnett: "Yes."

Me: (Eternally grateful)

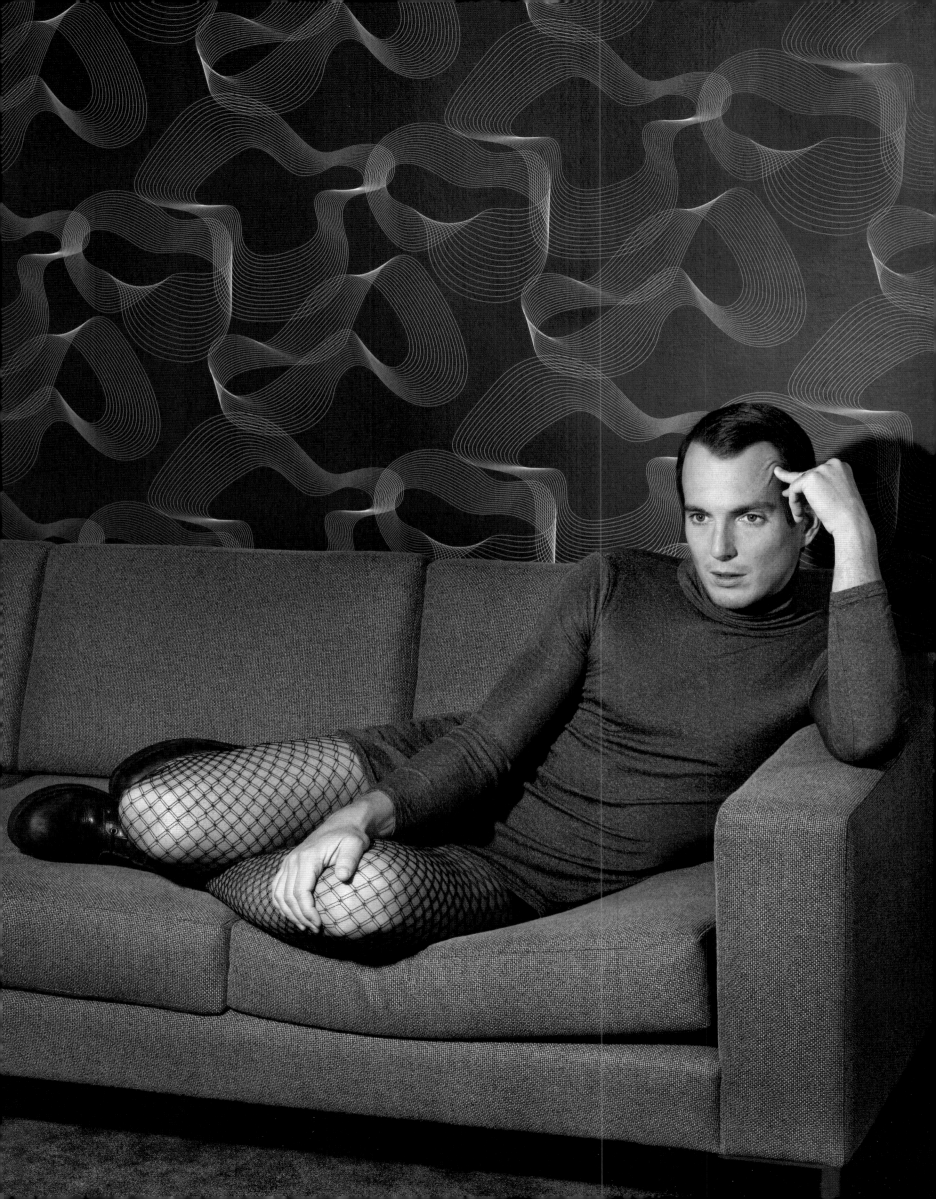

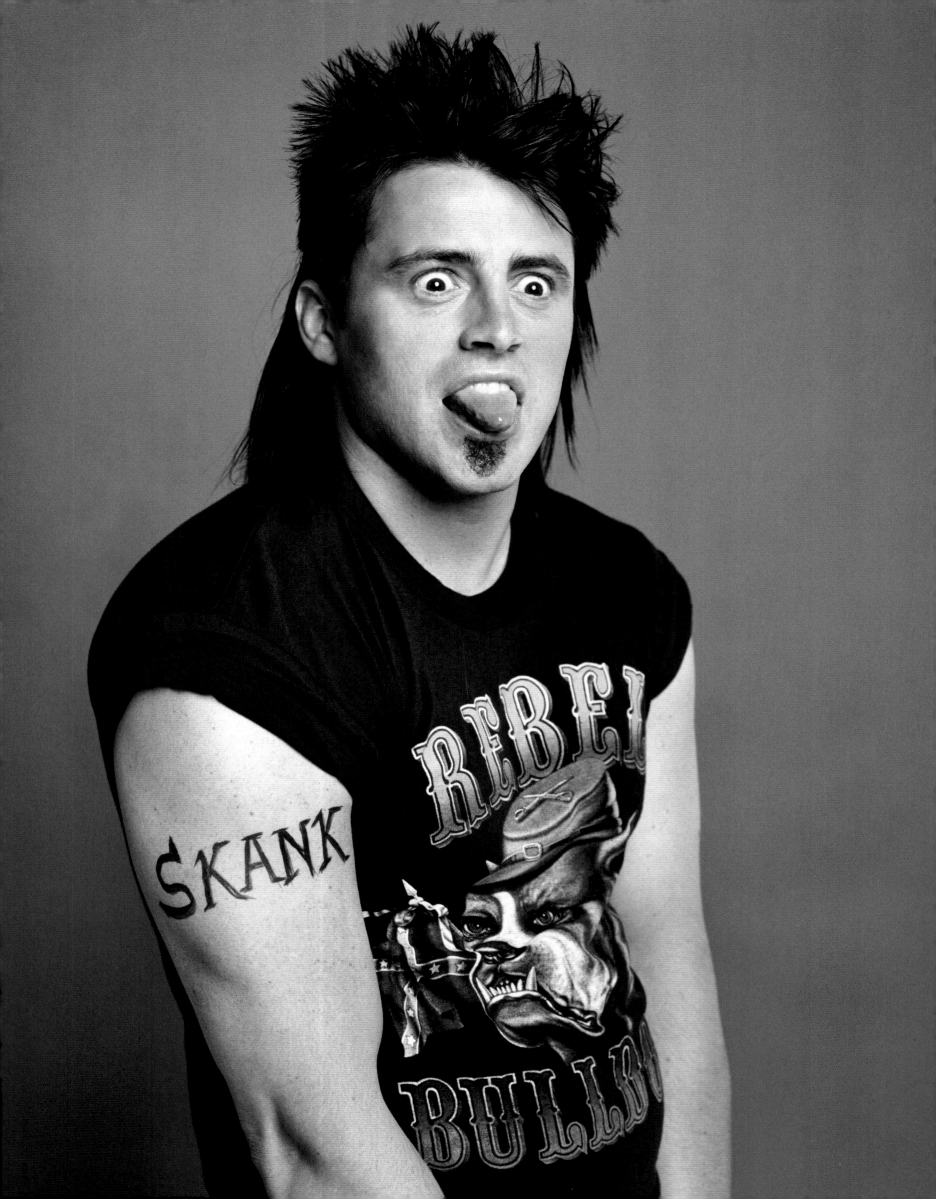

MATT LEBLANC

2002

I don't remember why we did this to him
(it was part of the same series pictured on the
title page as well), but damned if it doesn't
fit into the theme of this book, huh? It was
shot two years before *Friends* ended its run.
LeBlanc said to me matter-of-factly, "I'll never
do anything as popular ever again."

JOHN STAMOS

2013

We re-created a scene from the film *Brazil* to mark
the eternally handsome Stamos's fiftieth birthday.

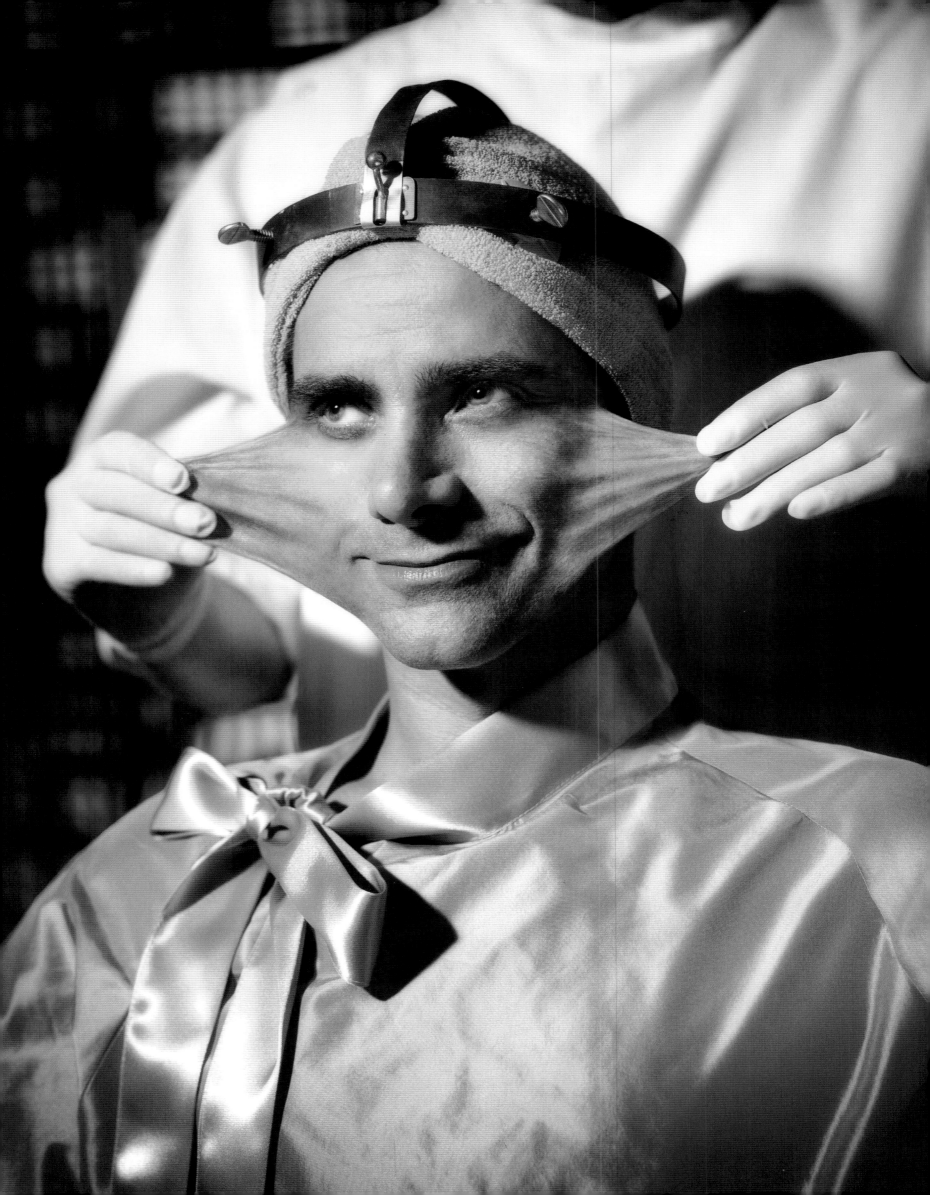

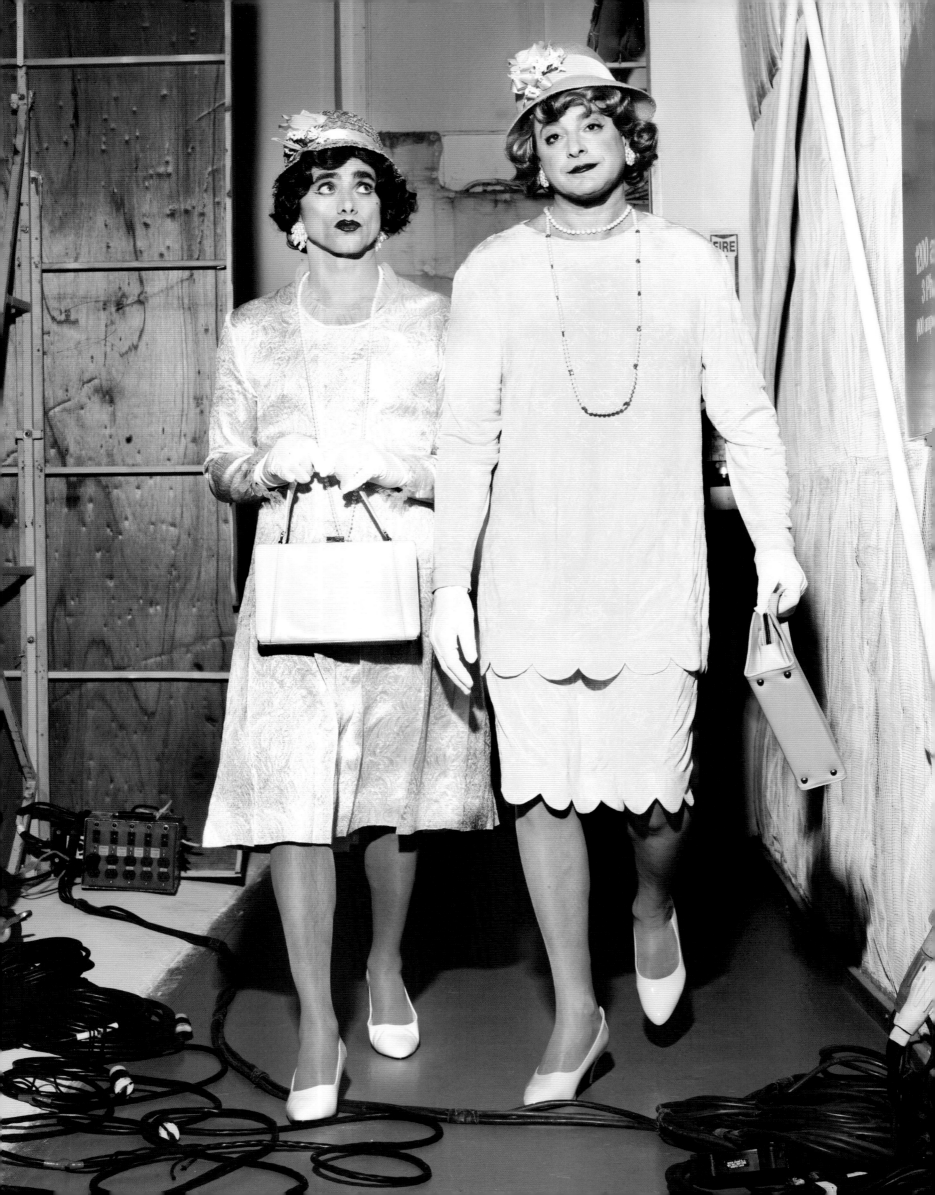

JOHN STAMOS and BOB SAGET

2013

This is an ode to Jack Lemmon and Tony Curtis in *Some Like It Hot*. Guys in women's clothes, who haven't made it a conscious lifestyle choice, will always be funny. Period.

SCOTT EASTWOOD

2015

I remember hearing years ago that during Hollywood's Golden Age, the MGM dancer Ann Miller was filling out her passport application and under occupation she wrote, "Movie Star." And that's Scott Eastwood. I have no idea if it's the genes (his dad is Clint) or the fact that he grew up on movie sets, but he walks in with an unbeatable combination of charisma and ease. Like the best of them, he hears the click of the shutter and stays one step ahead of me, changing things up, keeping it interesting.

(overleaf)

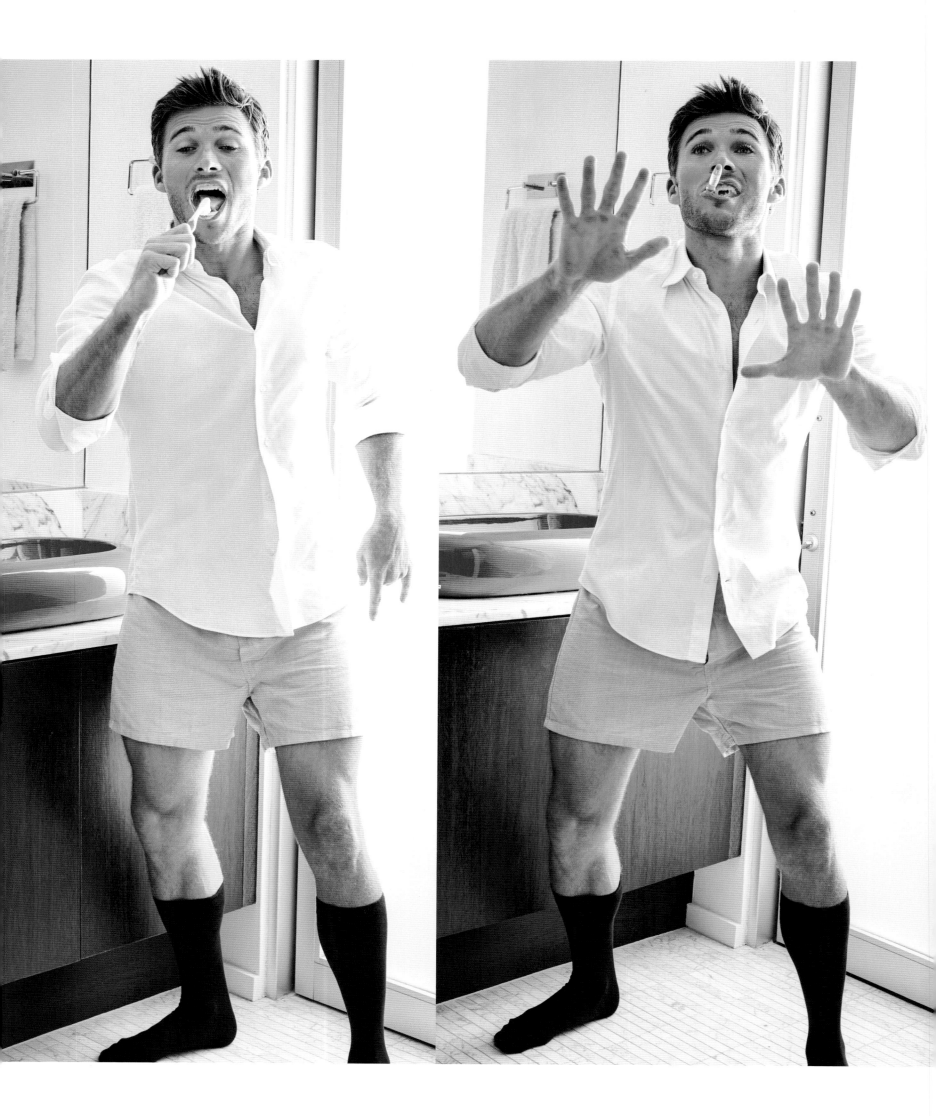

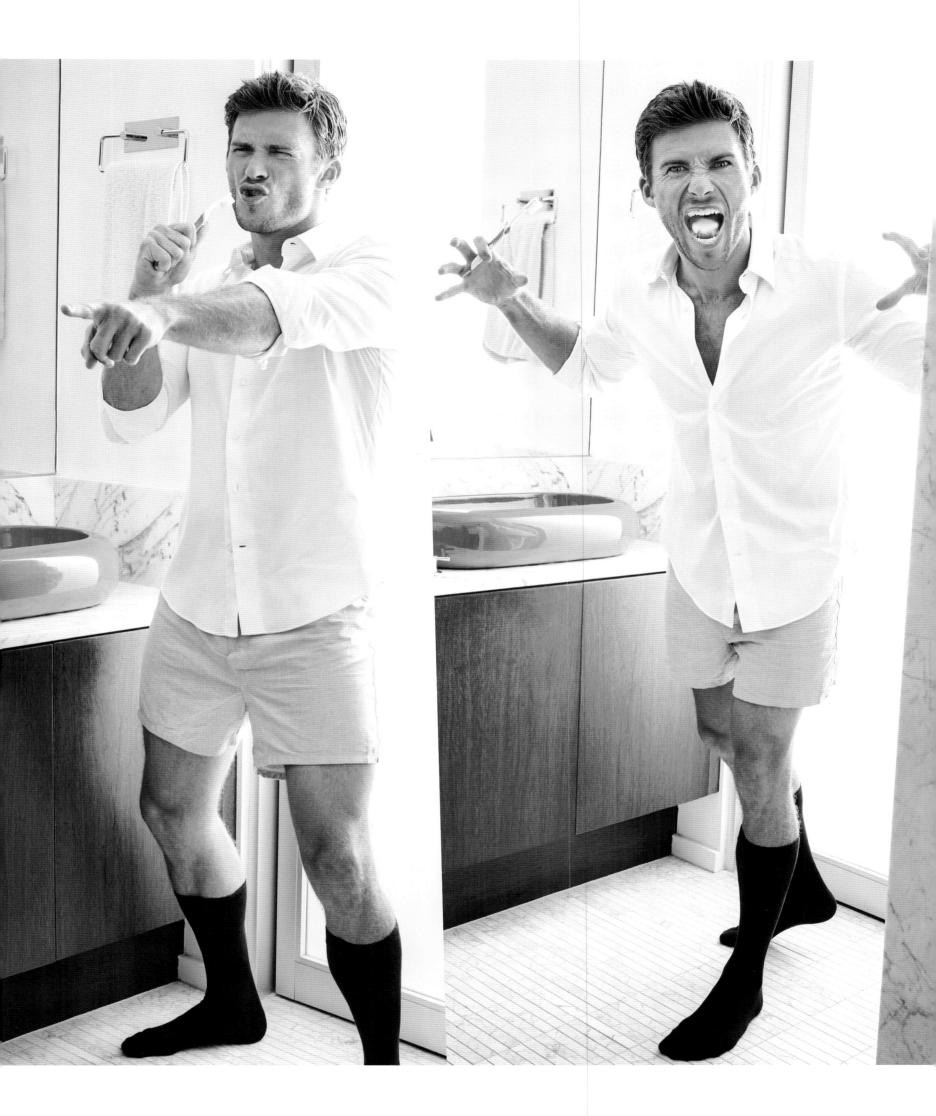

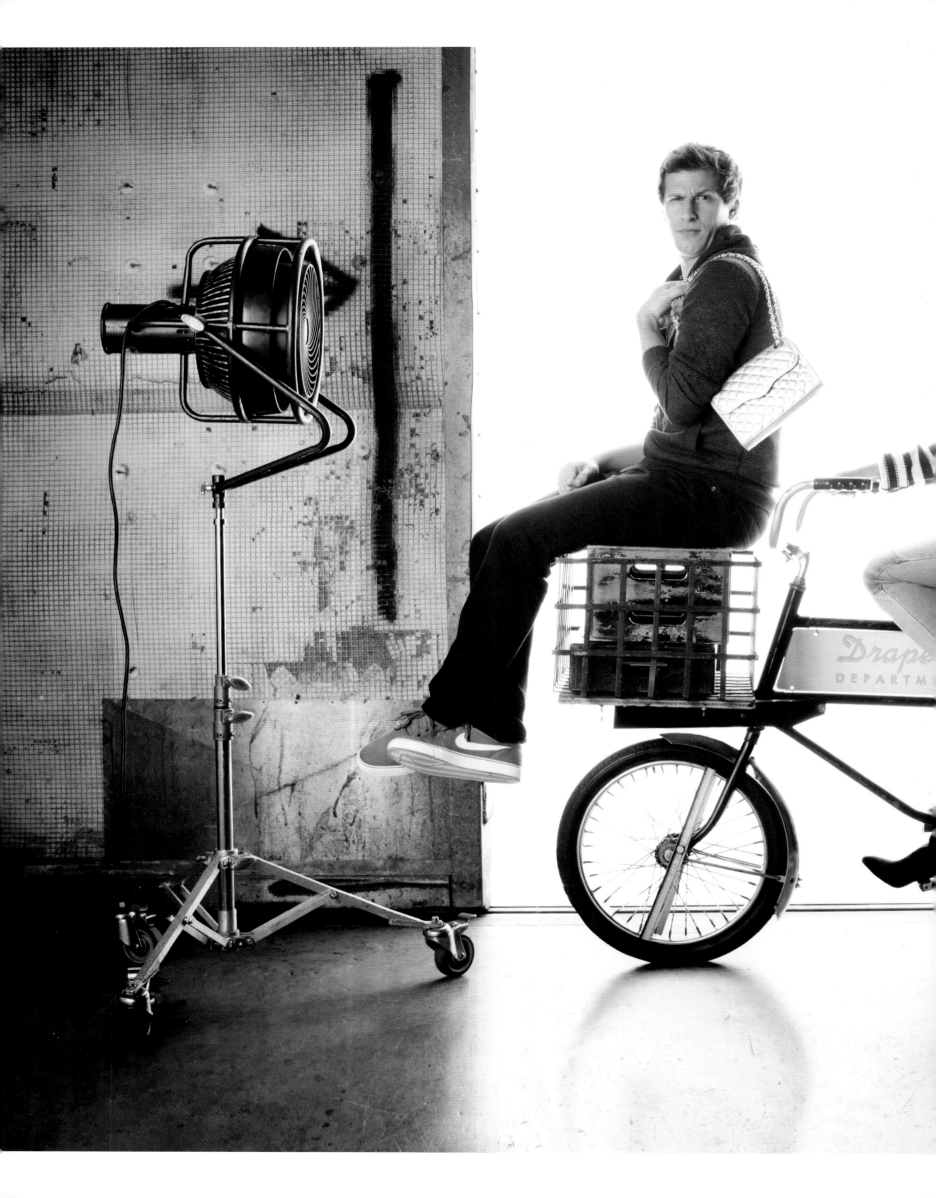

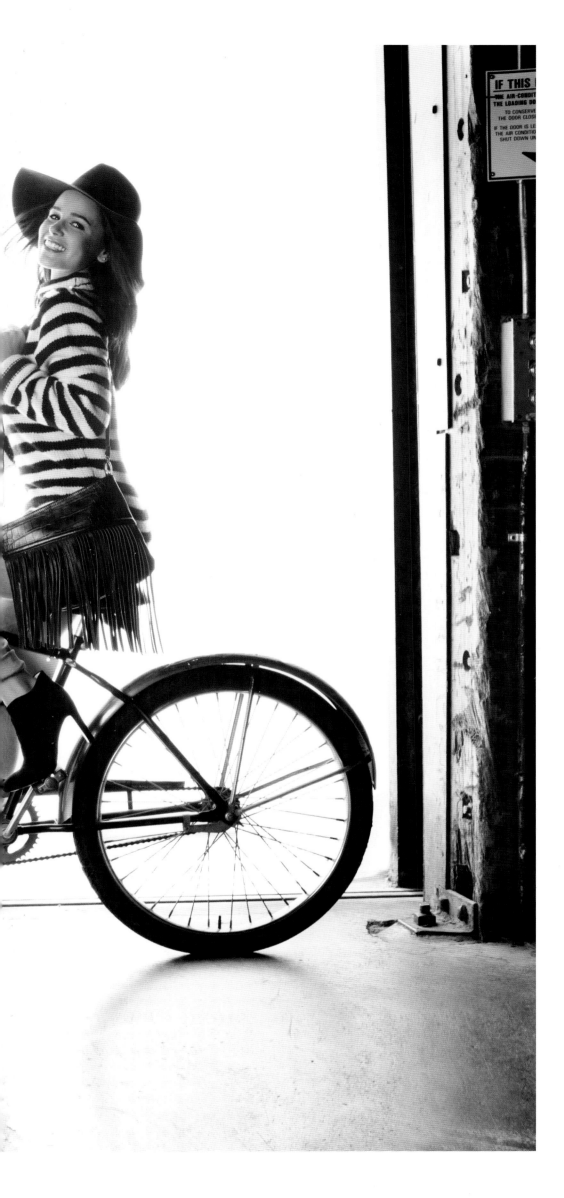

IF THIS
THE AIR-CONDIT
THE LOADING DO

TO CONSERV
THE DOOR CLOS

IF THE DOOR IS LE
THE AIR CONDITIO
SHUT DOWN UN

ANDY SAMBERG and
MELISSA FUMERO

2014

CORY STEARNS

2015

Principal dancer, American Ballet Theater,
New York City. Can't really ride a skateboard.
Loves to golf—who would've guessed?

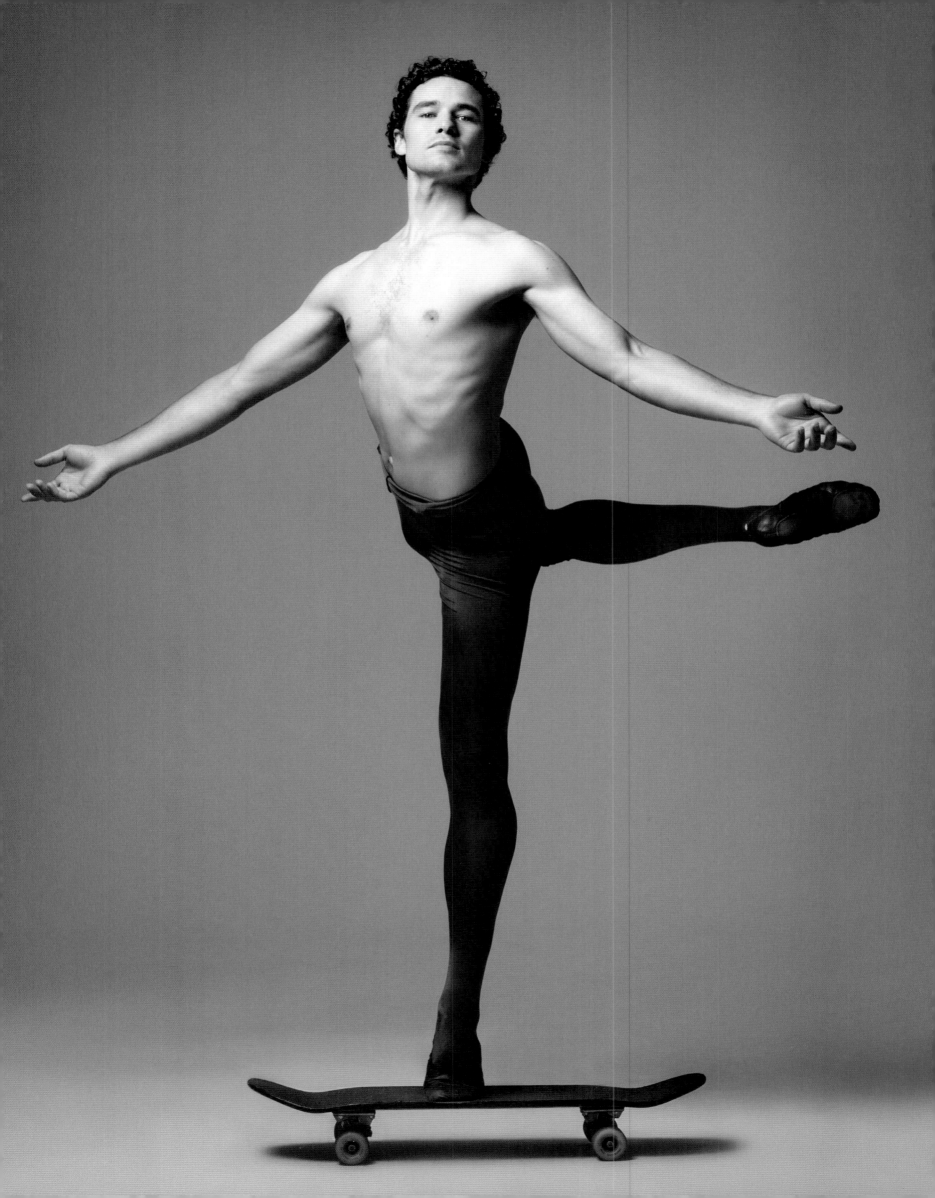

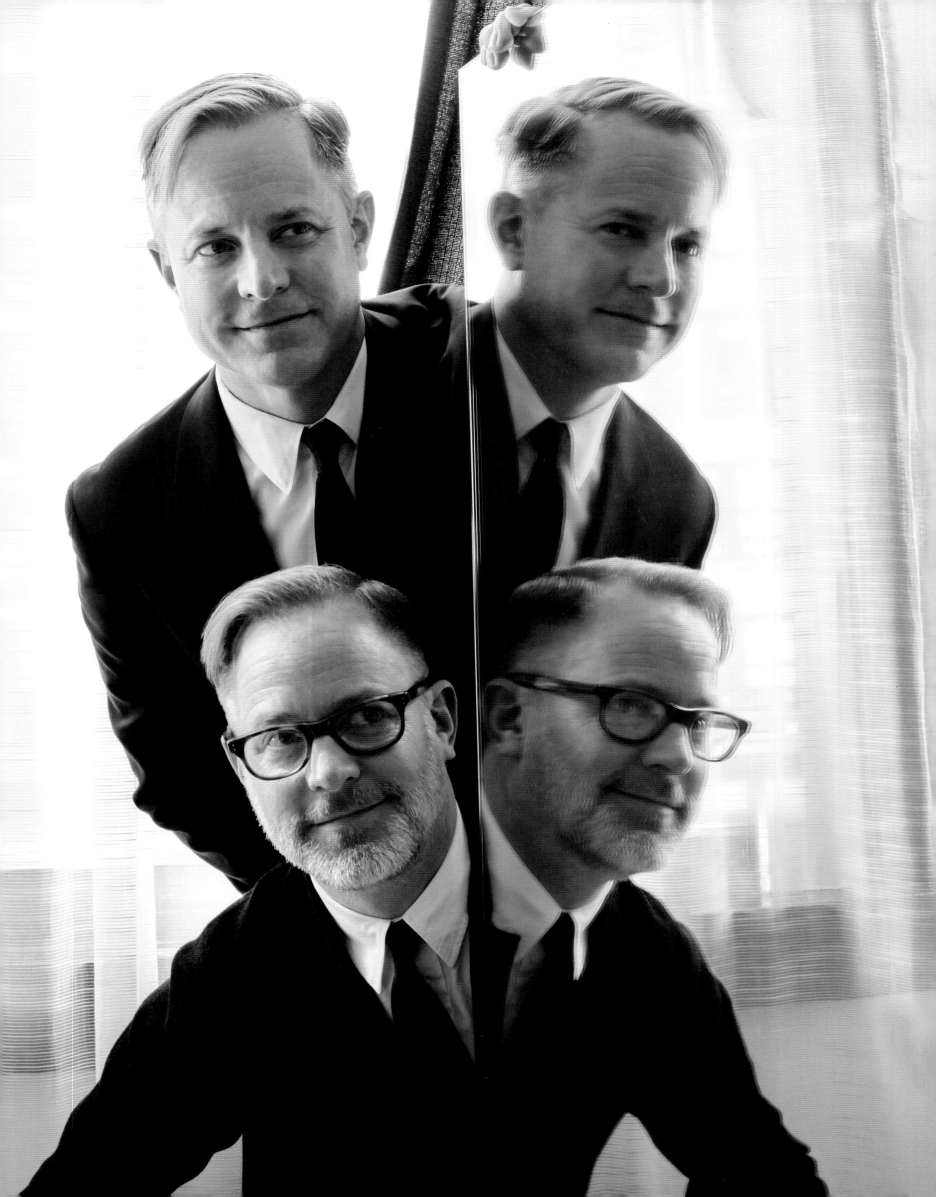

BRUCE and SCOTT PASK

2015

I'd heard about these two for years, and they always brought to mind a museum show of Andy Warhol's early commercial work called "Success Is a Job in New York." It's one of the great American stories: you come to Manhattan from a small town (in their case Yuma, Arizona!) and create a career, a life for yourself. Born identical twins, but unable to stay that way since Bruce screwed things up with the beard and the glasses, Scott (top) is a multiple Tony Award–winning scenic designer. Bruce has a long career in fashion journalism and is currently men's fashion director of Bergdorf Goodman. They are the epitome of good old-fashioned hard work, brains, and talent.

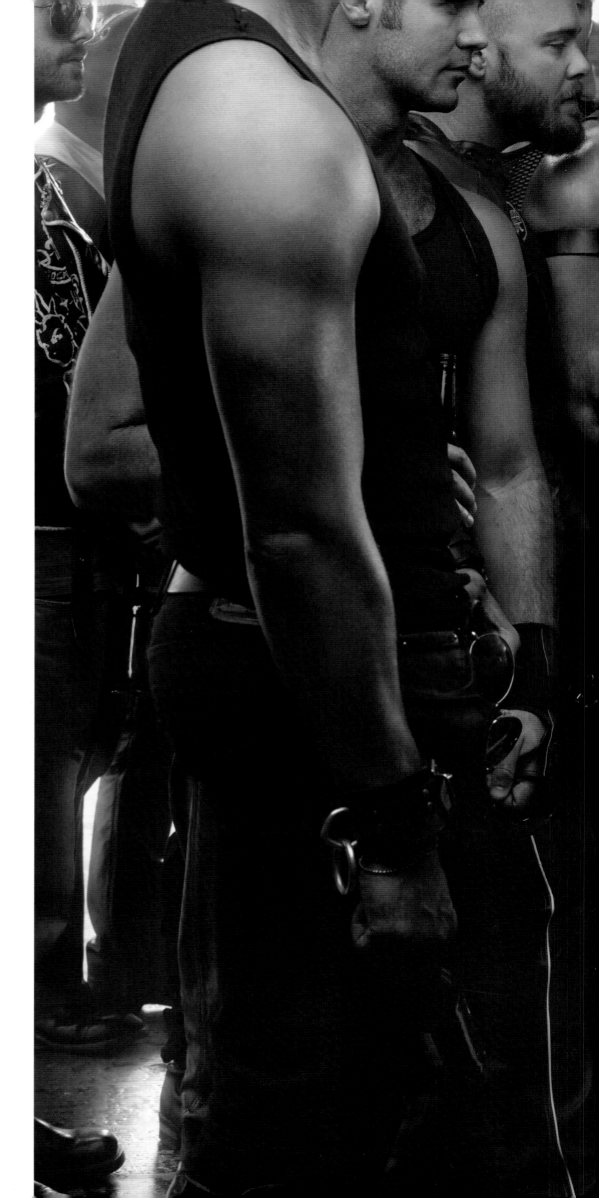

CHRIS COLFER

2010

These aren't actors—we found real guys into this look, asked them to bring their own clothes and show up at the Mother Lode bar in West Hollywood. They arrived with little wheelies stuffed with all their gear—like flight attendants for an all-leather airline. They were so nice. While we were lighting and Chris was getting ready, I told them to just dress themselves. When Chris and I turned around and saw what they had put on, it was . . . mind-bending, and mostly unprintable in a magazine. Who knew you could craft leather that anatomically? I felt really bad telling them that, while I respected their lifestyle choice, somebody had to put on a T-shirt and pants.

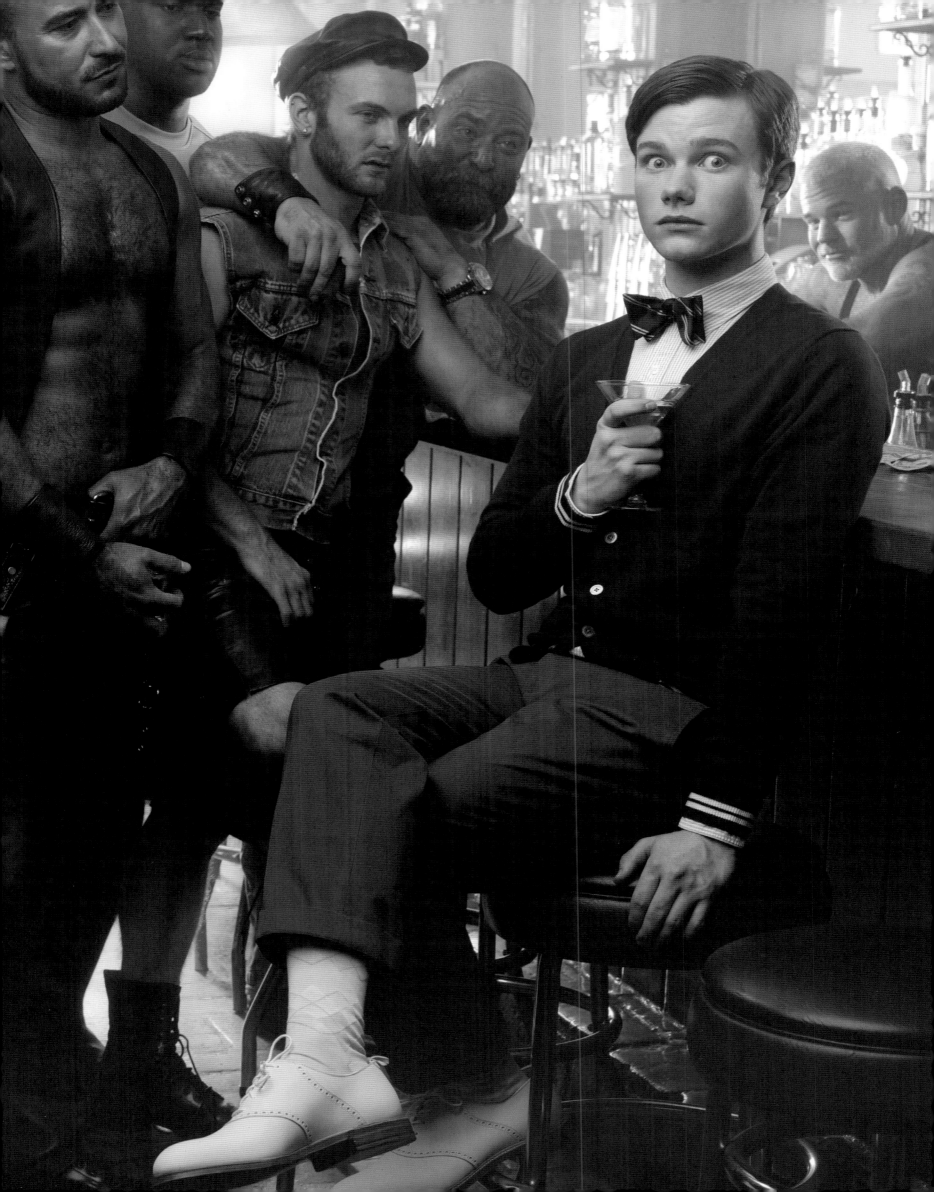

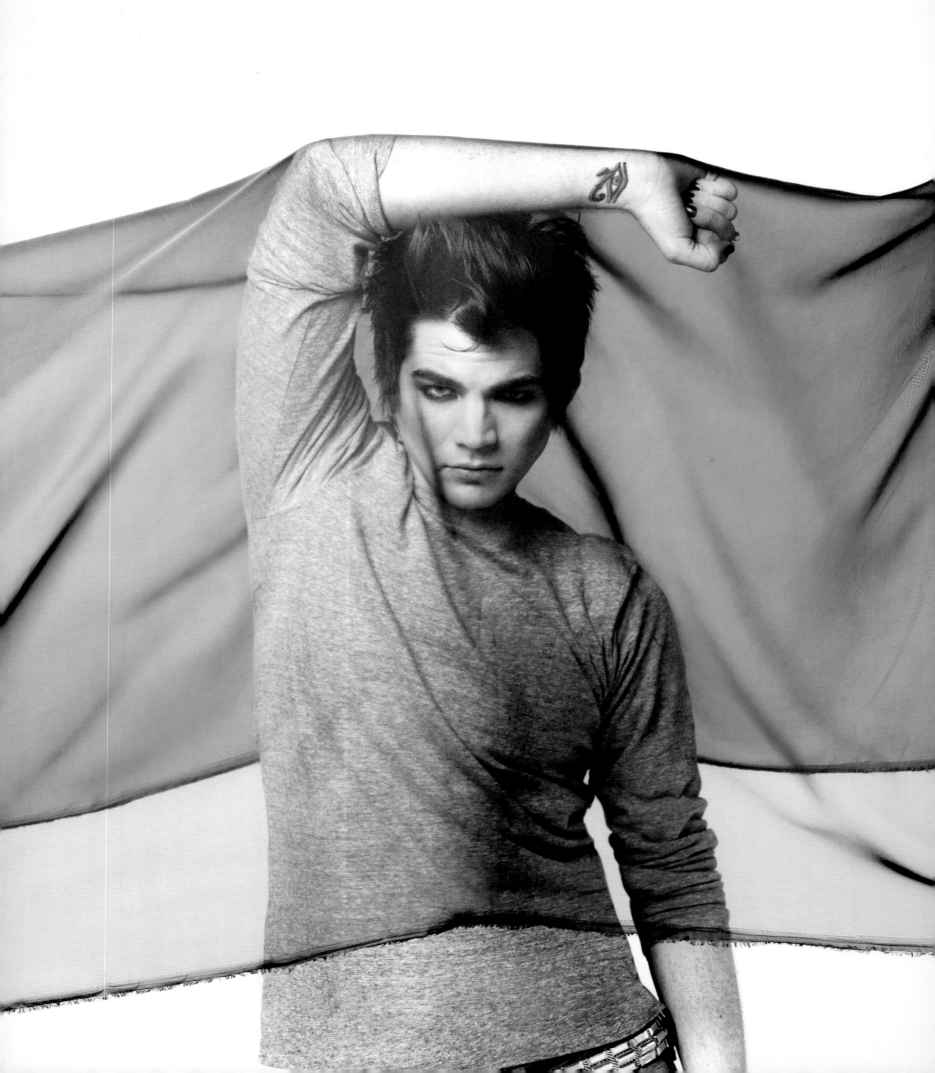

ADAM LAMBERT

2009

KEVIN HART

2014

Hart is really strong. Look at those muscles.
The dog was even stronger. It was freezing and
drizzling that day, but Hart was committed to
getting the shot. And he let that dog run him
up and down the beach till we got it. Hart is a
throwback to those great old Hollywood stars.
He gets how you have to show up and invest
yourself in all the details.

(overleaf)

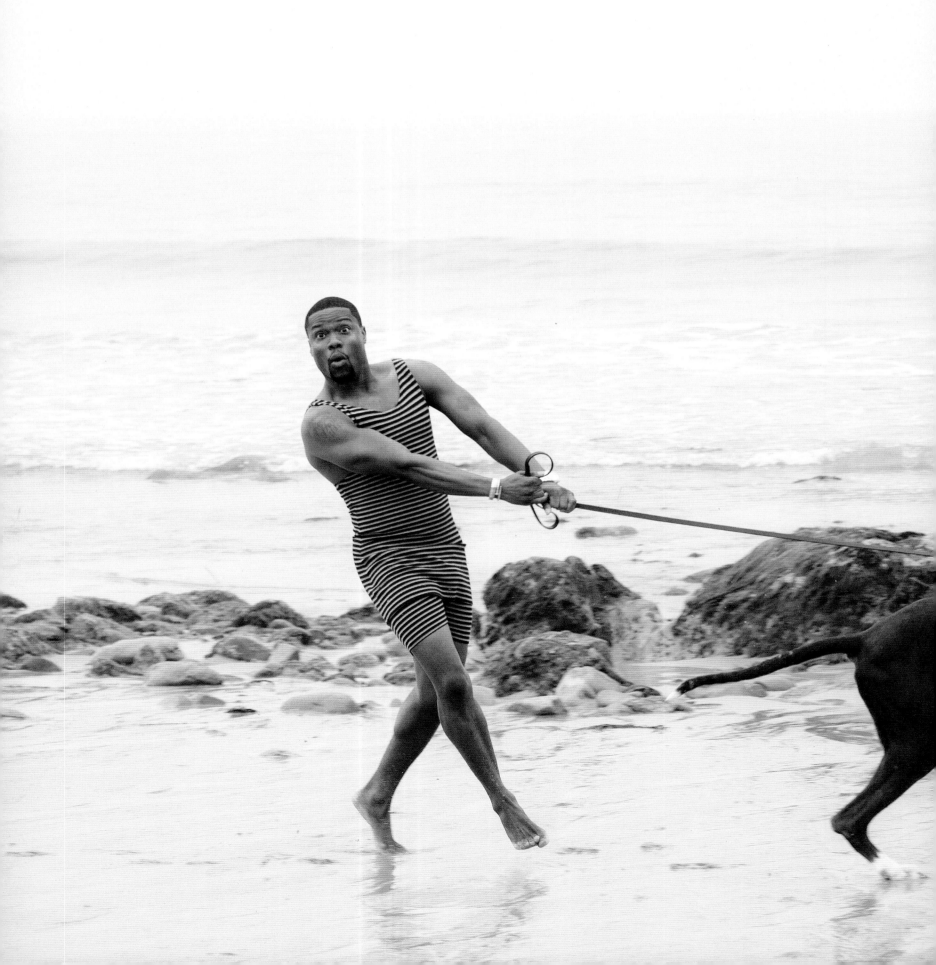

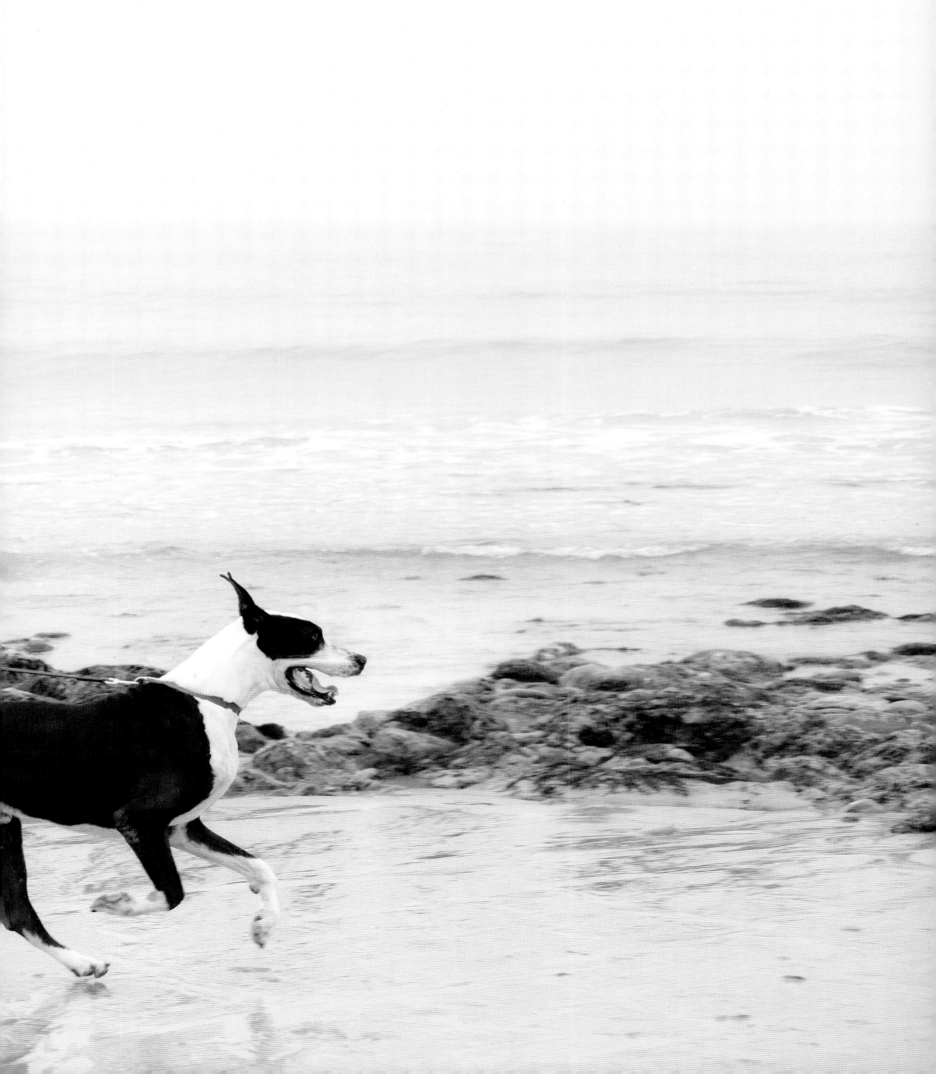

DON RICKLES

2003

"Who picked your clothes? Stevie Wonder?"
—standard Rickles line

He really is a sort of Comedy Emperor. Political correctness comes and goes, but for over fifty years, Don Rickles has been making fun of blacks, Jews, Puerto Ricans, Poles, gays, and whoever else he lays his eyes on. I find it really comforting.

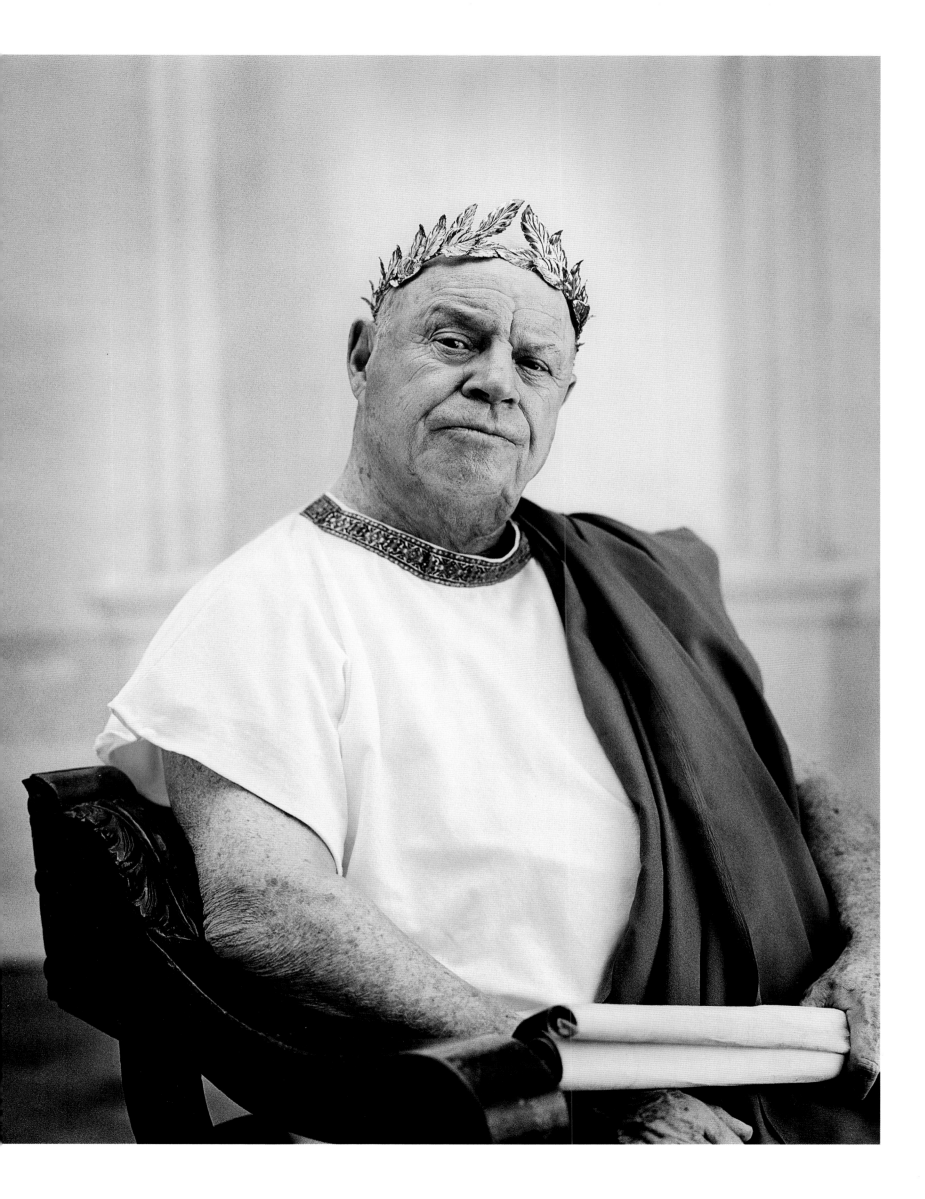

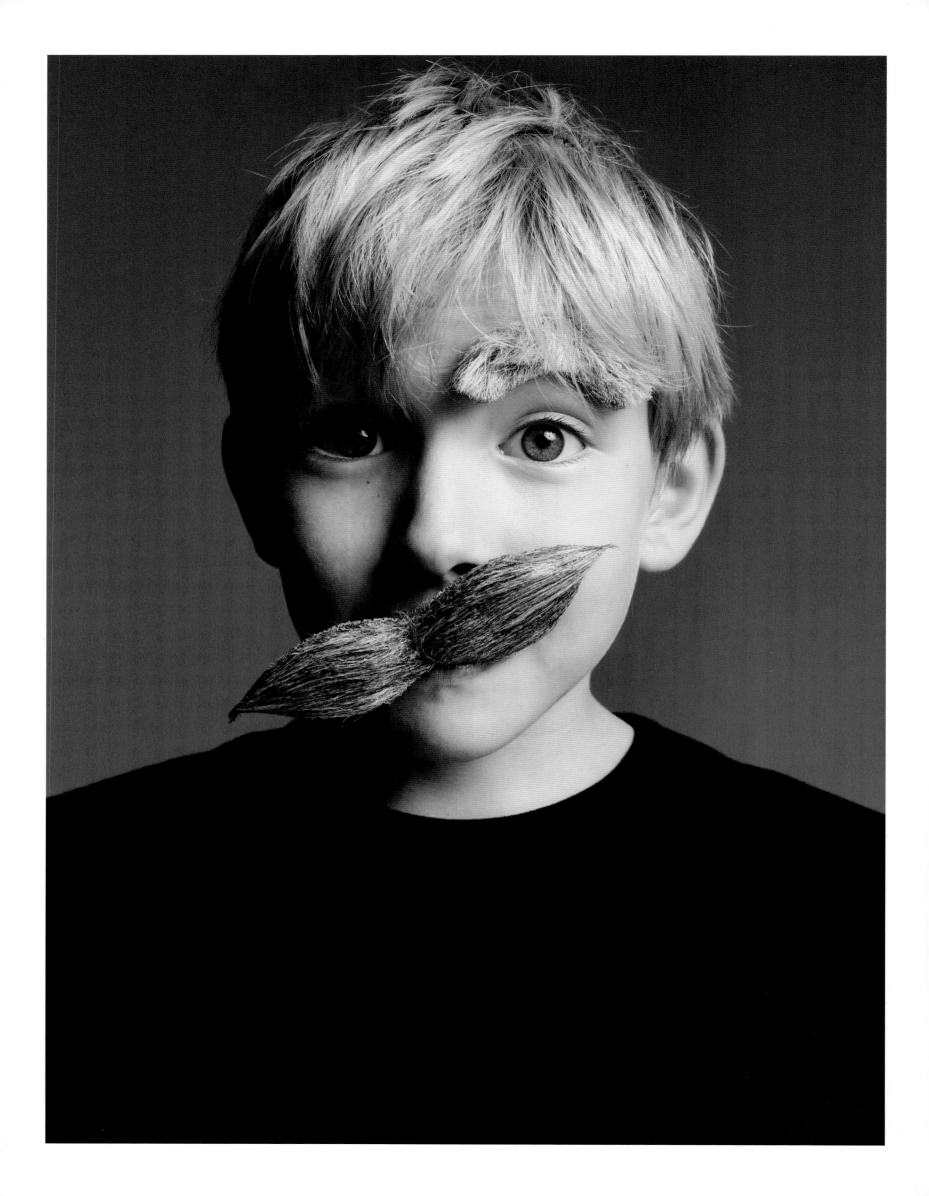

CALEB IVISON

2015

His mom is a brilliant editor who worked on my last movie. I owed her a favor for cutting a new project I was working on, so I offered to shoot her boys as thanks. She brought Caleb to the studio with his brother, Daniel, where they proceeded to not follow any direction and trash the set, the props, and each other. Safely restrained in the backseat of the car for the drive home, he said to his mother, "Well, that was nice, wasn't it?"

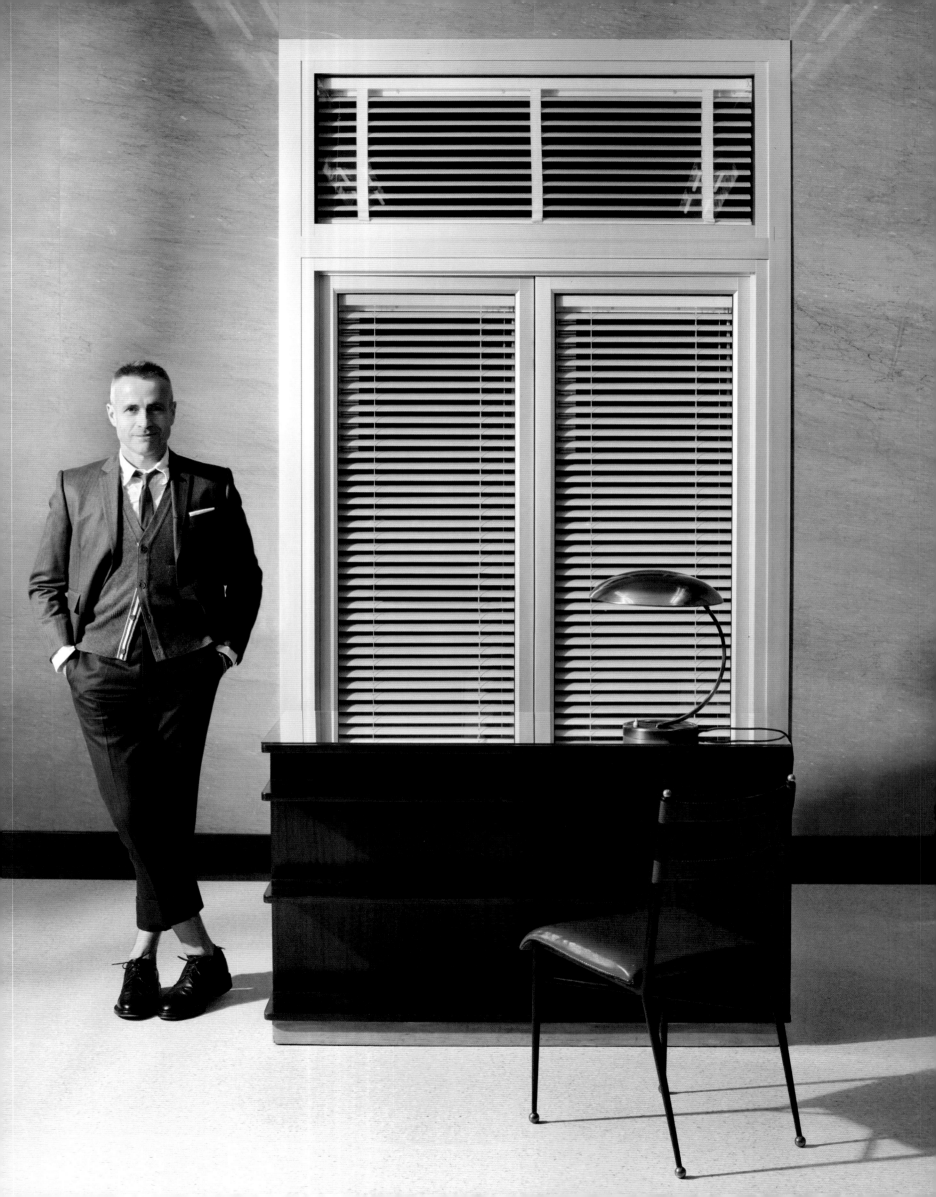

THOM BROWNE

2016

Photographed in his Tribeca store, Browne is the recipient of the Council of Fashion Designers of America award for menswear designer of the year. For the first time in memory, someone has moved the needle of what men's apparel could be, making us think about proportion, fit, and attention to detail in a new, uniquely American way. Browne's clothes are an amalgam of meticulous, rule-bending luxury. If you've ever been on a shoot with seven racks of snooze-inducing men's suits, you don't know what a game changer this is. If he hasn't reinvented the wheel, he's certainly reshaped it.

PRESTON TRITES and STEVIE FINEDORE

2016

(overleaf)

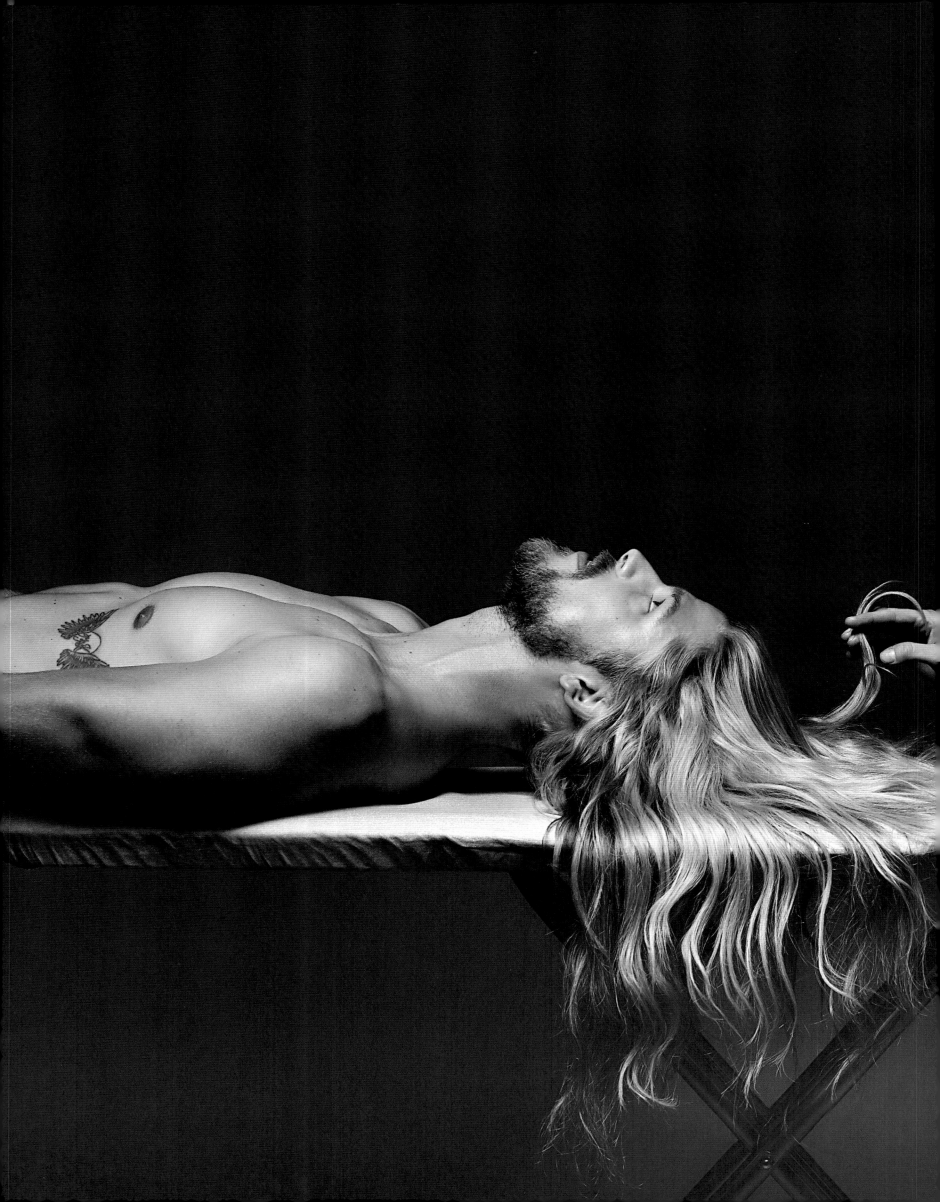

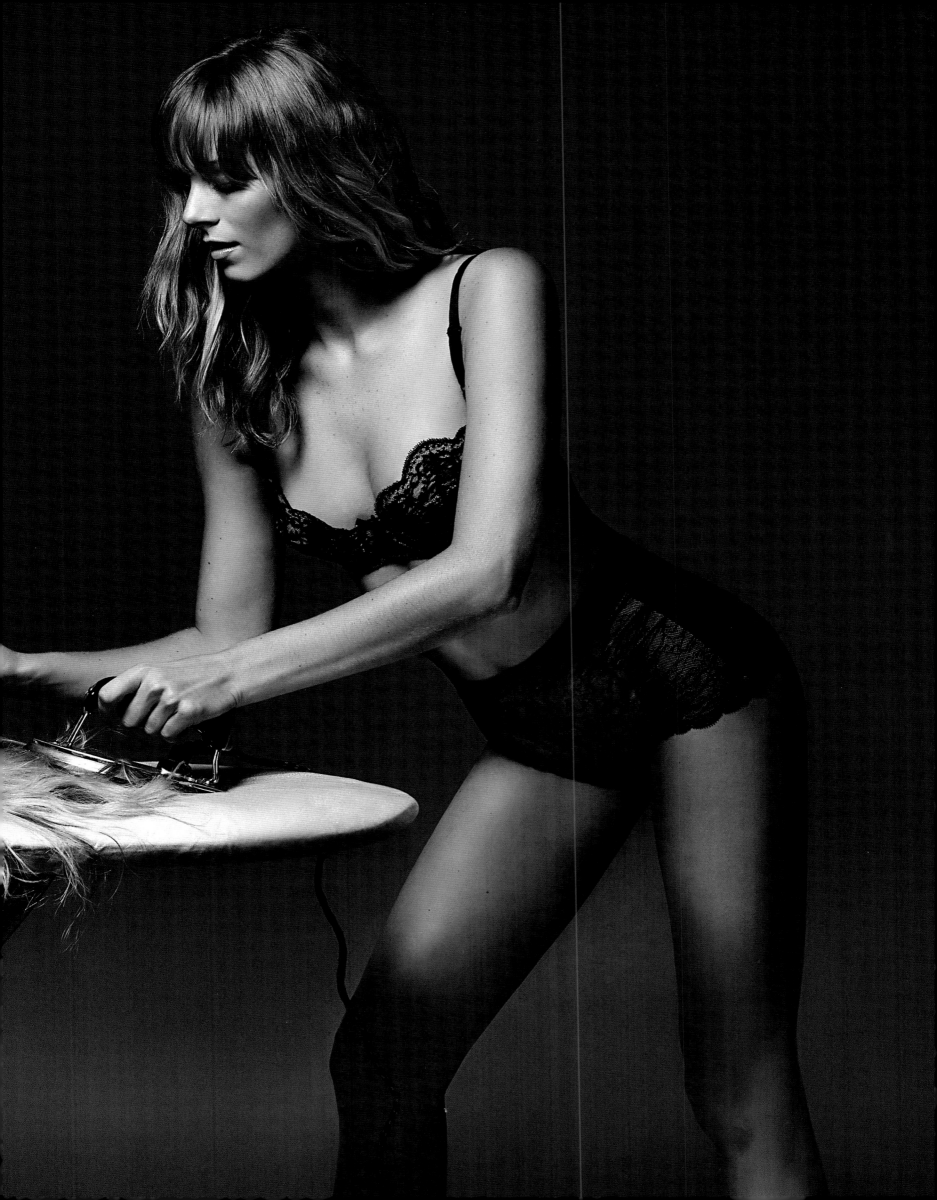

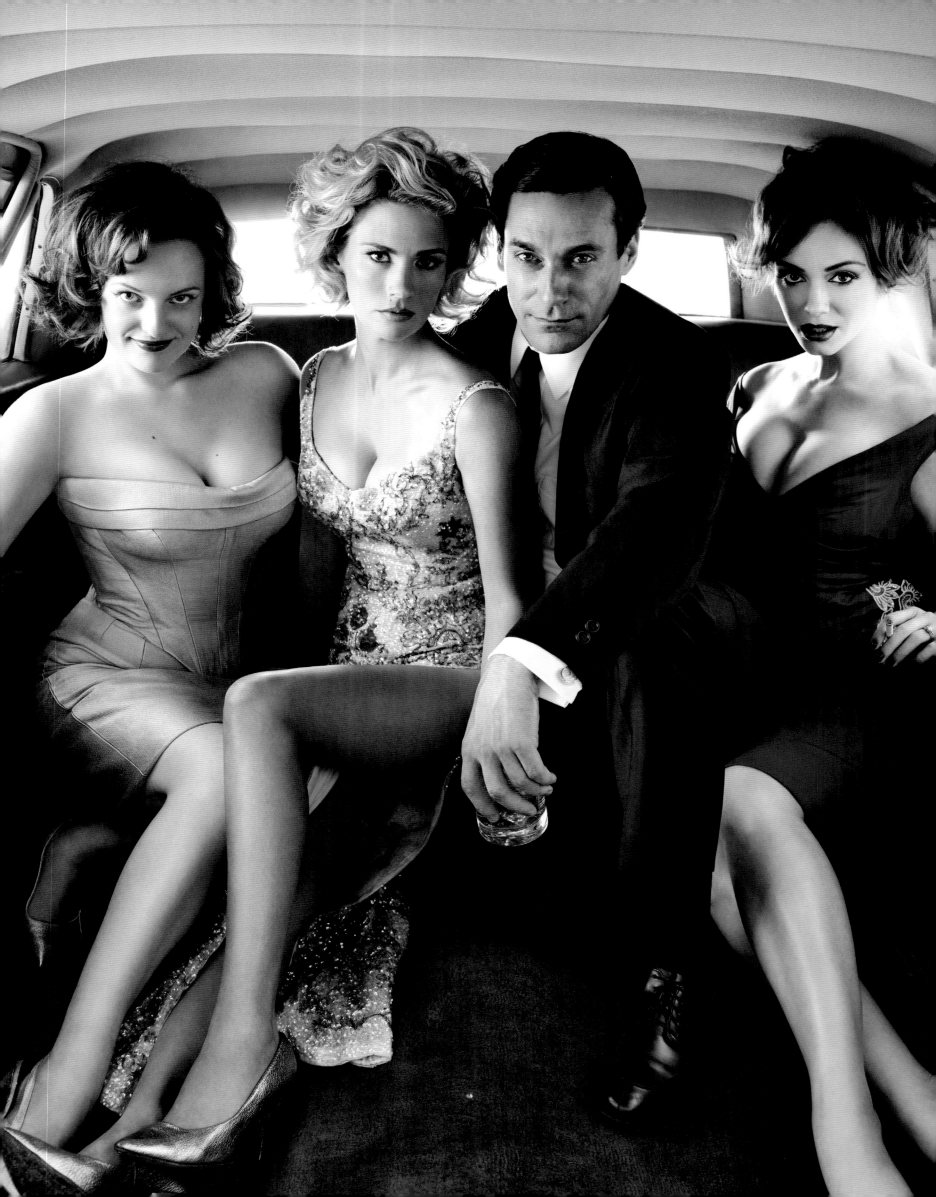

ELISABETH MOSS, JANUARY JONES, JON HAMM, and CHRISTINA HENDRICKS (Cast of *MAD MEN*)

2010

This shoot took my breath away. Literally. We punched out the windshield of a 1962 Lincoln limousine, and I lay facedown on the hood with my arms stretched out to get this shot. The next morning, I couldn't take a full breath. Next day, the same. I went to the doctor, and he told me my ribs were severely bruised from laying on this tank and would take a few weeks to heal.

JAMES VAN DER BEEK

2012

I didn't know how far they would let us go, so we moved the shirt a few times to be safe. The files I sent to the magazine were labeled "Tush," "More Tush," and "Even More Tush."

(overleaf)

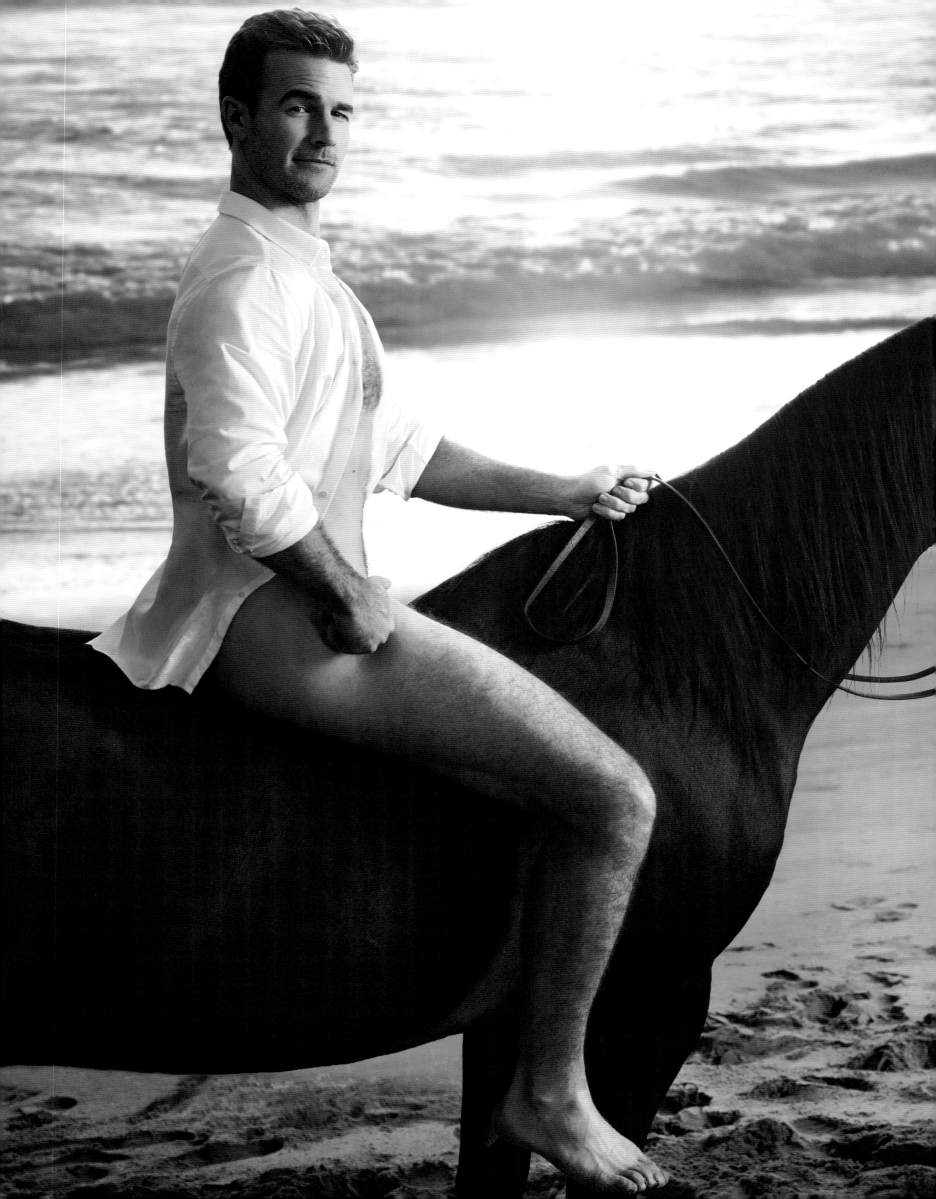

MICHAEL KIMMEL

2016

This is real.

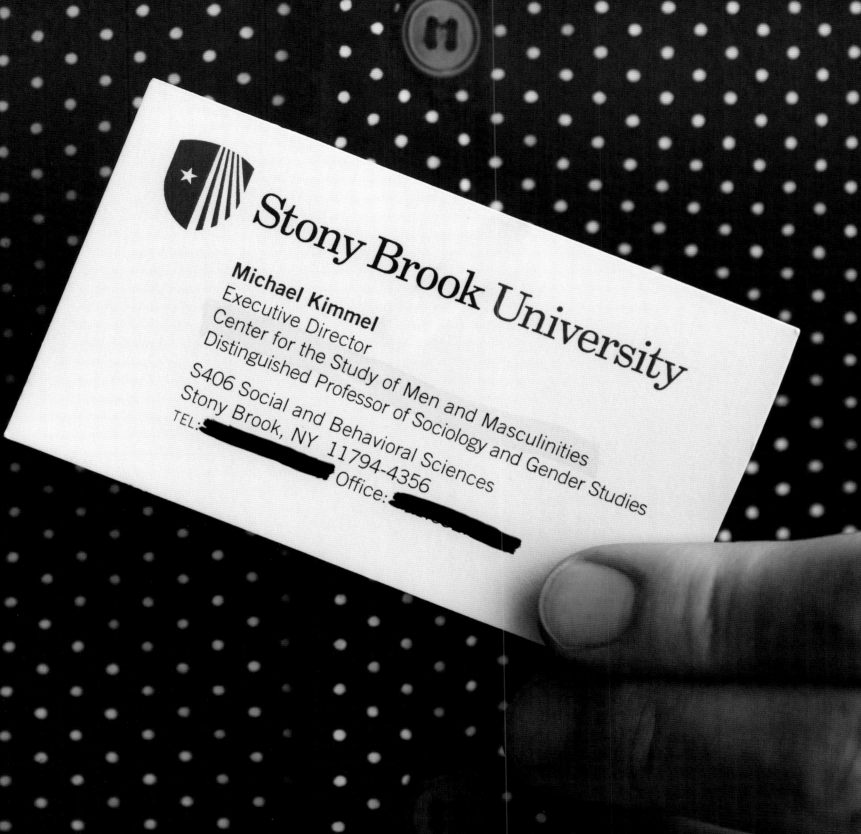

Stony Brook University

Michael Kimmel
Executive Director
Center for the Study of Men and Masculinities
Distinguished Professor of Sociology and Gender Studies

S406 Social and Behavioral Sciences
Stony Brook, NY 11794-4356
TEL: ███████████ Office: ████████

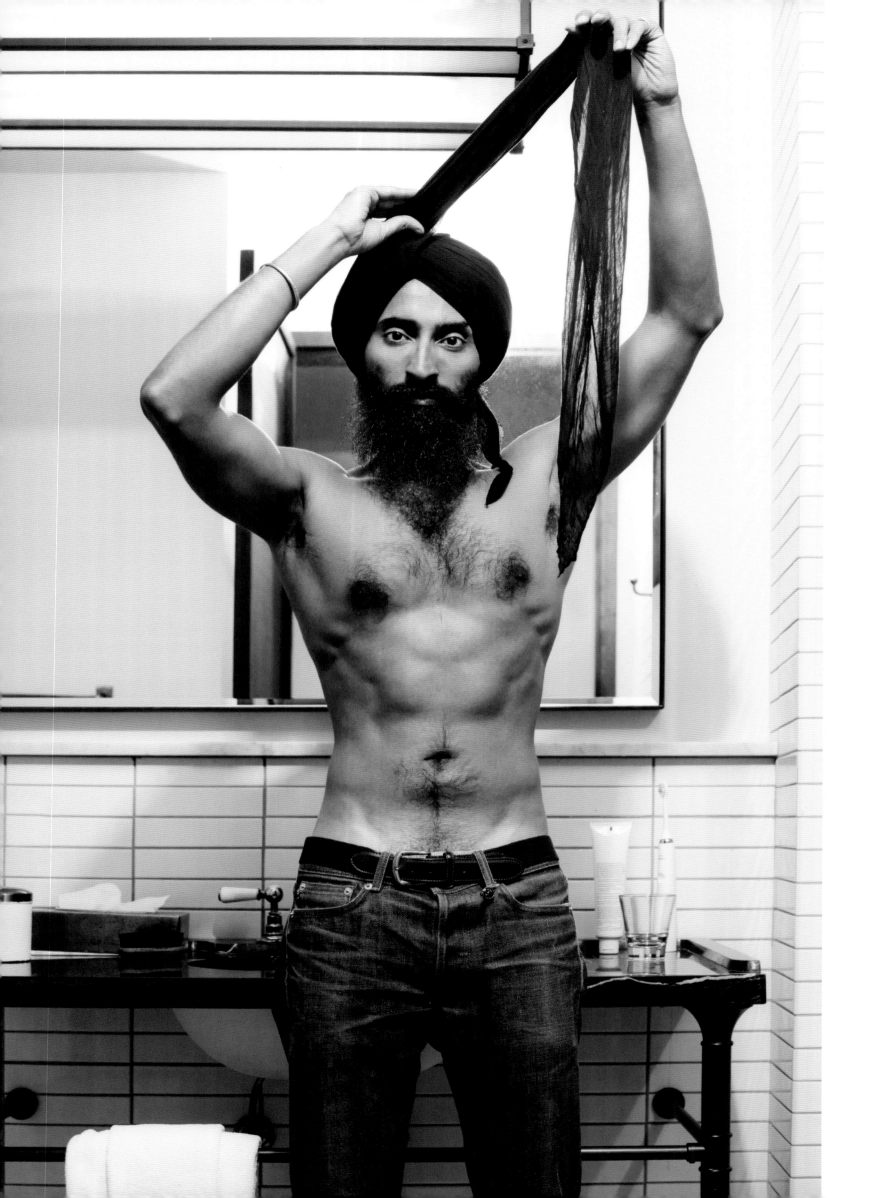

WARIS AHLUWALIA

2015

Born in Amritsar, Punjab, Ahluwalia has lived in New York since the age of five. Actor, designer, and, though this phrase usually sounds like bullshit, citizen of the world, you read about guys like him in magazines and you think, *No, it's not possible to be at an elegant wedding in London, a dinner party in Tuscany, and launching your own boutique in Venice, Italy, a few weeks later.* But he's that guy. A few days after this shoot, Ahluwalia was leaving for a five-hundred-kilometer trek in an auto rickshaw across India to raise awareness and money for elephant survival. Several months after that, he was detained on a flight from Mexico to New York because of his turban. It became an international news story, and Ahluwalia handled it with the utmost delicacy and tact, while bringing attention to the very real issue of racial profiling. He makes me want to stop playing solitaire on my phone and do something.

TIM GUNN

2006

We were chatting before the shoot, and somehow, with complete sincerity, Gunn told me that after two seasons, he had only just started earning money for appearing on *Project Runway*. He didn't think people on reality shows got paid until an agent "set him straight." Any smart-ass comment I would've made melted away in the face of this lovely, guileless educator whose commitment and belief in mentoring students through the grueling world of fashion was so unexpectedly moving.

(overleaf)

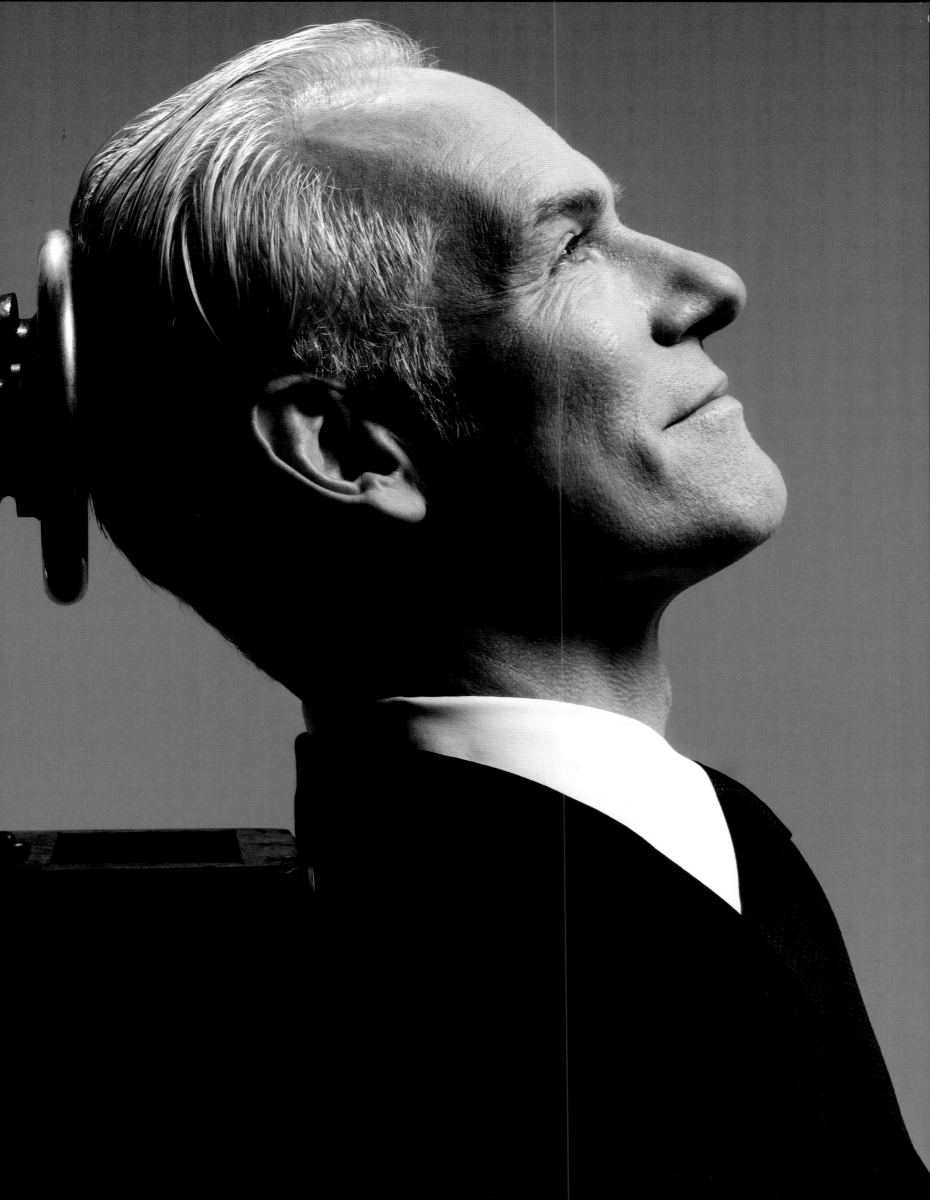

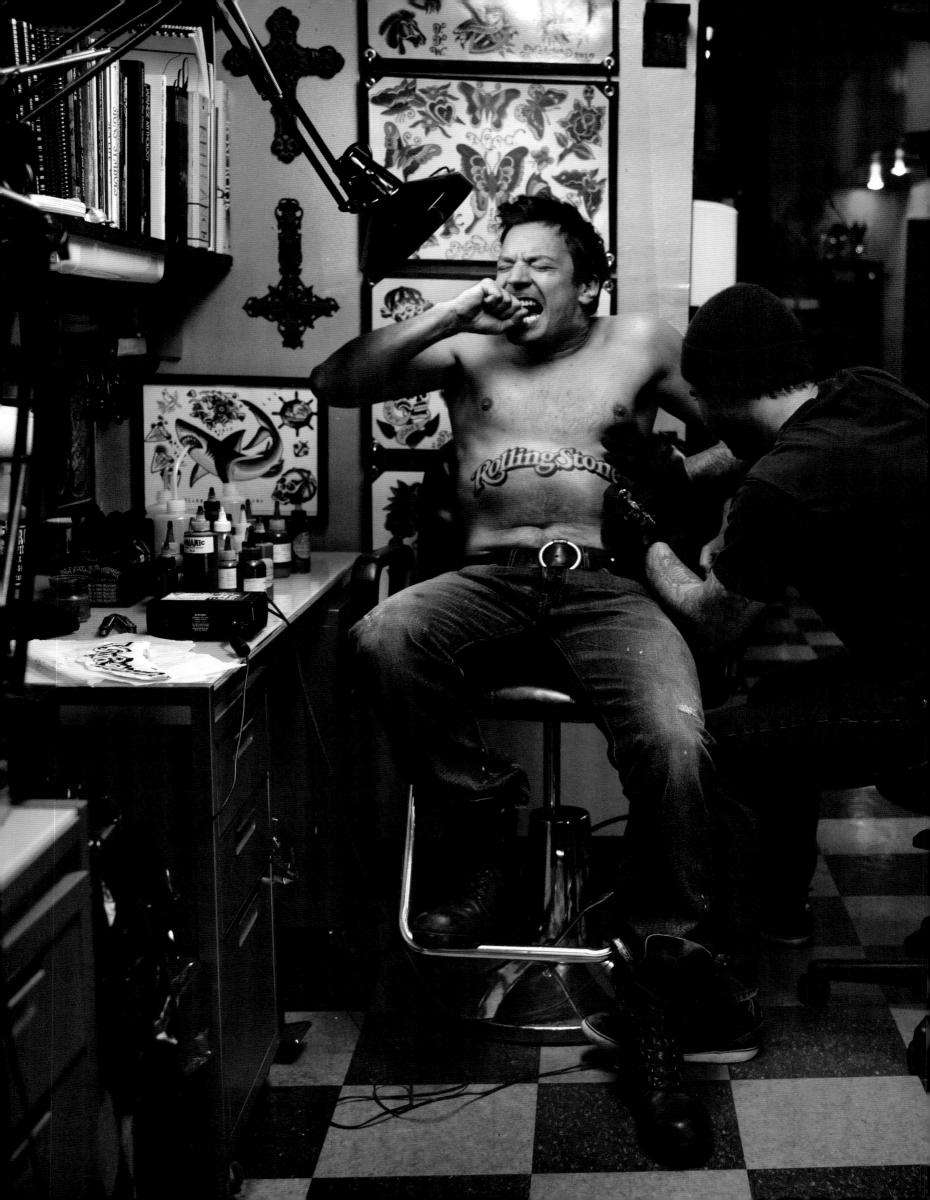

JIMMY FALLON

2012

Here's how this went down: Fallon had
his writers come up with what should be
tattooed on his stomach. But it was too
many words; it would have been too small
to read. We kept going back and forth,
the tattoo guy needed to make the stencil,
and we were running out of time. So Jann
Wenner, founder and editor of *Rolling
Stone*, decided for us.

JIMMY FALLON

2015

I love shooting Fallon because he's so damn
busy that we're always done by ten a.m., and
once we land on an idea, he's 100 percent
committed. Here he's wearing the angel
wings used in the Victoria's Secret fashion
shows on a cold, rainy fall morning on a
terrace at 30 Rockefeller Plaza.

(overleaf)

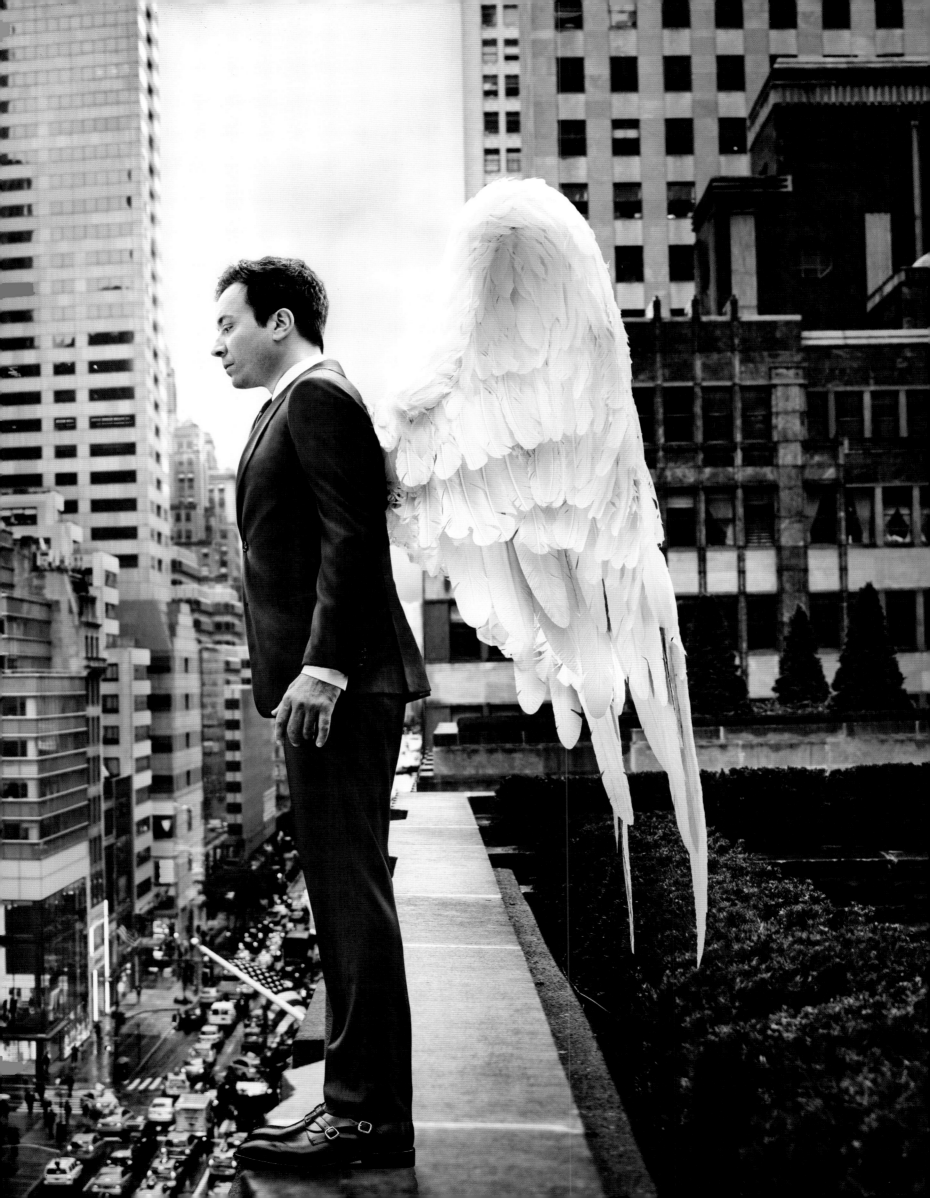

WILL FORTE

2015

If I have to shoot one more guy in a denim shirt,
shoot me first. Luckily, Forte agreed it was time to
reconsider the cape.

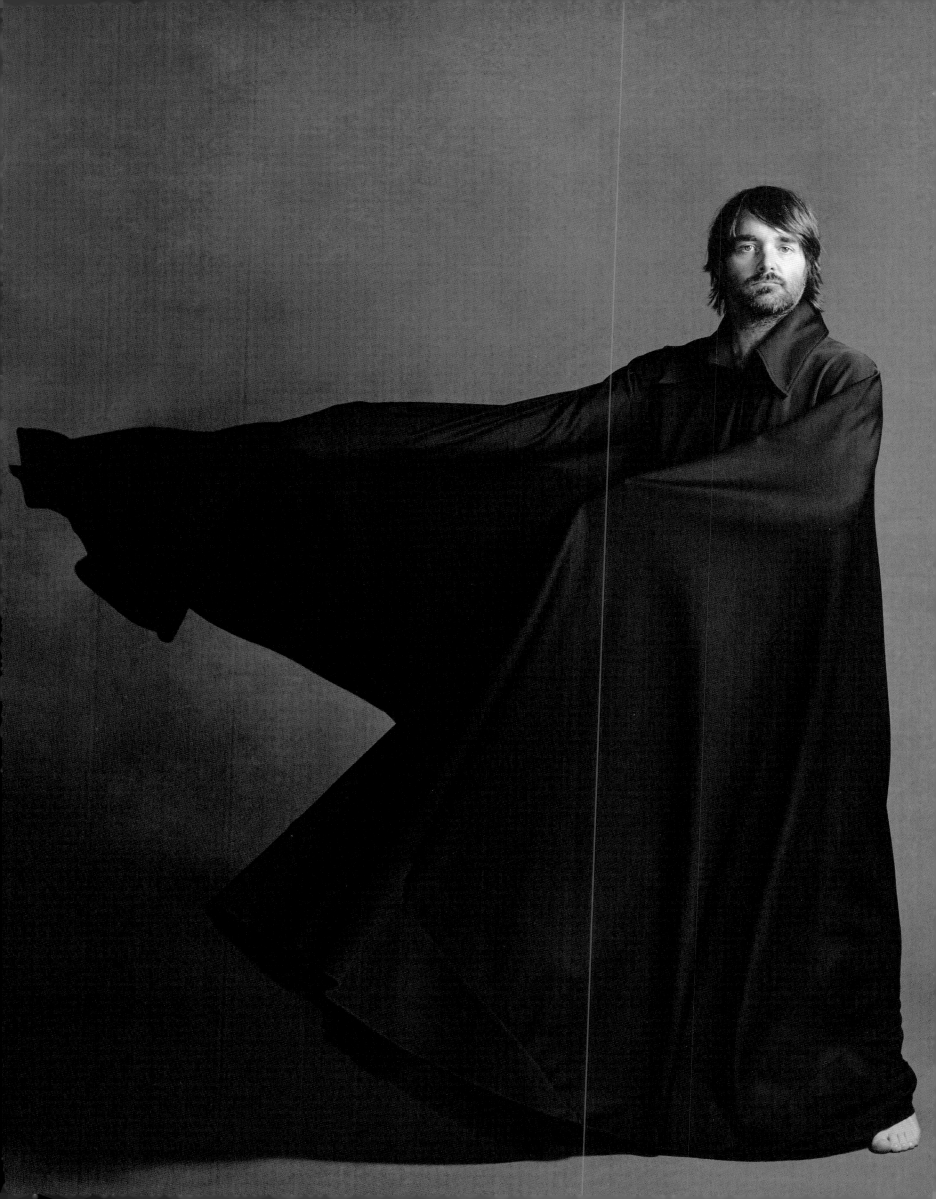

DENIS LEARY

2007

LUCIAN and DANIEL CAPELLARO

2015

Brothers since birth, Daniel is a musician, Lucian a film executive. It's always interesting and infinitely touching for me to shoot brothers, because there's an unspoken language between them that transcends any direction I could possibly give.

(overleaf)

ANDY COHEN

2015

What didn't happen on this shoot? Andy's dog bit
the stylist in the shoulder? Check. The model we
hired passed out on the floor from dehydration
(even though there was a table of beverages twenty
feet away)? Check. Sixteen bottles of champagne
were sprayed all over the rooftop penthouse?
Check. Andy ended up in the hot tub in his
clothes? Check.

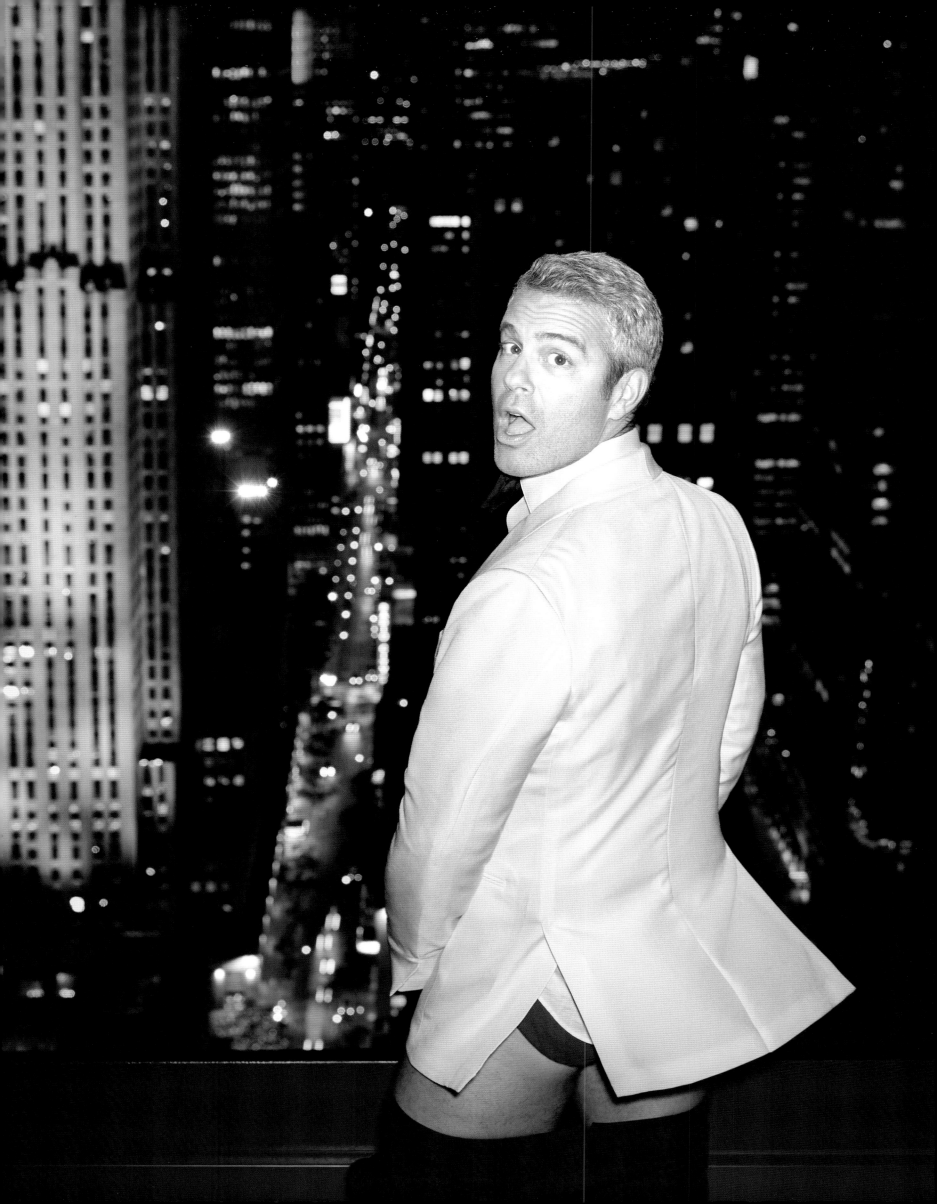

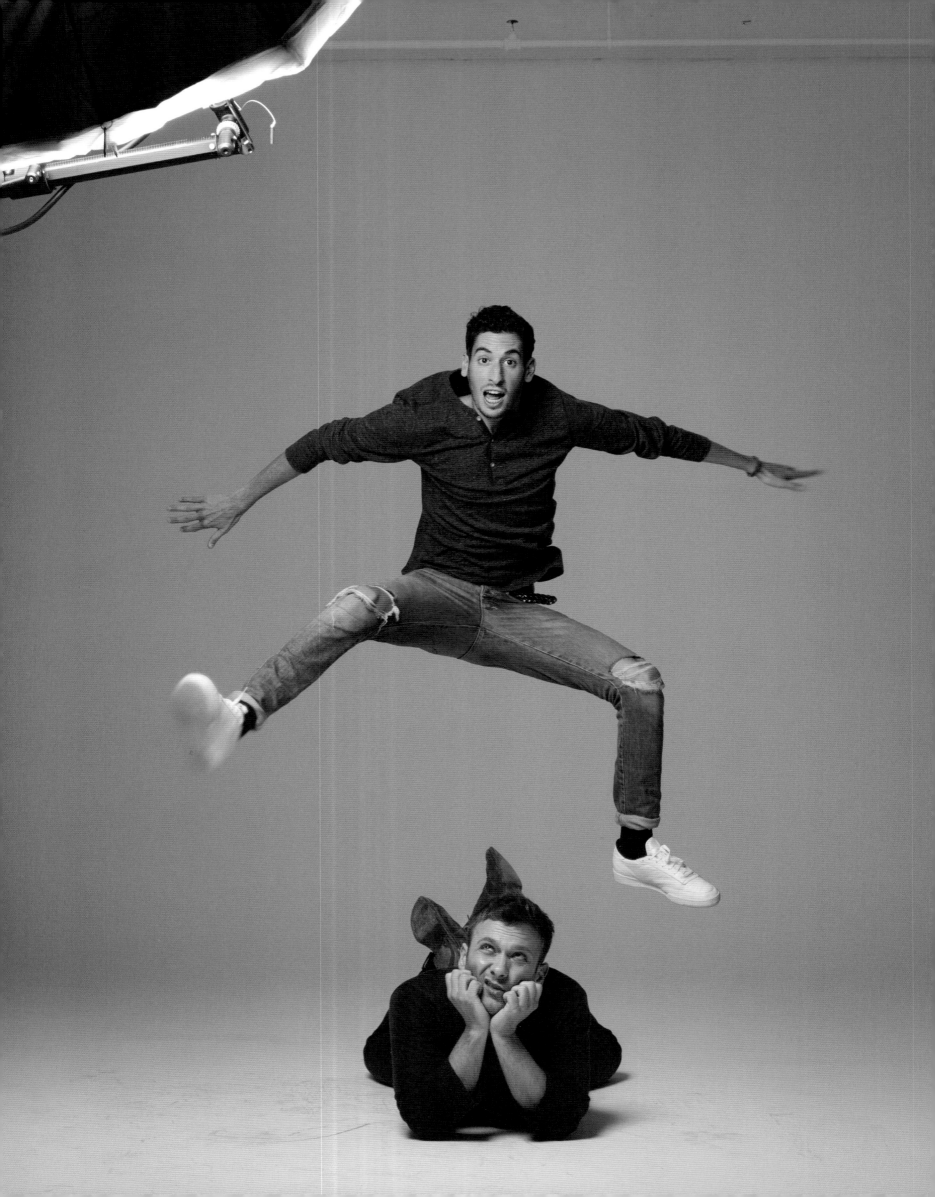

@FUCKJERRY and @KRISPYSHORTS

2015

Elliot Tebele (@fuckjerry) and James Ohliger (@krispyshorts) are two of Instagram's biggest stars. Tebele was working for a wholesale cell phone business and not having a great time. After a friend suggested he check out Tumblr, he soon moved over to Instagram and things quickly blew up with his well-curated daily posts of randomly funny shit. He's turned that into a retail website business, hosting gigs, and leveraging the strategic product mention. When we did this shoot, Ohliger had a regular day job in the finance world, and his boss had no idea that hundreds of thousands of people were watching his posts every week. He and Tebele have now formed a production company creating branded video content.

BEAU BRIDGES, JEFF BRIDGES, and MICHELLE PFEIFFER

2014

More than twenty years later, the three stars of *The Fabulous Baker Boys* were reunited for this photo.

(overleaf)

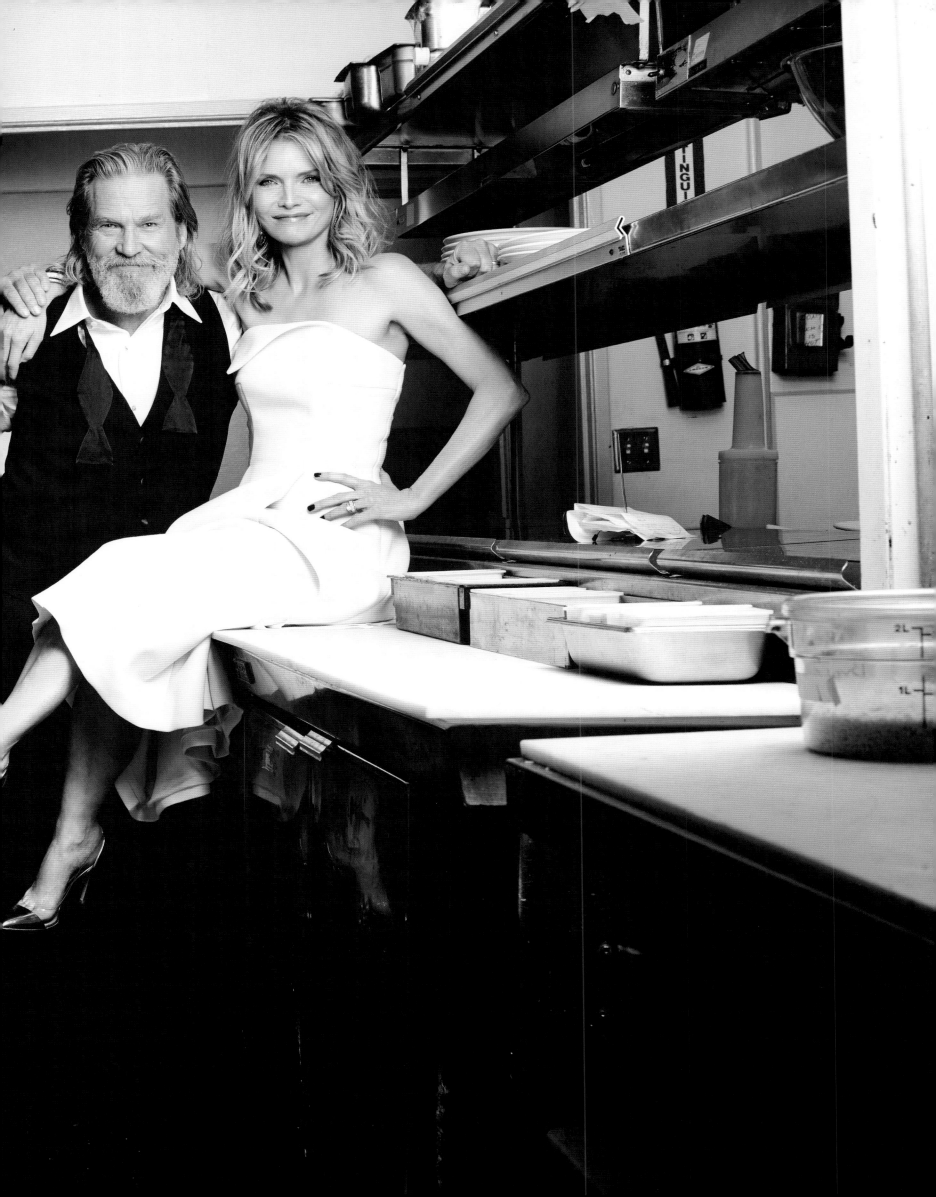

AYDIAN DOWLING

2015

A friend of mine recently said, "You can't swing
a cat lately without hitting a transsexual." And he
meant that as a good thing as more people come
into their own and receive support and acceptance.
But what I can't support or accept is how
transgender pioneer and activist Aydian Dowling
can look this good and be a trained pastry chef.
I mean, come on. . . . Yes, he works out, but
he was around flour, sugar, and butter for *years*.
When we shot this, I was still wearing a red
velvet cupcake I had eaten in July of 2011.

FLYNN MCGARRY

2015

McGarry is sixteen years old in this photo,
braising beets in butter in the kitchen of a pop-up
restaurant he created in New York City. A prodigy,
McGarry taught himself to cook after tiring of the
food his parents were feeding him. By eleven-and-
a-half, he was hosting a private supper club out of
his mother's living room creating dishes like Slow-
Roasted Abalone with Kale and Almond Puree
and Amber Roasted Chicken Broth. By fifteen, he
was on the cover of *The New York Times Sunday
Magazine*. And by the time I got to him, he had
already worked in the kitchens of some of the
world's greatest restaurants. Offering what he calls
"progressive American cuisine," McGarry usually
cooks every component of his prix-fixe meals
himself. That might have to change as he gears up
to open a permanent spot in New York. His aim,
he says, is quite simple: "I want one of the best
restaurants in the world."

(page 142)

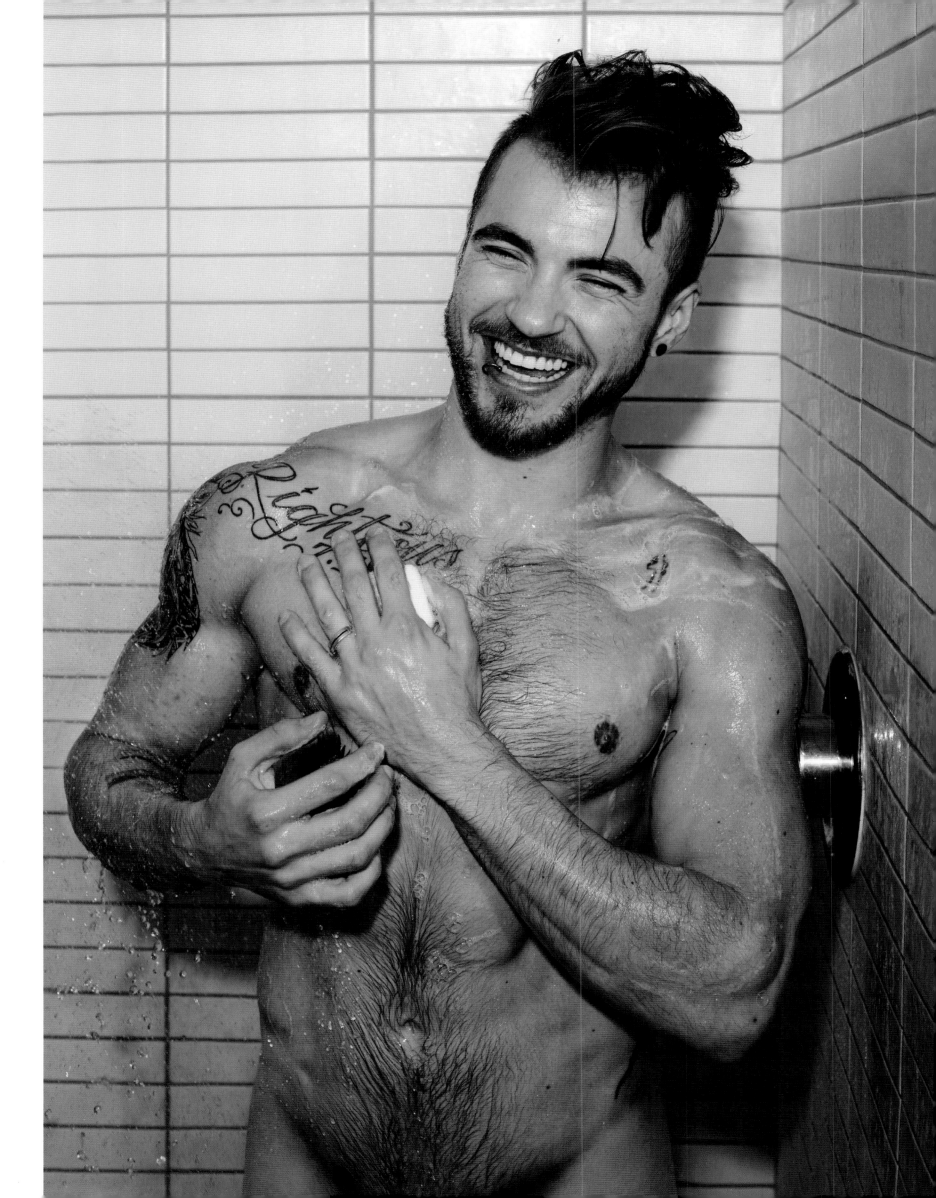

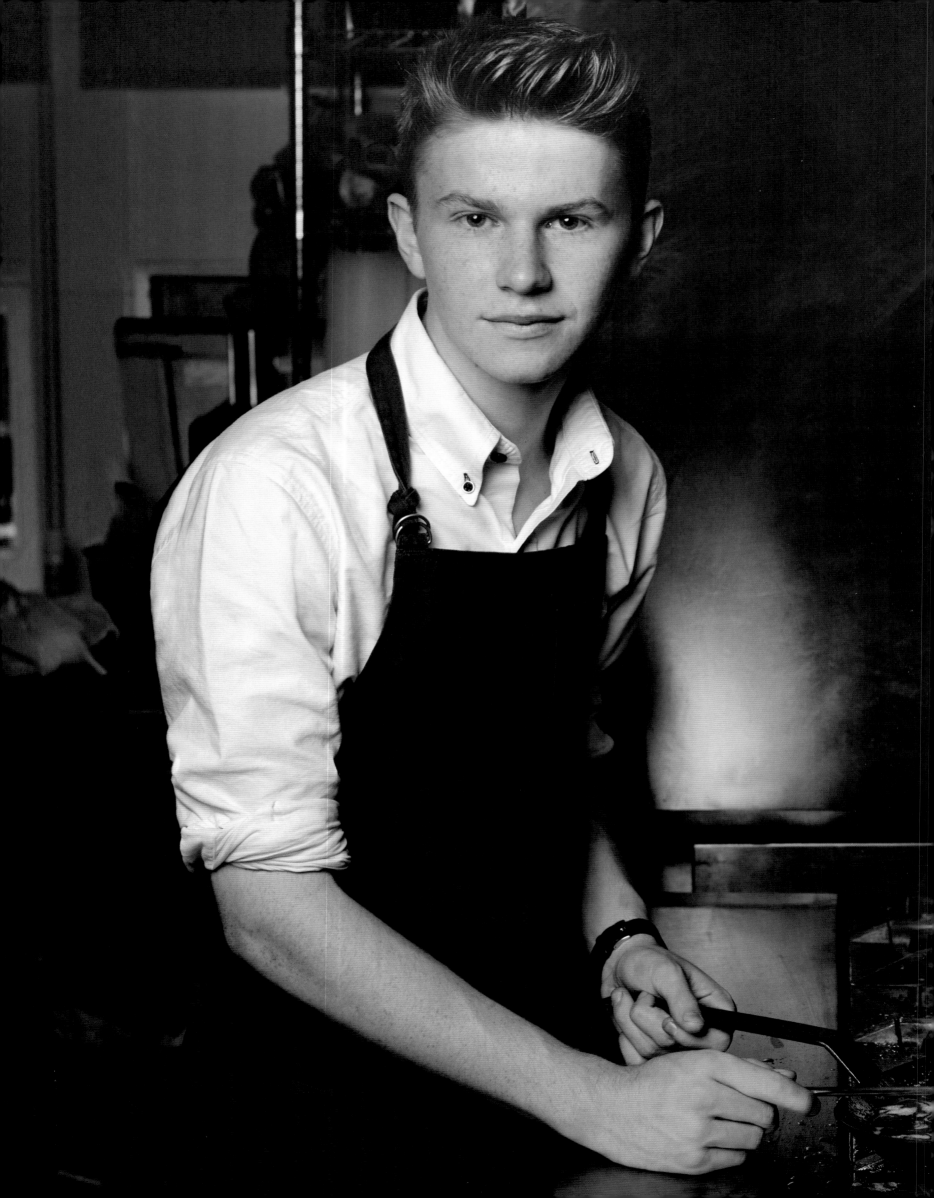

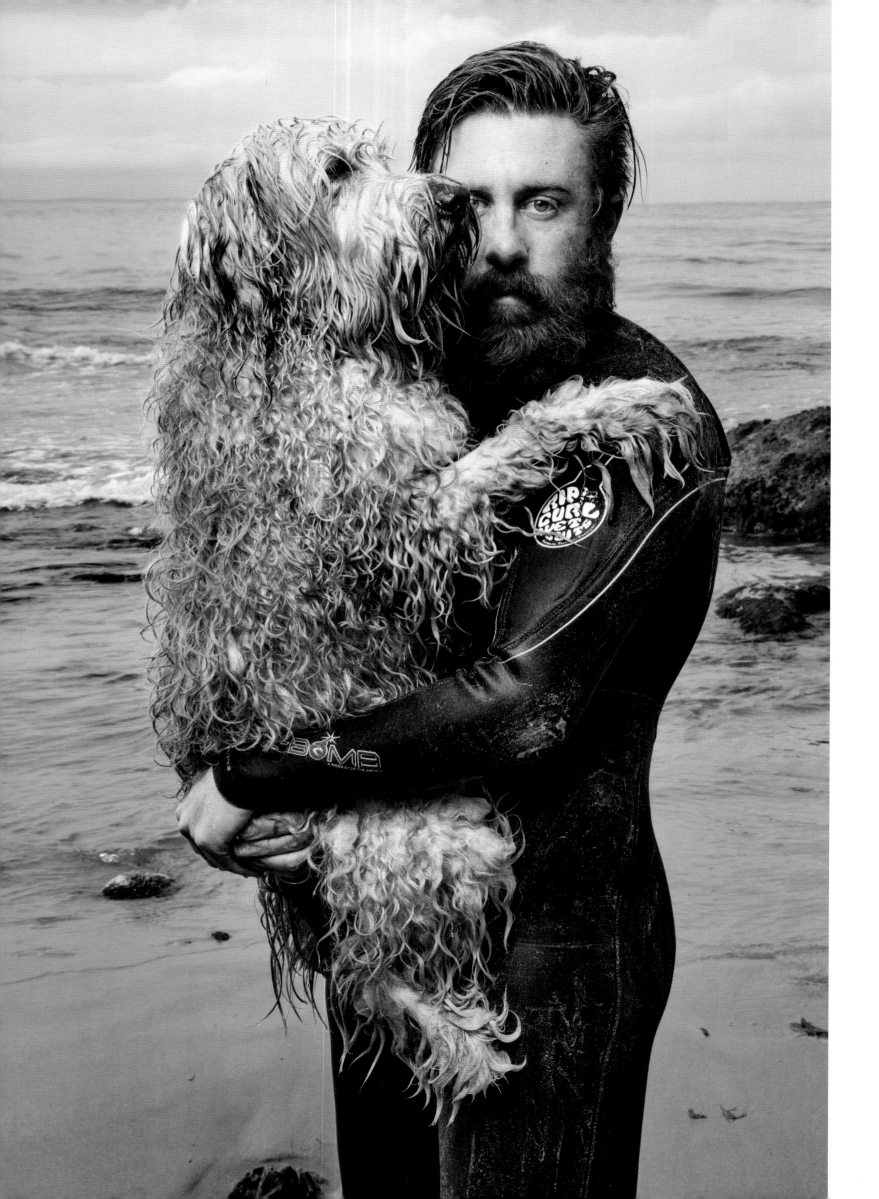

NICK TOOMAN and RUSSELL THE DOG

2015

Nick and Russell have been dating for several years now and hope to marry soon, if Russell's parents will approve. Actually, this is one of the perks of being in Southern California: on a Malibu shoot day, my incredibly talented lighting assistant Nick can come early, let Russell play on the beach, and get a little surfing in.

CHRISTIAN BORLE

2016

Dressed as William Shakespeare for his Tony Award–winning performance in the Broadway musical *Something Rotten*, Borle bounced into the studio with a cup of coffee and a big smile. I'm always kind of shy about asking actors to go full-tilt, but I had seen Borle in his other Tony Award–winning performance in *Peter and the Starcatcher*, and I knew what he was capable of.

Borle: "What would you like me to do?"

Me: "Uh . . . you know, bounce off the walls, pretty much."

Borle: "You don't have to ask me twice."

And off he went. This is truly the biggest joy I get as a photographer: being able to capture the spontaneity and talent of someone like this. It's a visceral thrill to watch Borle perform. There's no editing or camera tricks to hide behind—it's just raw talent out there on stage, with no net.

(overleaf)

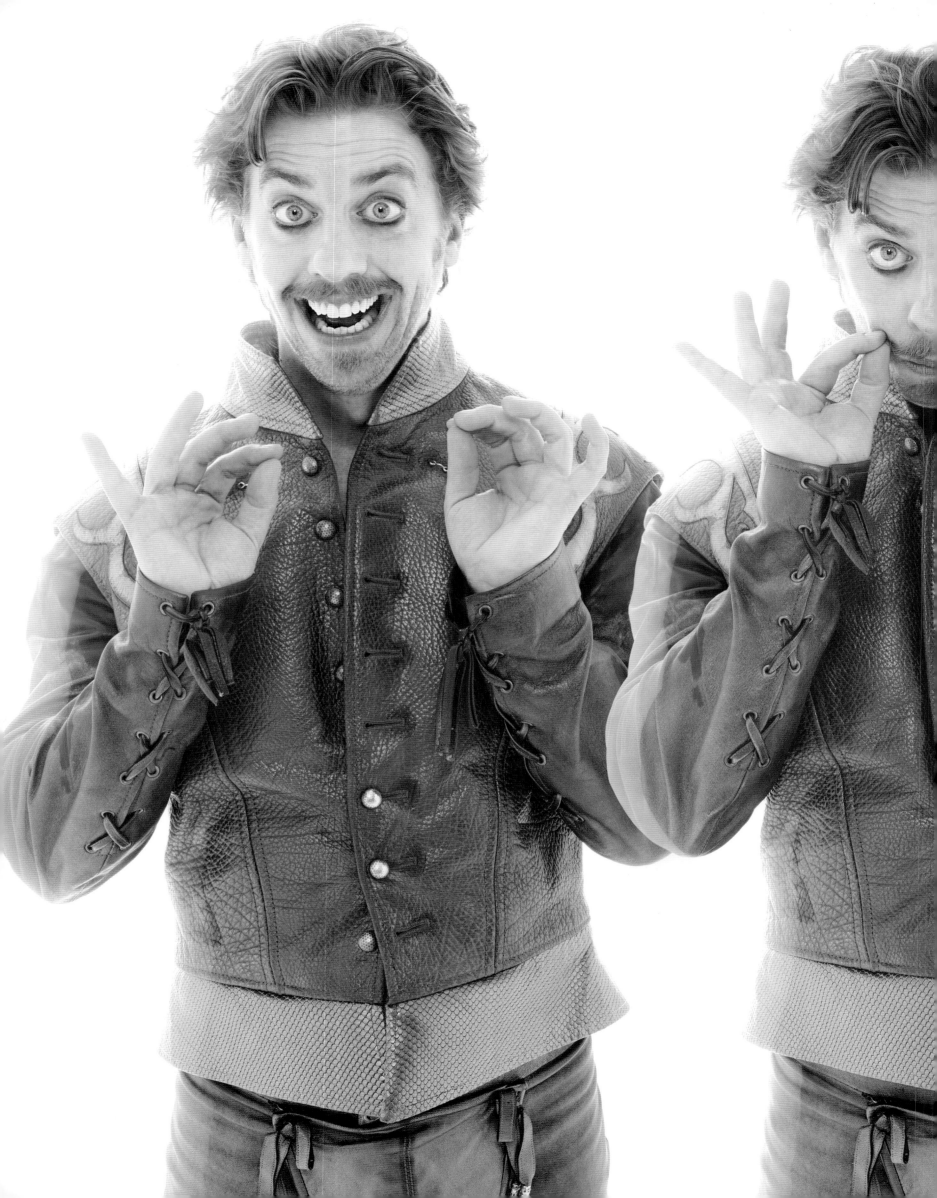

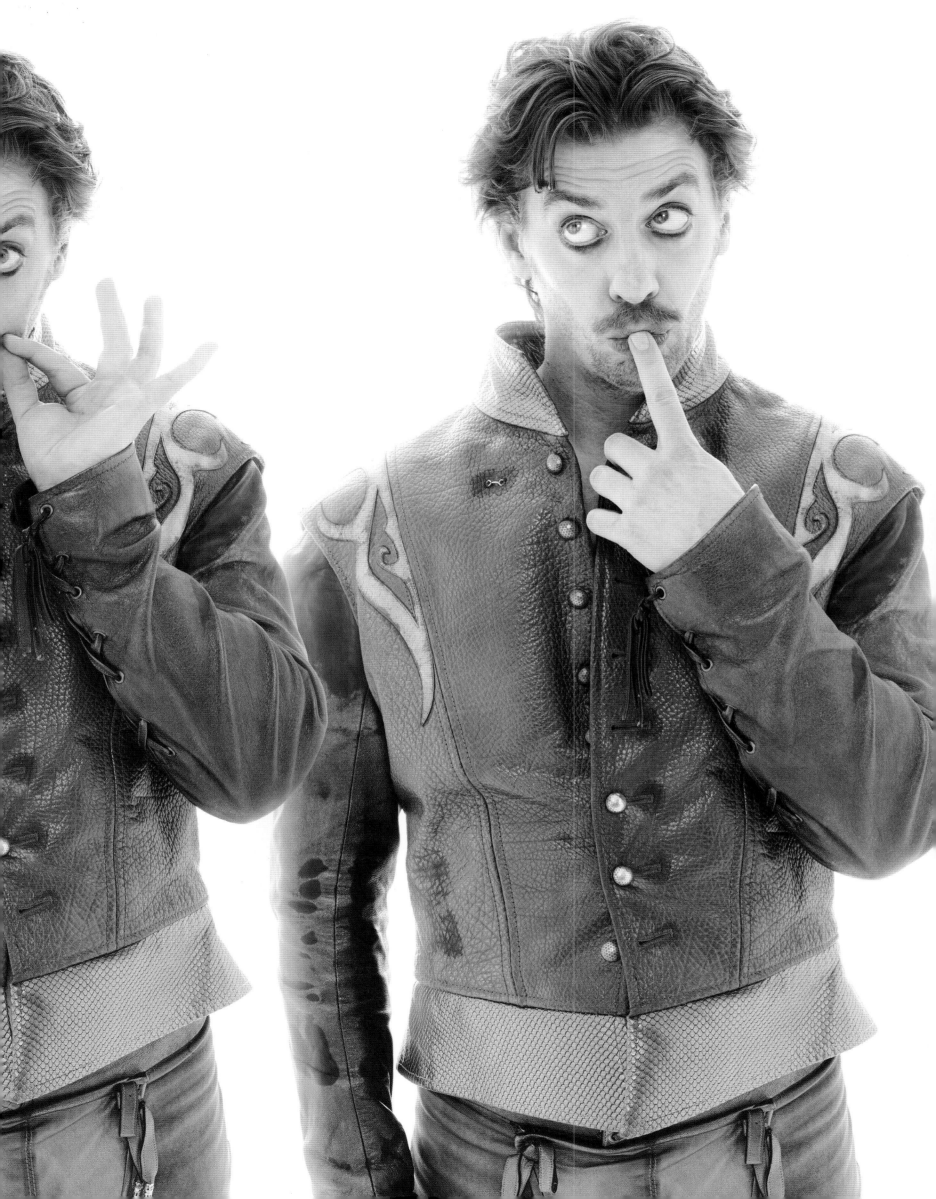

MARC SHAIMAN

1993

As the composer and co-lyricist of the Broadway musical *Hairspray*, Shaiman became a household name, but chances are also very good that he has had a hand in creating other music that you've thought was incredibly clever, moving, or both, over the last thirty years. He's won the Emmy, the Grammy, the Tony, and just reading his credits on Wikipedia is exhausting.

BRIAN SIMS

2016

Member of the House of Representatives, Sims is the first openly gay elected state legislator in Pennsylvania history. He is also an accomplished attorney and gets smart, legible tattoos, like the quote from Benjamin Franklin pictured here. Another memorable quote came from Sims himself during a heated floor debate with his colleagues over personal choice and religious freedom. "Each of us put our hand on the Bible and swore to uphold the Constitution. We did not place our hands on the Constitution and swear to uphold the Bible." We need this guy.

(page 150)

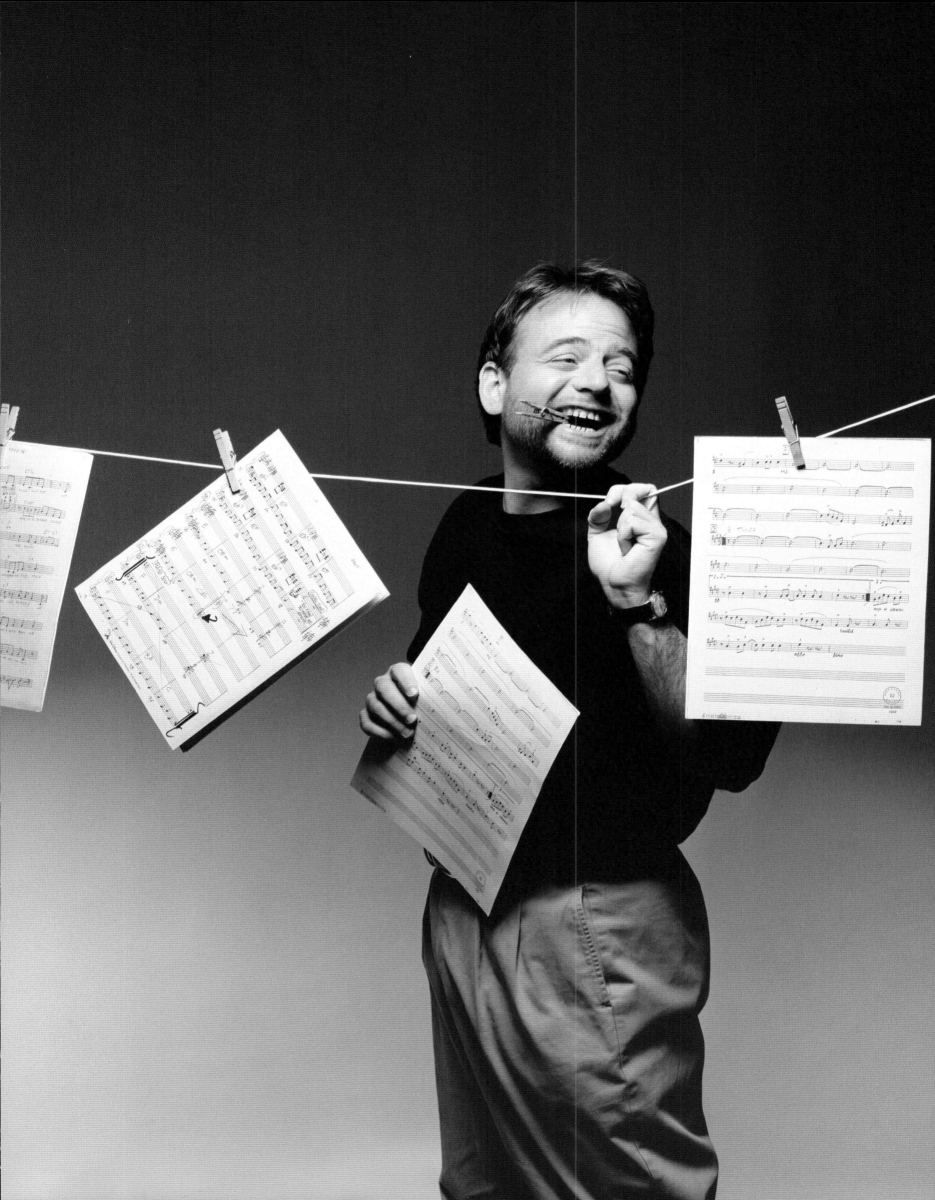

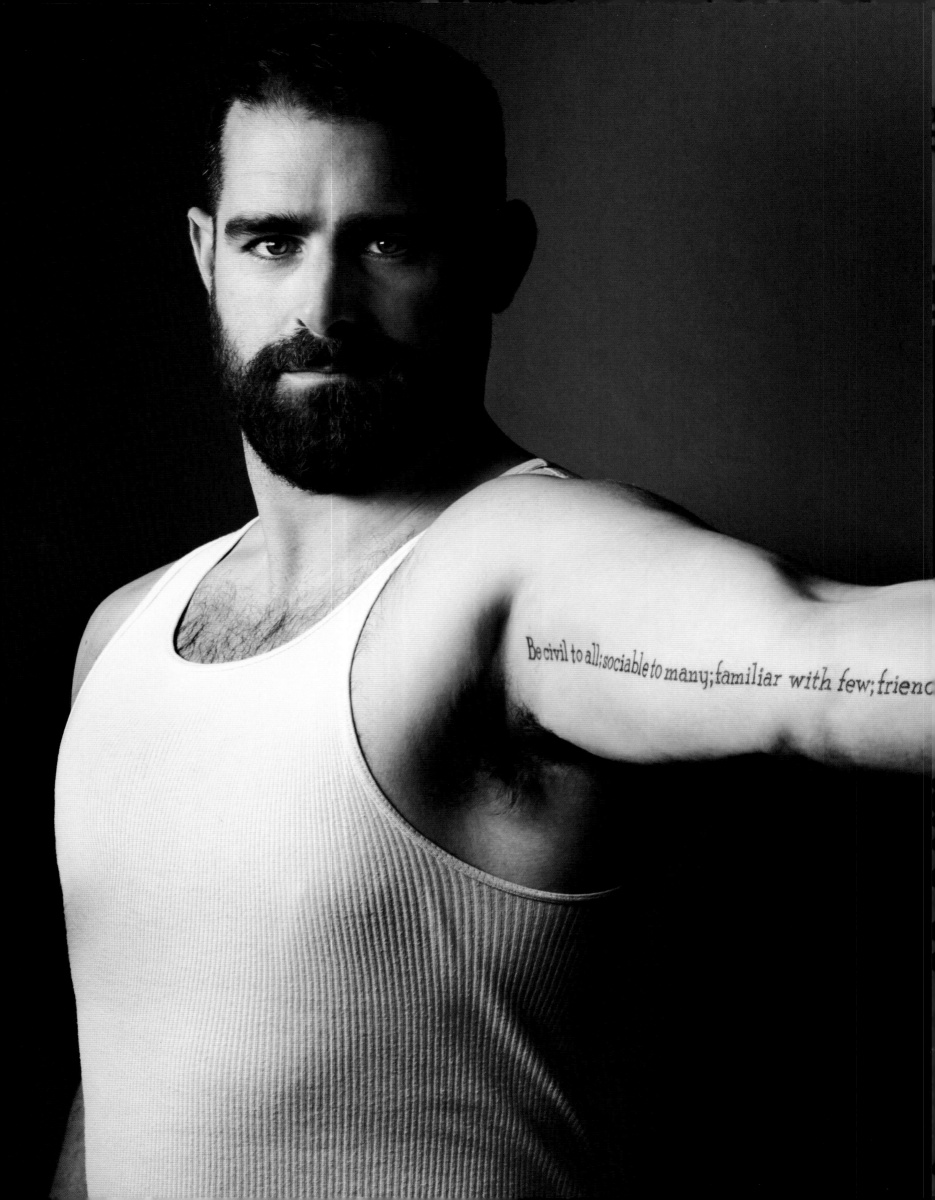

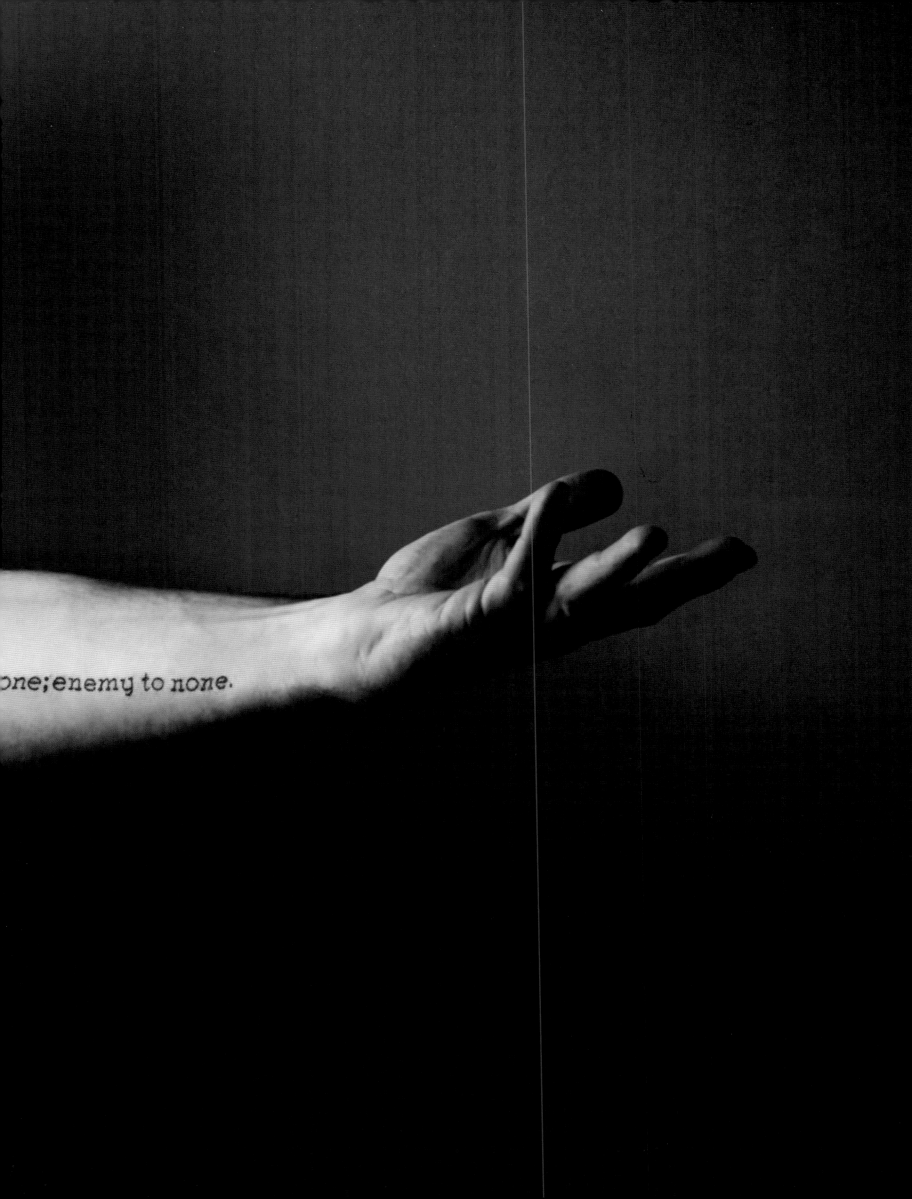

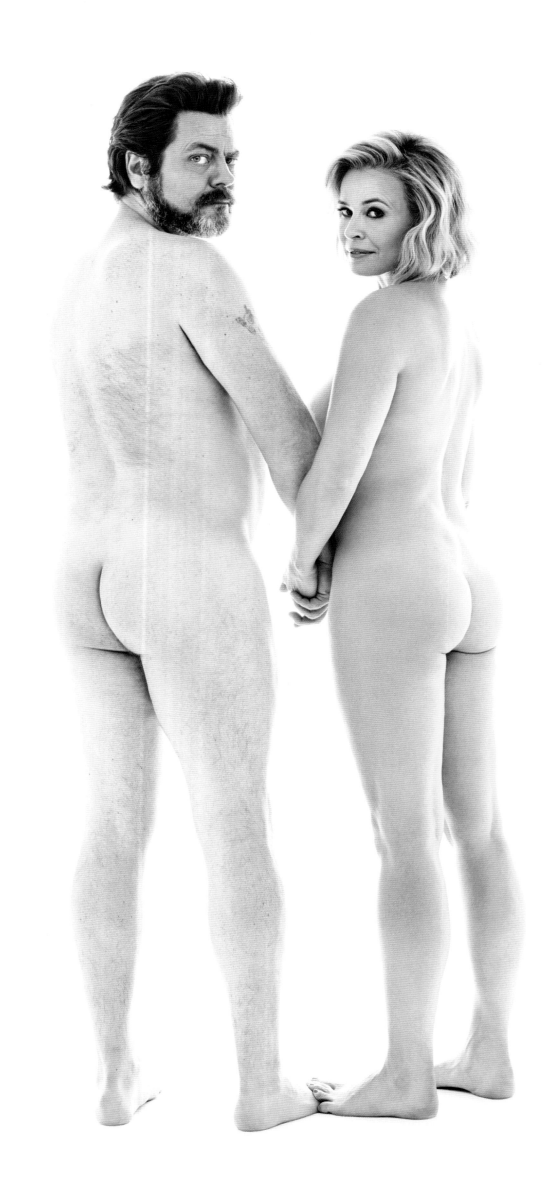

NICK OFFERMAN and CHELSEA HANDLER

2015

They had never met before this photo. I'm still haunted by Offerman's final words to me before he dropped his pants: "Please. Be gentle with me."

HUGH LAURIE

2007

Technically British, but screw it. Anybody willing to do this for me is in.

(overleaf)

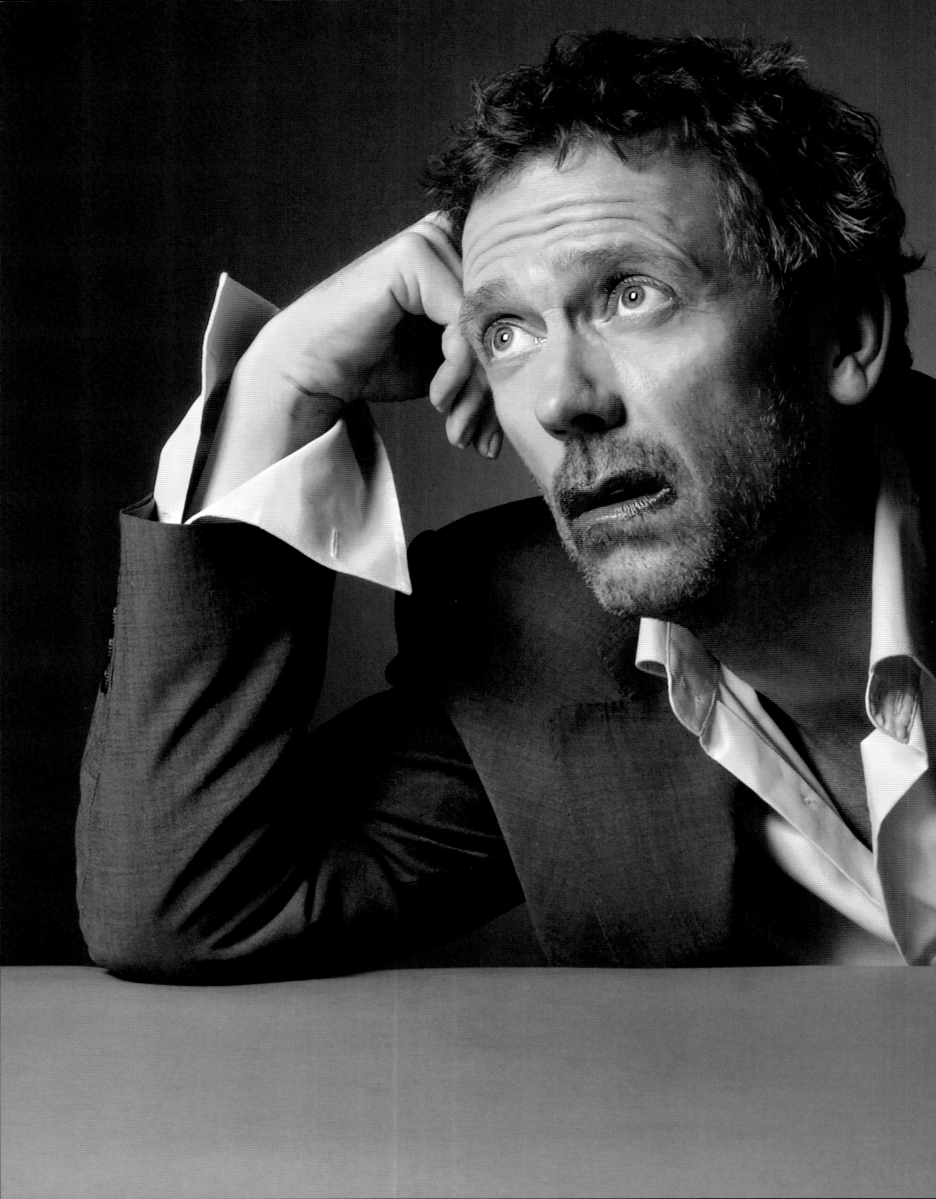

WILLIAM NORWICH

1999

This was shot for the *New York Times* to
accompany an article Norwich wrote. It was
a high-concept pitch to wear a space-shuttle suit
with matching helmet around Los Angeles for a
day, because that's what he had been led to believe
everyone would be wearing by the year 2000,
based on every sci-fi movie and TV show of his
childhood. He lasted less than an hour. Tops.

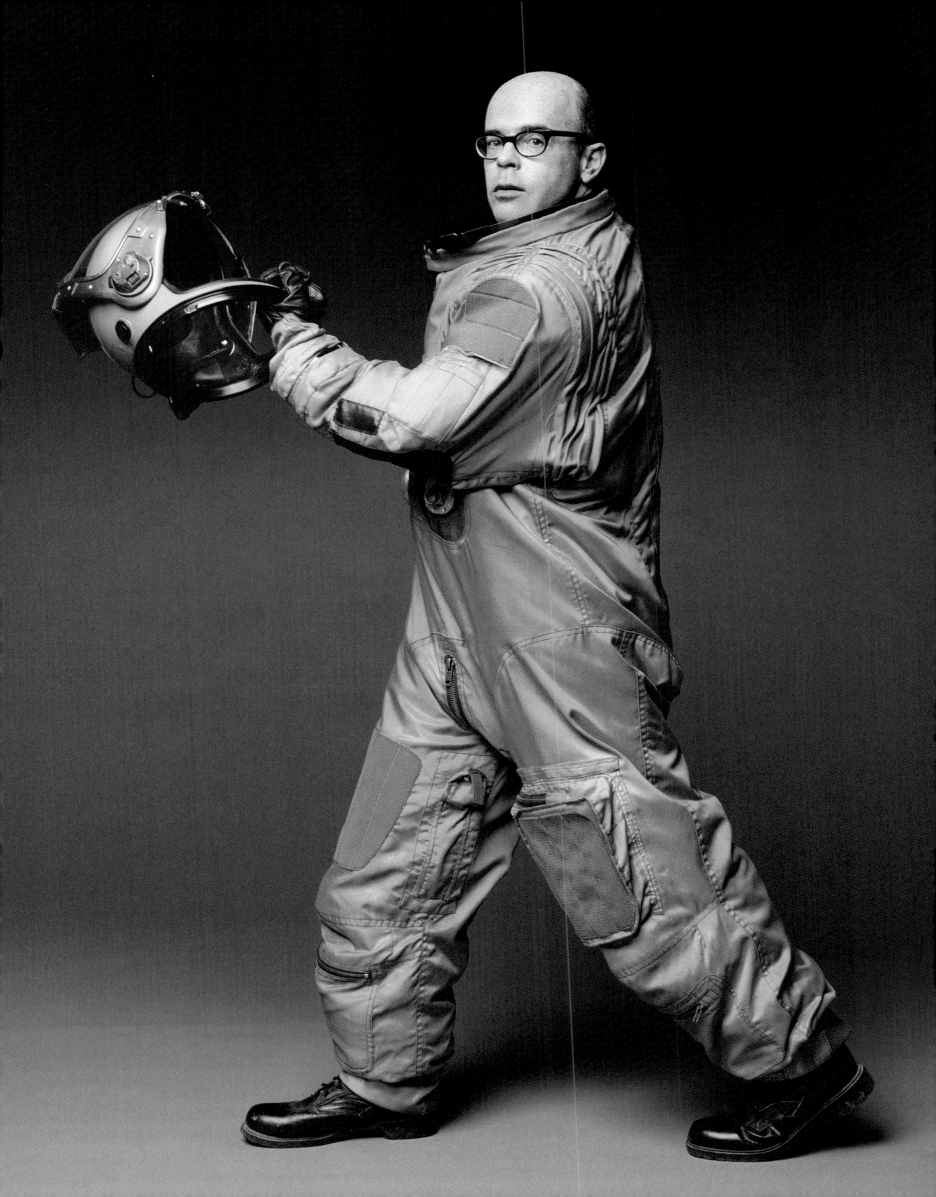

**BROOKE ADAMS and
TONY SHALHOUB**

2002

Shalhoub had just directed his first
feature, starring Adams. They let me play
out my fantasy of what it must've been
like on set for the long-married couple.

x

JACK LEMMON

2000

This is a story of loyalty. Director George Cukor had cast Lemmon in his first starring role in 1954's *It Should Happen to You*, and it made him a star. I had interviewed Lemmon for my Cukor documentary, and when it came time to promote it, we took a bunch of actors to whom Cukor had given their first big break—including Angela Lansbury and Shelley Winters—up to his legendary home where they had auditioned, been coached, and come to dinner at the start of their careers. Over forty years later, Lemmon didn't hesitate for a moment when asked. He still felt grateful and indebted to the man who had changed his life. From our interview:

"I had just come from doing a Broadway play, so I guess unconsciously I was still playing to the balcony. We were shooting a scene and George would say, 'That's good, that's good, Jack, but let's do just one more—and a little less. Less. Do less.' We did another take, and George said, 'Oh, that's perfect, that's wonderful, but I'd like to do just one more. And, Jack, less, a little less.' We'd go again, same thing. 'Less, a little less.' By then I'd really had it, so uncharacteristically for me, I said, *'George, are you trying to tell me not to act at all?!'* And he said, 'Oh yes, God, yes!'"

MICHAEL STRAHAN

2016

(overleaf)

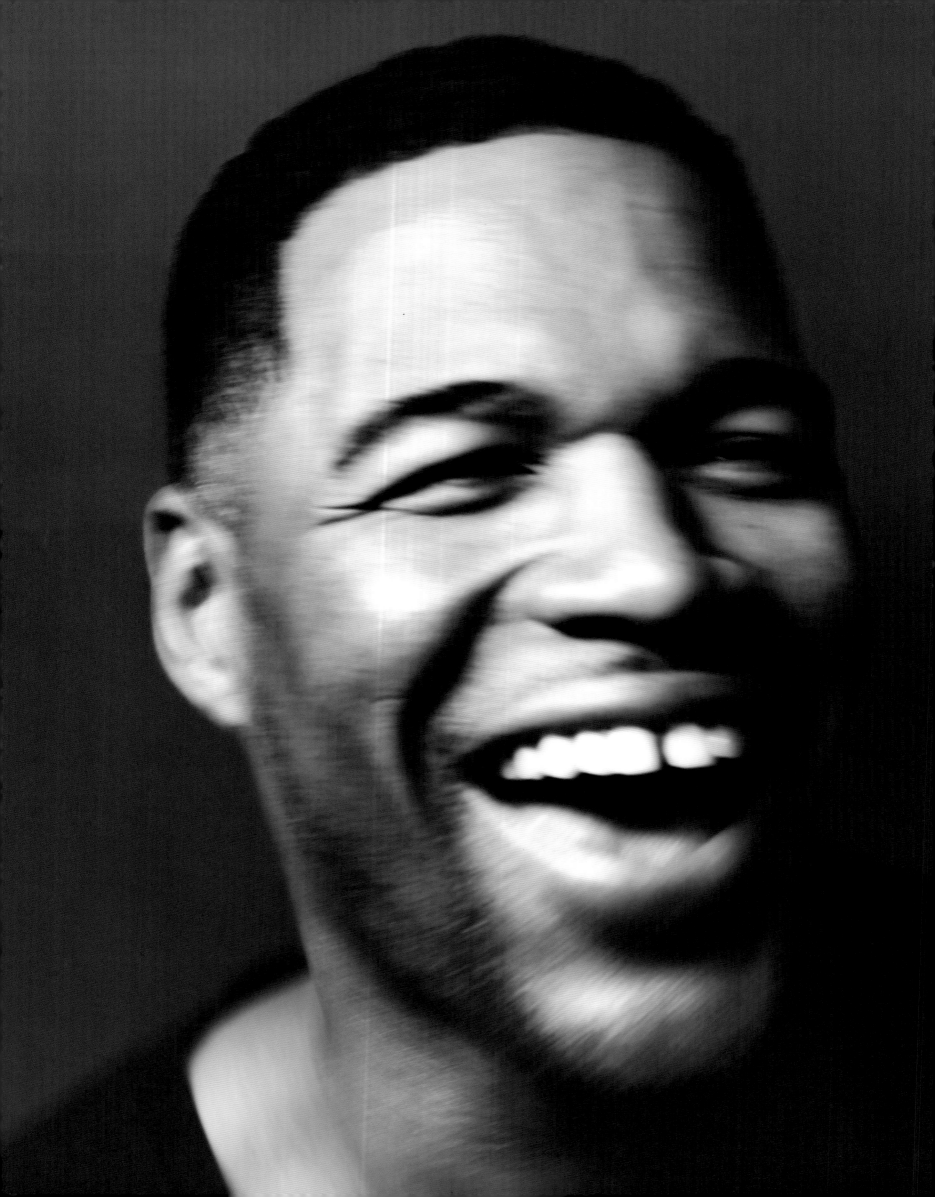

CEELO GREEN and DANGER MOUSE

2006

For that one summer, all you heard anywhere
you went was their Gnarls Barkley song *Crazy*.
At their live shows, they always dressed themselves
and the band in full costume. For this shoot,
I had my choice of 1950s toughs or country-club
tennis players.

LUCA LAFAYETTE, MATTHEW JACOBSON, ELI OFFER, and EZRA LEVY

2015

These four are proving that the game of mahjong—
once thought to be the sole purview of elderly
Jewish women—is alive, well, and a very cool
antidote to cards for the red-blooded American
male. If memories of coming home from school
only to find your mother or grandmother playing
with their friends, their stockings rolled down to
their ankles, their hair in curlers, and the air filled
with cigarette smoke come to mind, try picking
it up. Poker is bullshit in comparison; "mahj" is
way harder.

(overleaf)

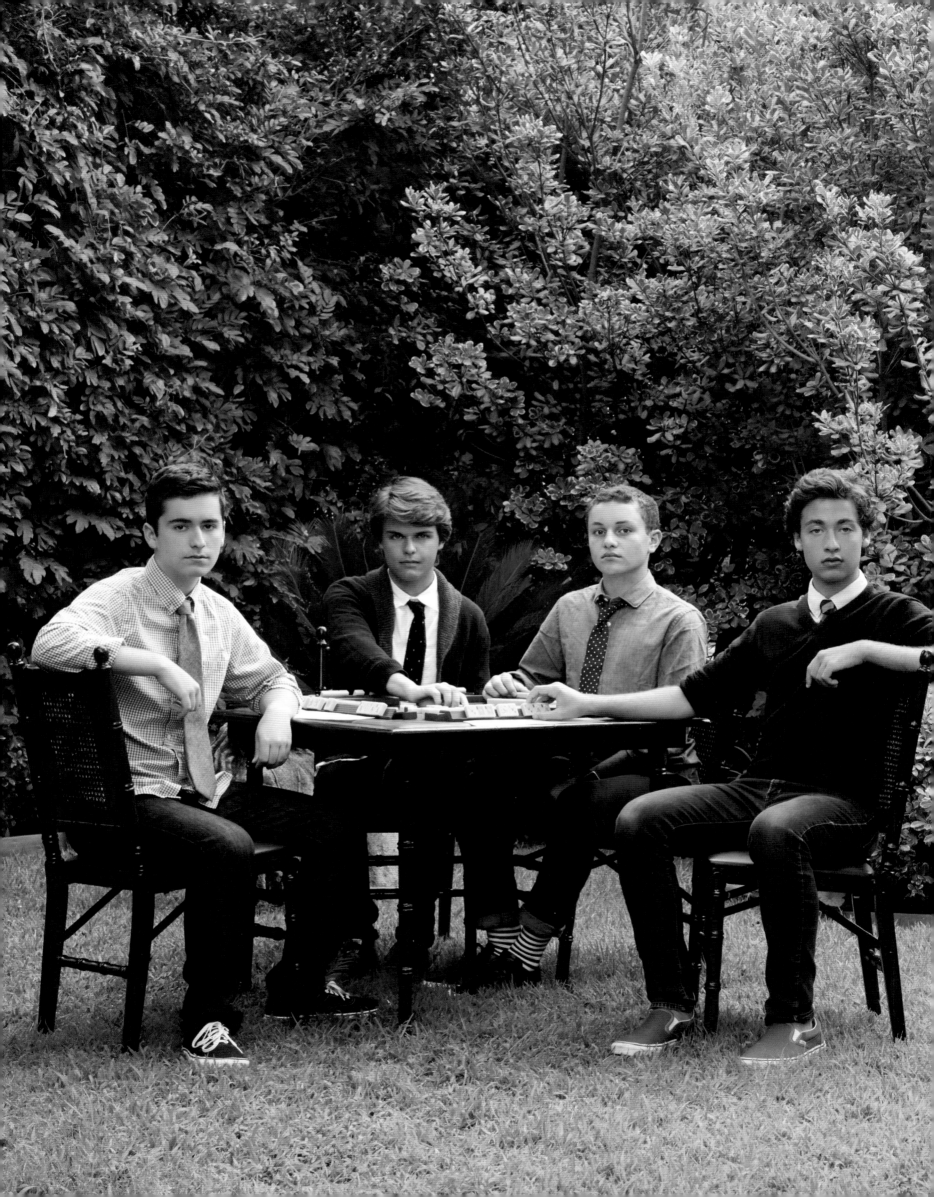

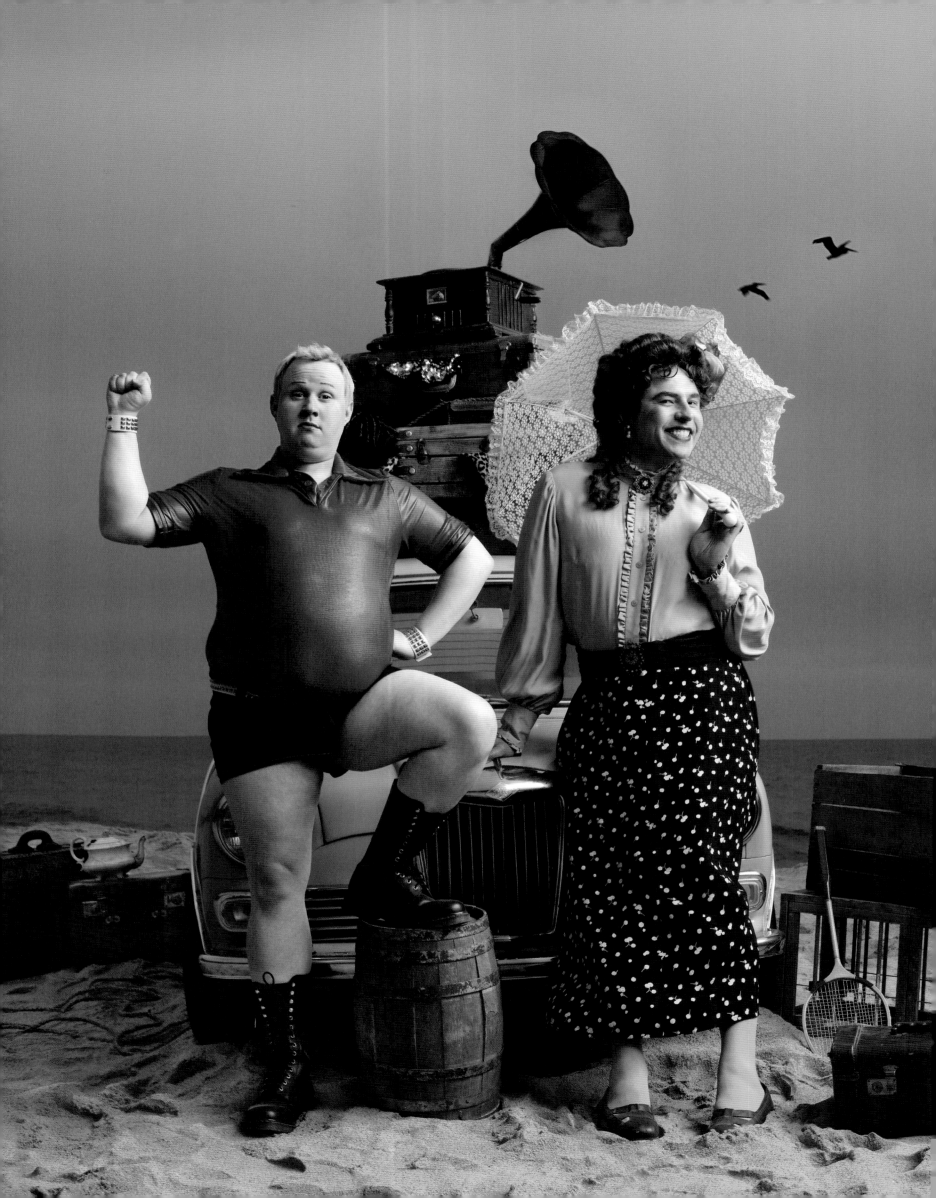

MATT LUCAS and DAVID WALLIAMS

2008

Together, Lucas and Walliams formed the British comedy team known as Little Britain. As they were bringing their television series to the United States for the first time, I wanted to avoid palm trees, Hollywood Boulevard, Rodeo Drive, or any of the usual Los Angeles clichés. I came up with the idea that they had literally been dropped on our shores (in this case Malibu) with all of their belongings.

NATI KNOBLER

2015

Born in Addis Ababa, Ethiopia, Nati was adopted
at the age of five by Mary and Claude Knobler, and
now (at fifteen) lives in Santa Monica, California.
Claude wrote a wonderful book about the slog of
trying to raise his new son in his own likeness
(e.g., a neurotic Jew) and finally accepting Nati for
who he intrinsically was. When I spoke to Nati
he said, "For a long time I felt that I was American.
But as I get older, I'm feeling the pull of Ethiopia.
I need to go back and explore where I came from."

BRYCE PINKHAM and
JEFFERSON MAYS

2016

Pinkham (left) and Mays were photographed
on stage at the Walter Kerr Theater, in costume
for their multiple-award-winning musical
A Gentleman's Guide to Love and Murder.
Sure, they may do a TV series or a movie, but
these guys will always return to the theater—
it's in their DNA. At a time when people become
worldwide sensations for doing close to nothing,
the devotion, dedication, and talent they bring
eight shows a week gives you a real sense of
hope. In a dwindling cultural universe, these
two are saviors.

(page 172)

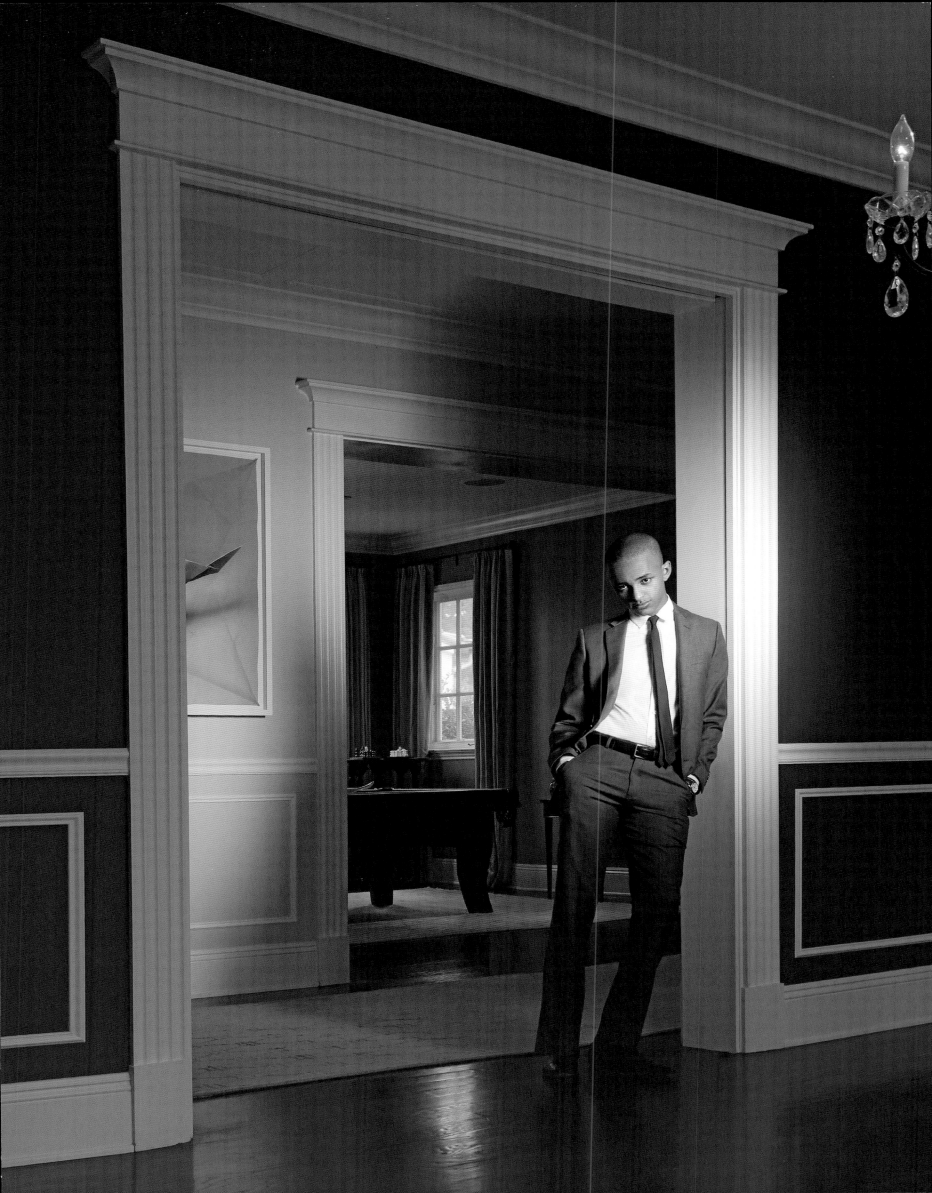

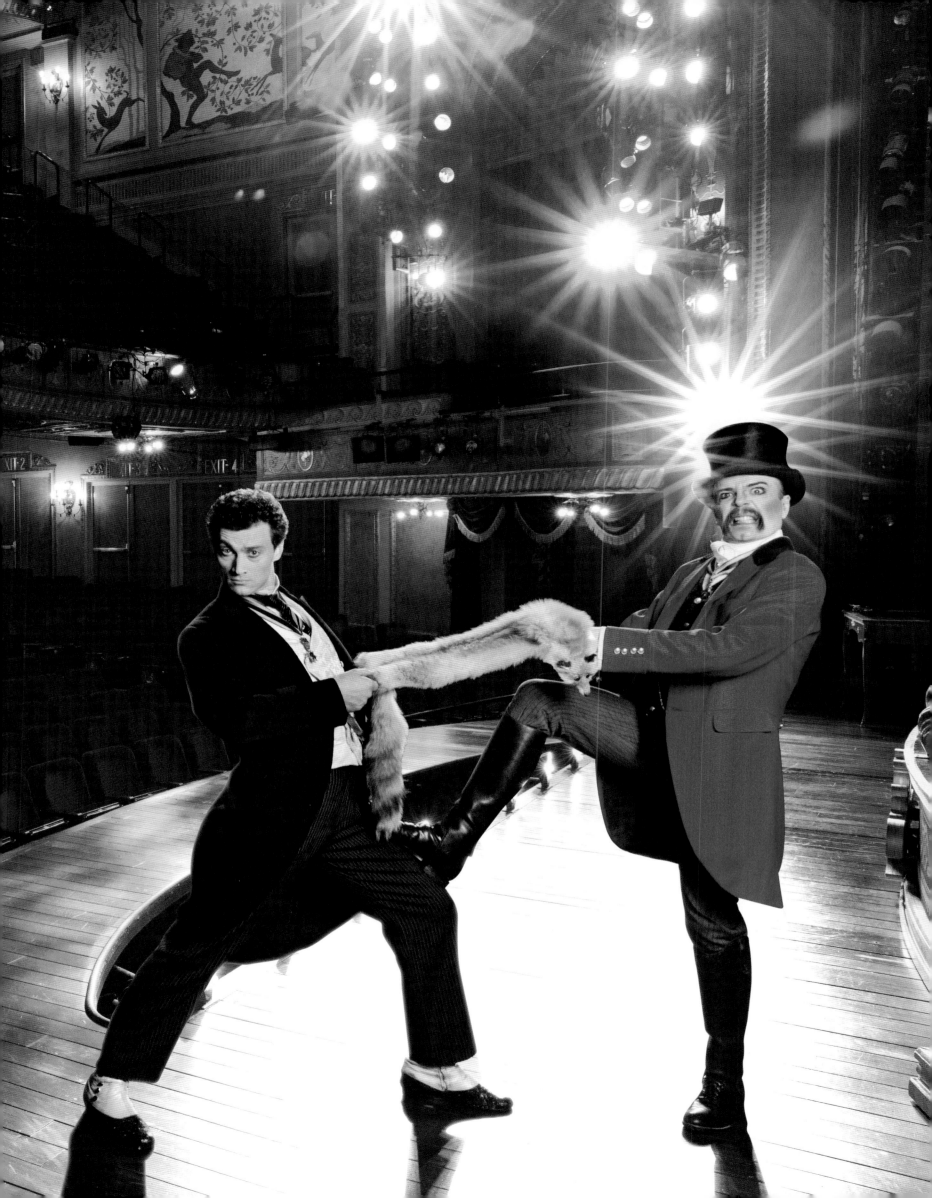

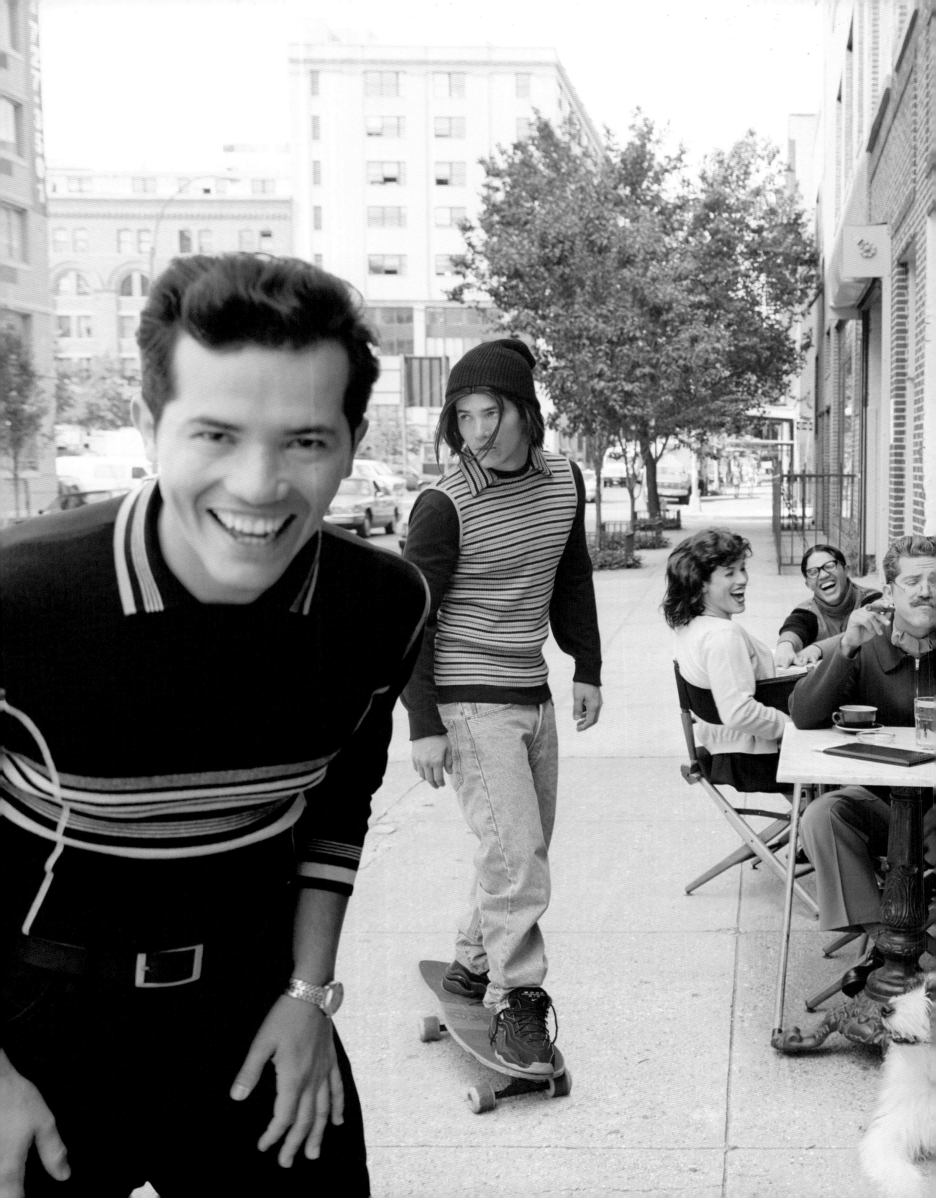

JOHN LEGUIZAMO

1996

We did this very quickly before the restaurant opened. Every few minutes he came out in full character, with subtle shifts in body language and carriage fully in place. If you've never seen one of Leguizamo's one-man shows (*Mambo Mouth, Spic-O-Rama, Freak, Ghetto Klown*), search the usual Internet places. He's so incredibly gifted. I kept thinking, *What the hell would he do if he didn't have this outlet?*

175

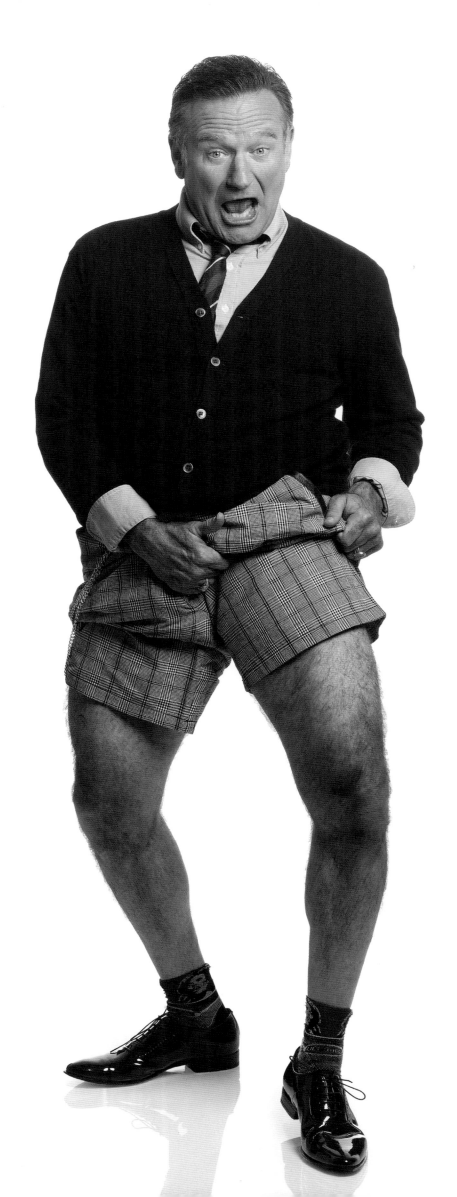

ROBIN WILLIAMS

2008

What can I say? He was lovable and endlessly imaginative. Before I ever picked up a camera, I wardrobe-styled him for several shoots. By his own admission, the hairiest forearms in show business.

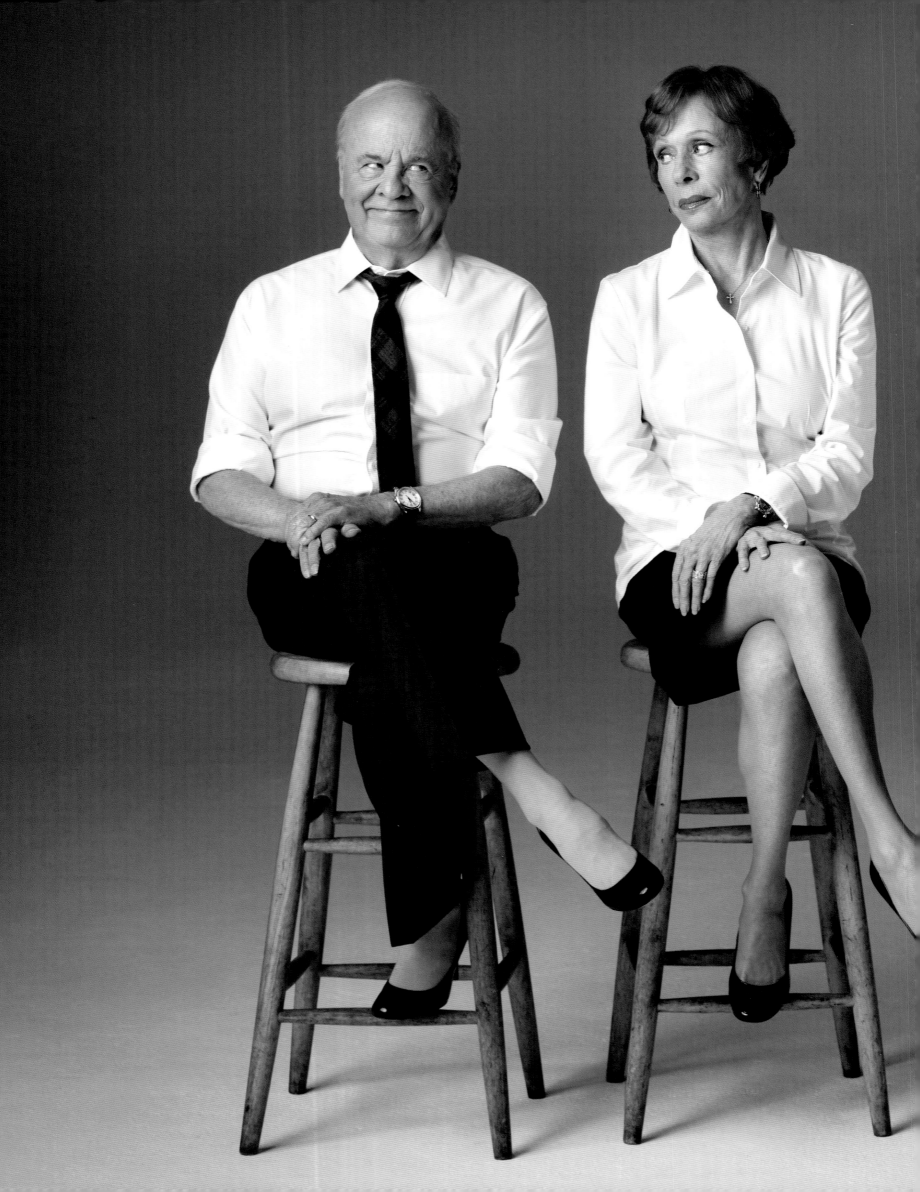

TIM CONWAY,
CAROL BURNETT, and
VICKI LAWRENCE

2012

The Carol Burnett Show had been off
the air years before any of my assistants
were born, so they had little or no
knowledge of who Conway, Burnett,
or Lawrence were. This was shot the day
after a grueling job with a young star who
was an unprofessional shit in every way
possible, so it was amazing to see my crew
fall in love with these talented, game-to-
try-anything legends. Later, as they were
breaking the equipment down, I heard
one of them say to another, "That putz
from yesterday will never last as long as
these three."

JEFF GARLIN

2010

I've run into Garlin at the Farmer's Market, at the airport, at gallery openings, and I'm so glad it always goes like this:

Me: "How are you?"

Garlin: "Young and handsome!"

This shot was completely his idea, and it's almost Buster Keaton-like in its simplicity.

ISAO HASHIMOTO, ABRAHAM MARTINEZ, MARK THOMPSON, and GREGORY ROBINSON

2010

I've done a few white-shirt fashion stories. I like the challenge because it's so inherently stupid: it's a white shirt, you're not going to get much from it in a photo, so what else do you do? One time, I found and shot a group of Orthodox Jews wearing them, since that's their everyday wardrobe. By the way, not easy talking them into it.

(pages 182–85)

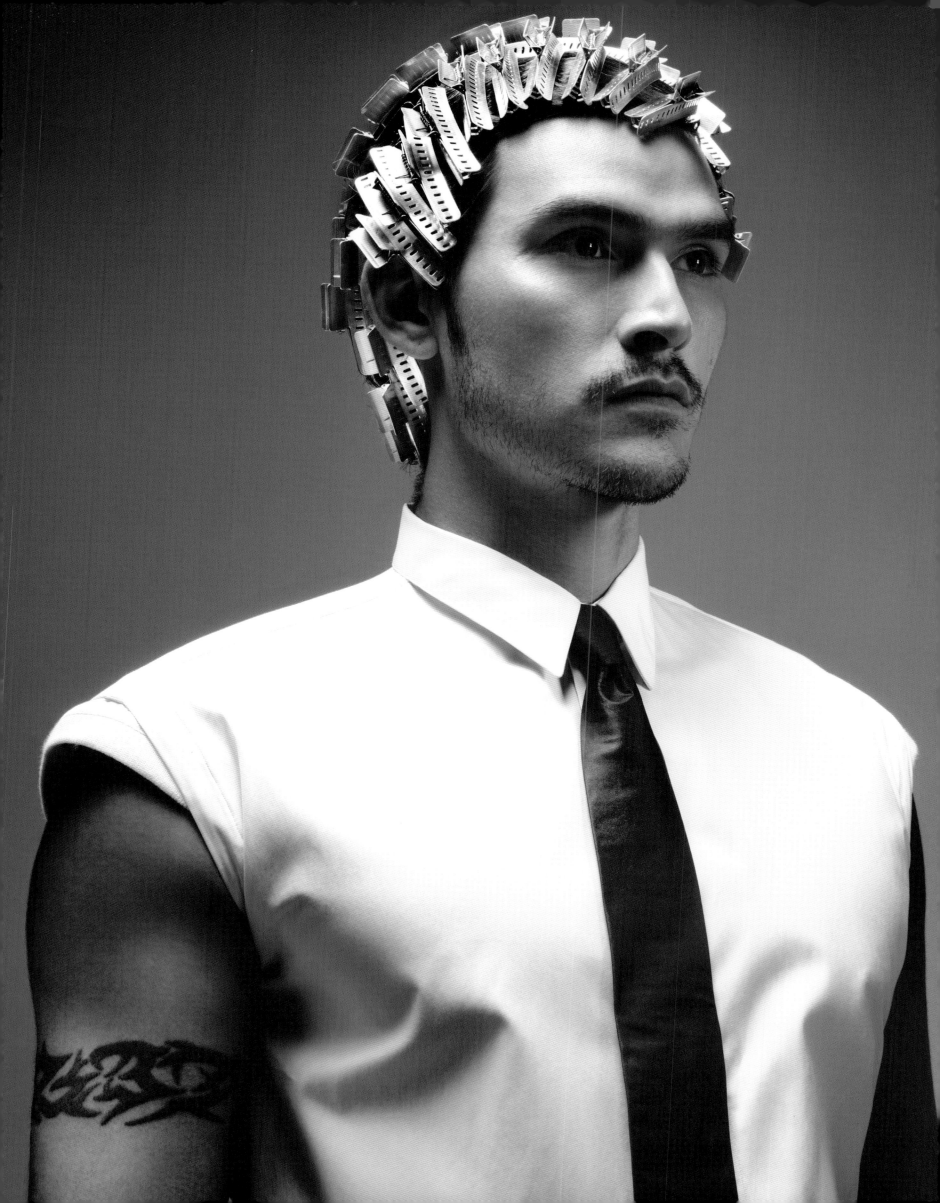

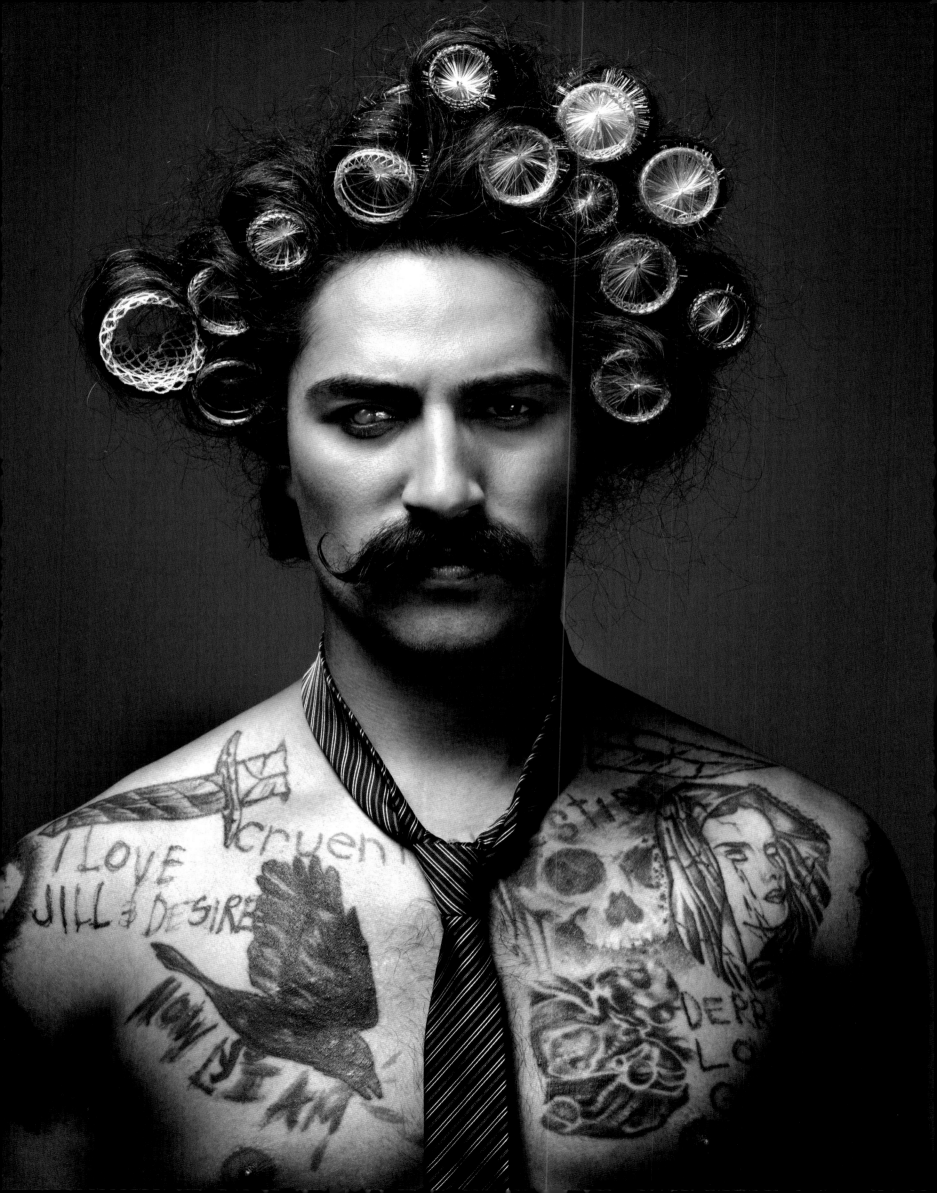

JULIA LOUIS-DREYFUS
and KEVIN SPACEY

2014

Coincidentally, these two were playing
U.S. presidents on their respective TV series,
so to have them battling it out seemed natural.
They were both incredibly committed to getting
everything right—the pose, the tension, the
makeup bruises. They worried a lot about it—
especially since they weren't in the same room:
Spacey was shot in Baltimore and Louis-
Dreyfus, in Los Angeles, a week later.

TRACY MORGAN

2010

I've shot Morgan a few times, and each time he
starts off by saying, "I don't wanna take my clothes
off because I've done that too many times."
And then somehow . . . I have no idea how or
why a fur coat was there. If someone on the
crew remembers, please get in touch with me.

(page 188)

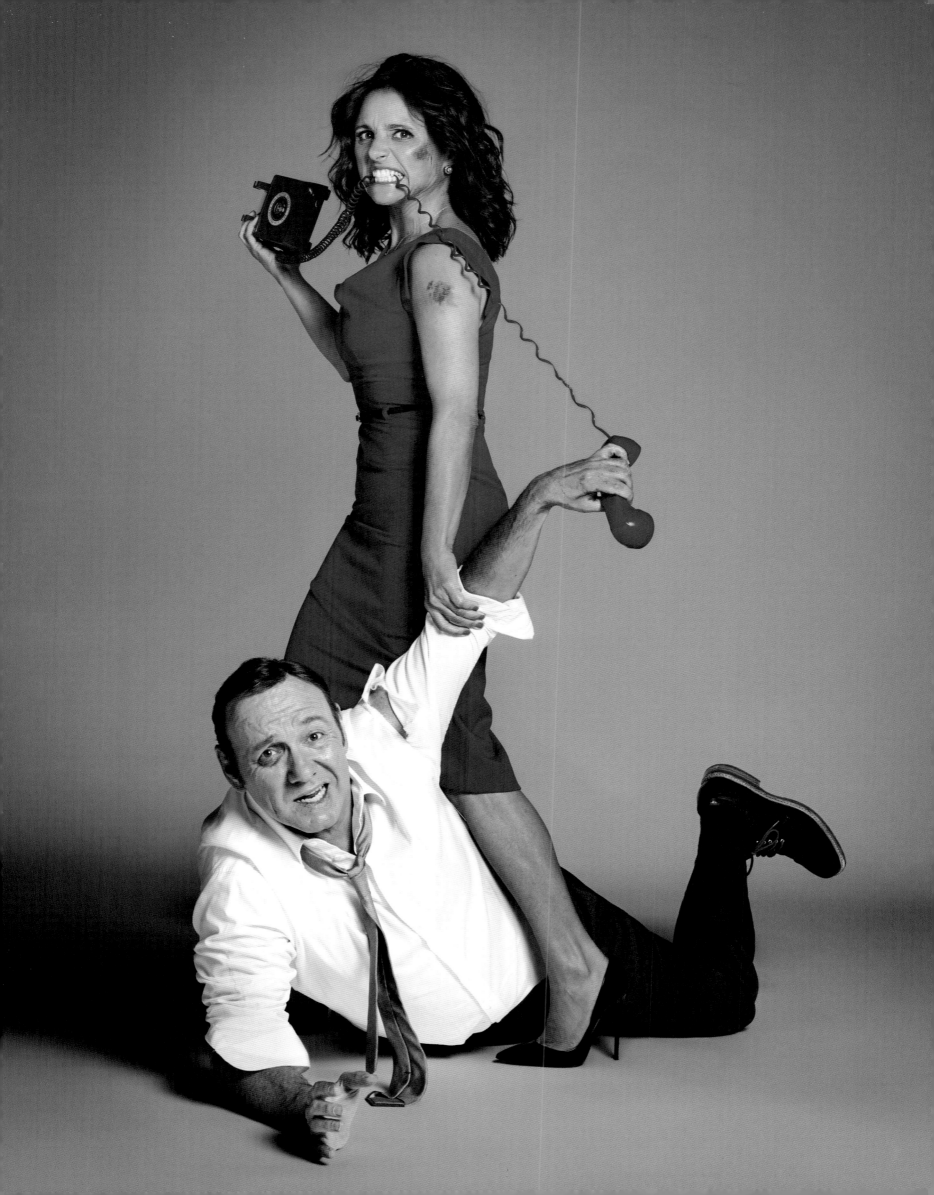

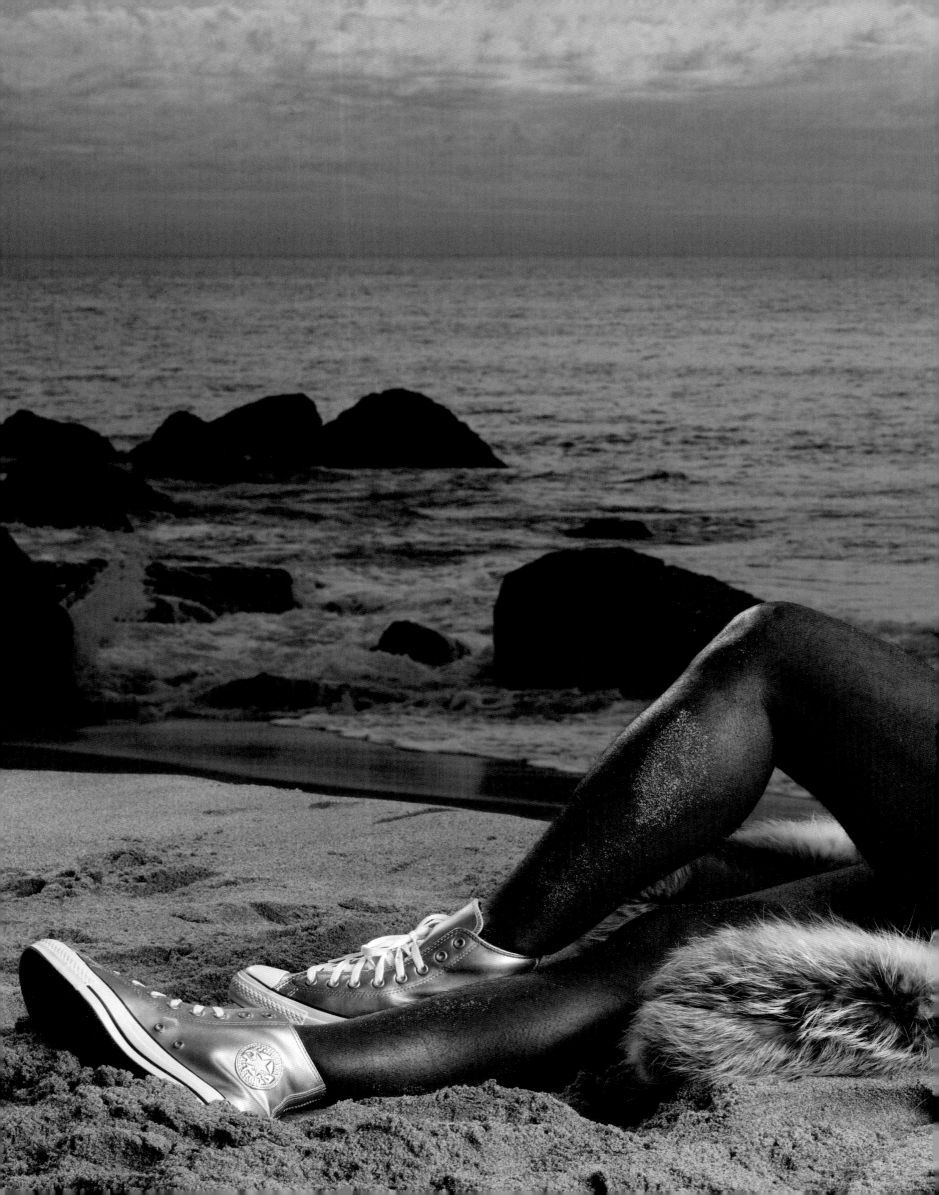

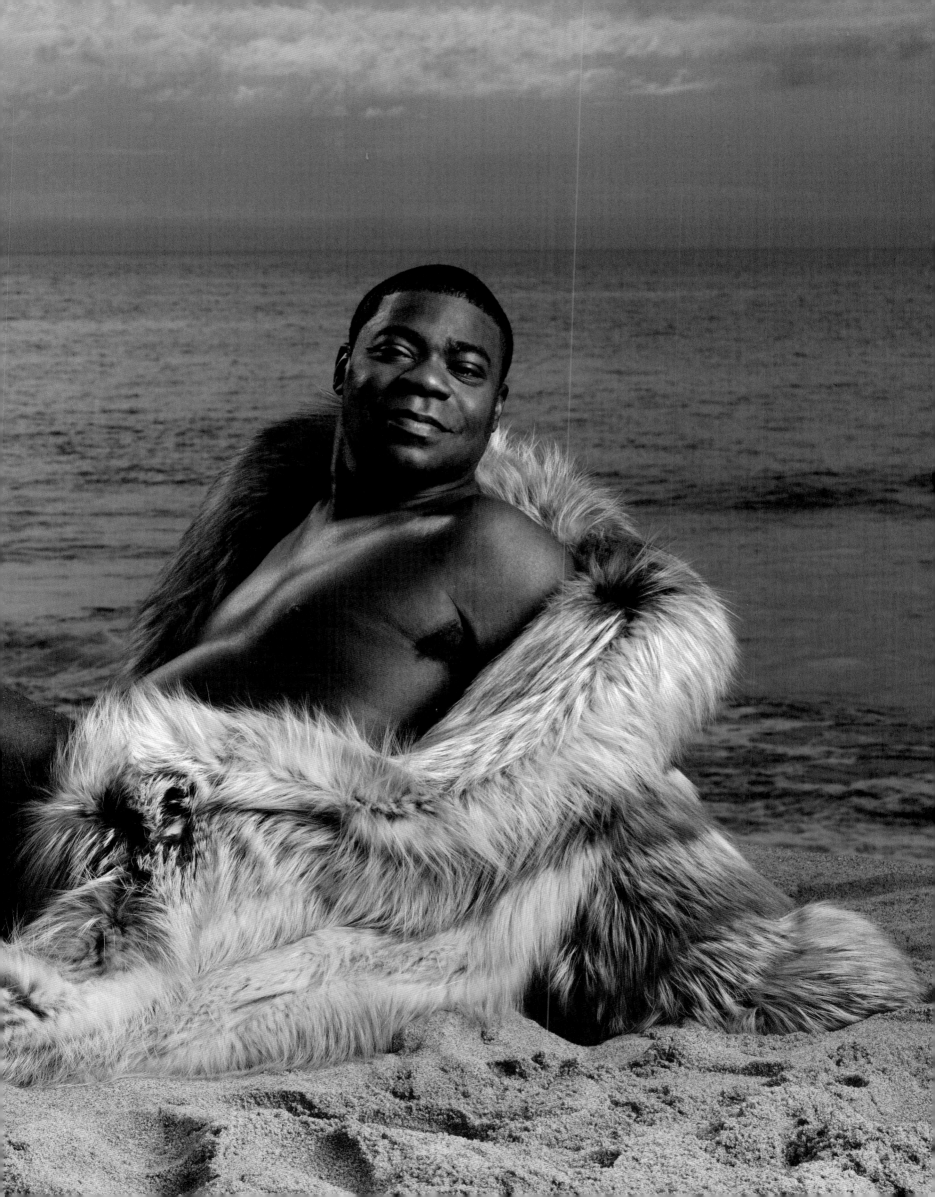

KELLAN LUTZ

2010

Showed up to the shoot like this.

Kidding.

190

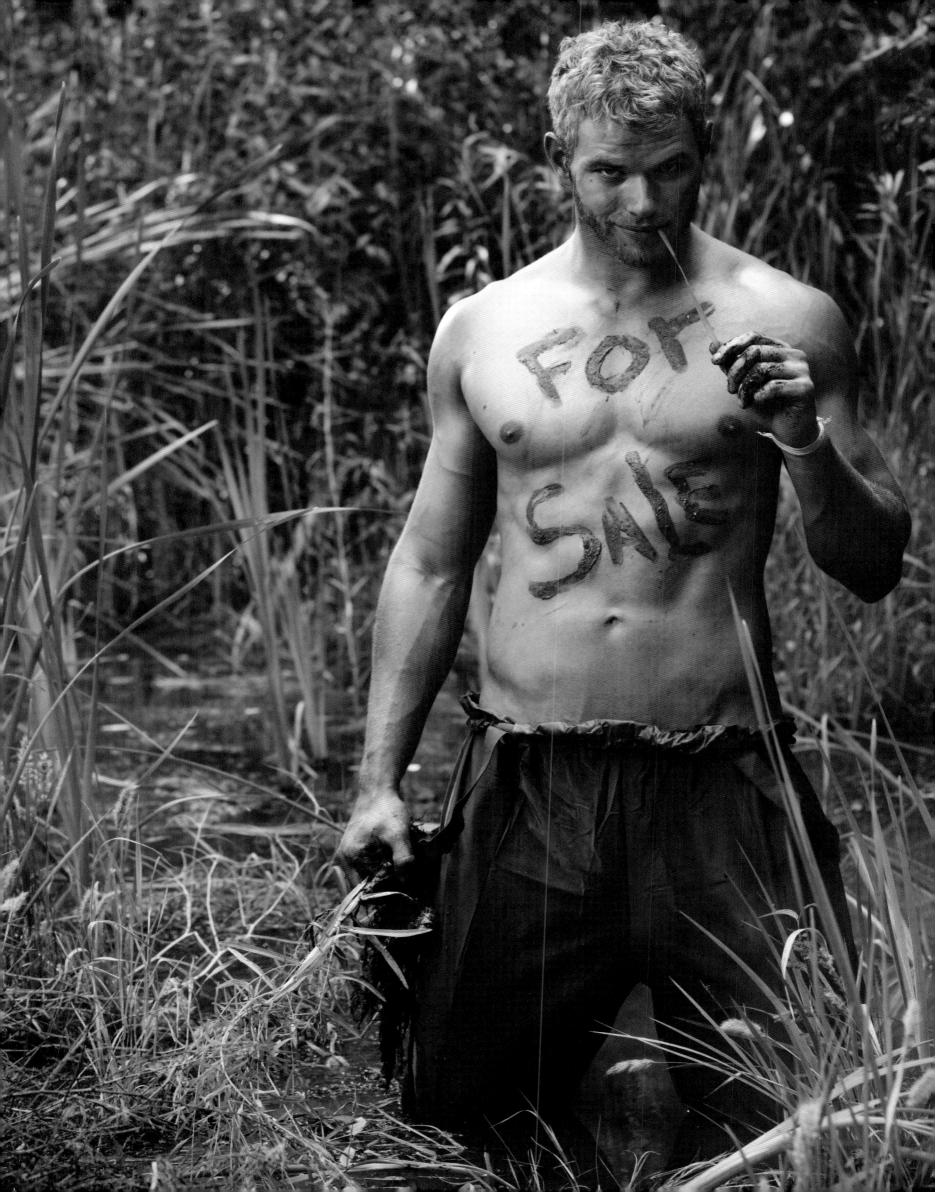

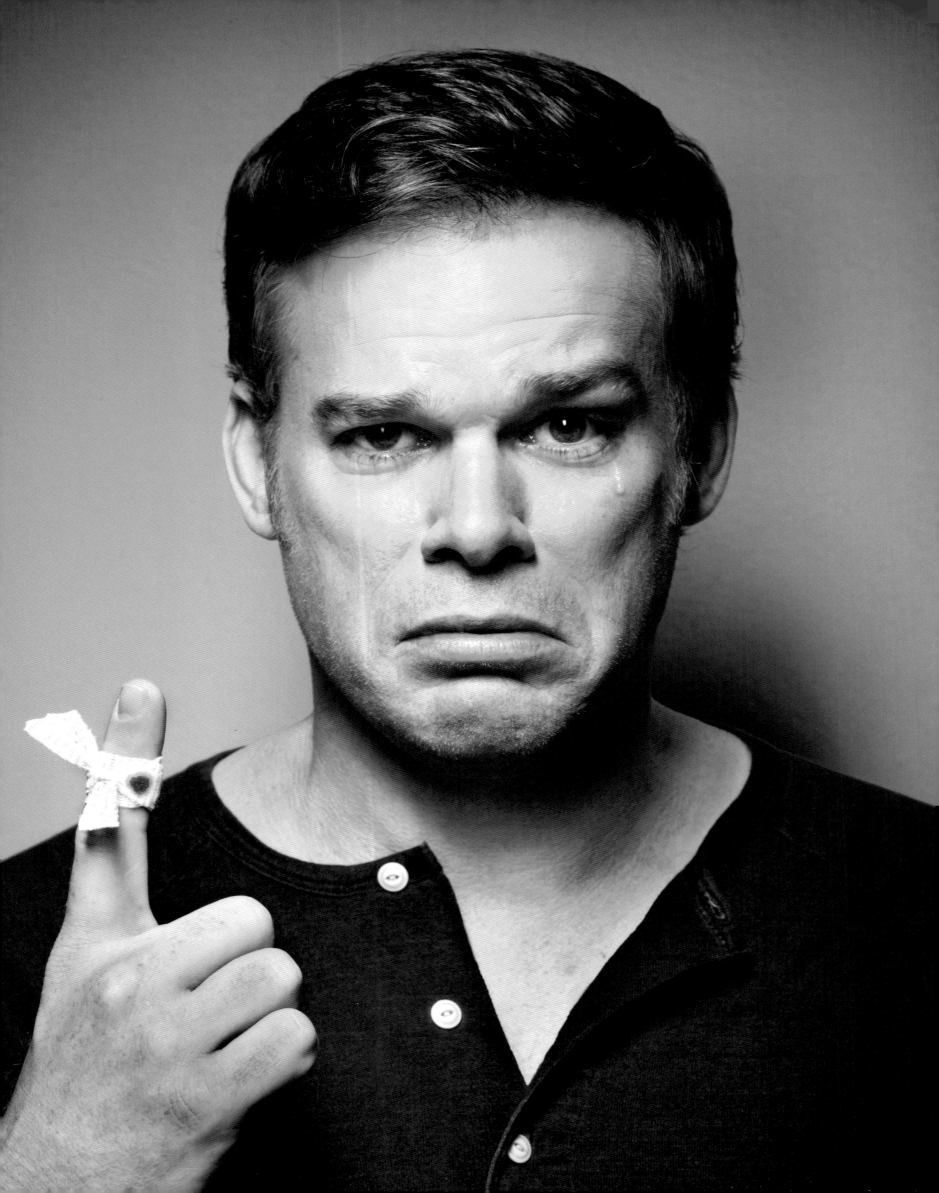

MICHAEL C. HALL

2013

This was shot at the end of the run of the
TV series *Dexter* in which Hall played a serial
killer. By the time I got around to him, he had
been photographed splattered with blood, bathed
in blood, and dropped into a pool of blood, so
there wasn't much left to do except pull it way
back to this.

WAYNE BYRD and MARK KELLER

1998

Mark was one of my favorite models to shoot, and then one day he very sensibly quit the business and got a career with some longevity. Today, he and his wife own and operate the first Non-GMO Project Verified charcuterie company in the United States, located in Napa, California. This photo is from a "courtroom drama" suit story. I'm so happy he was able to pursue such a productive and useful life. My only regret is that he wholesales, so no samples.

JONAH HILL and CHANNING TATUM

2014

This image was used with the headline "Isn't It Bromantic?" above it, which I thought was pretty clever. A few weeks later at the red carpet premiere of *22 Jump Street*, a journalist surprised them by showing the issue hot off the press. They took one look at it and said, "We hate the word *bromance*." Damn.

(page 196)

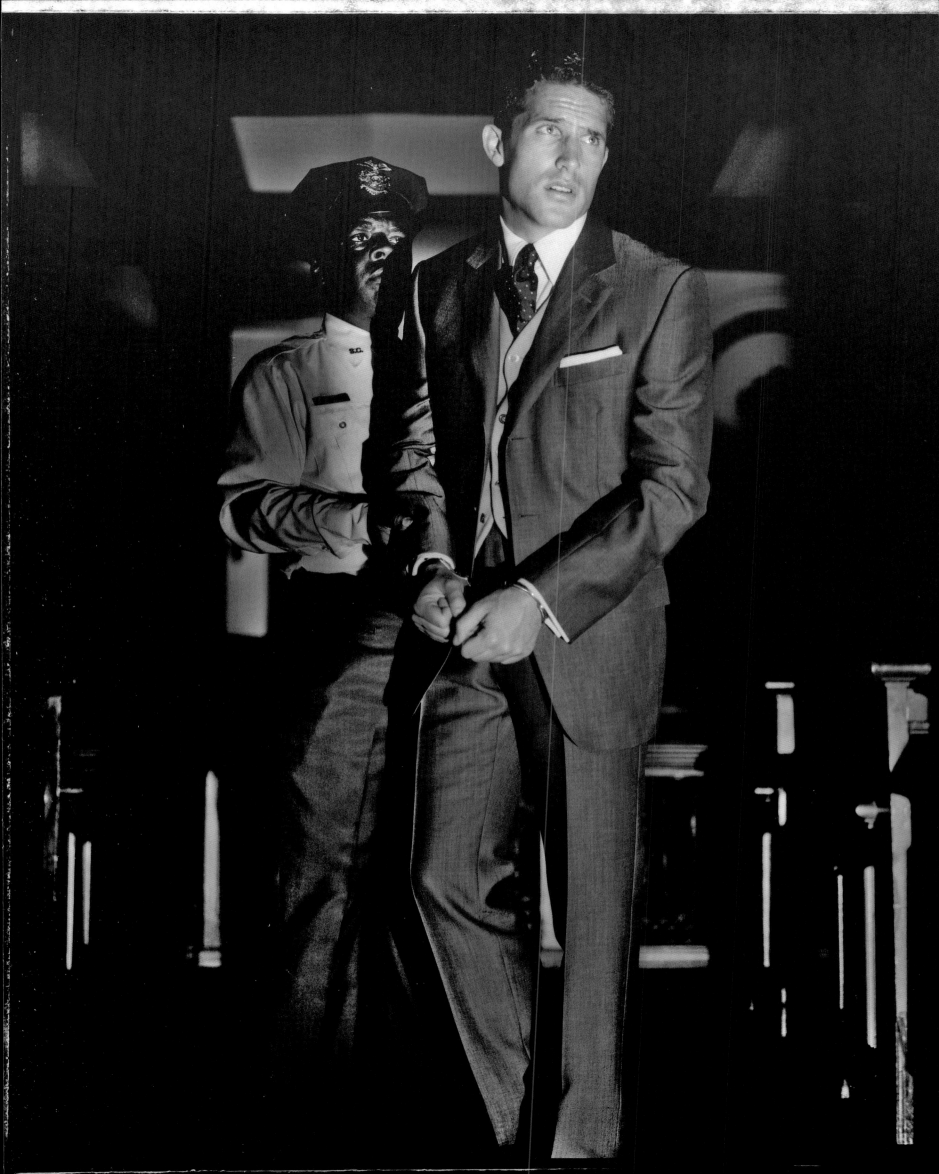

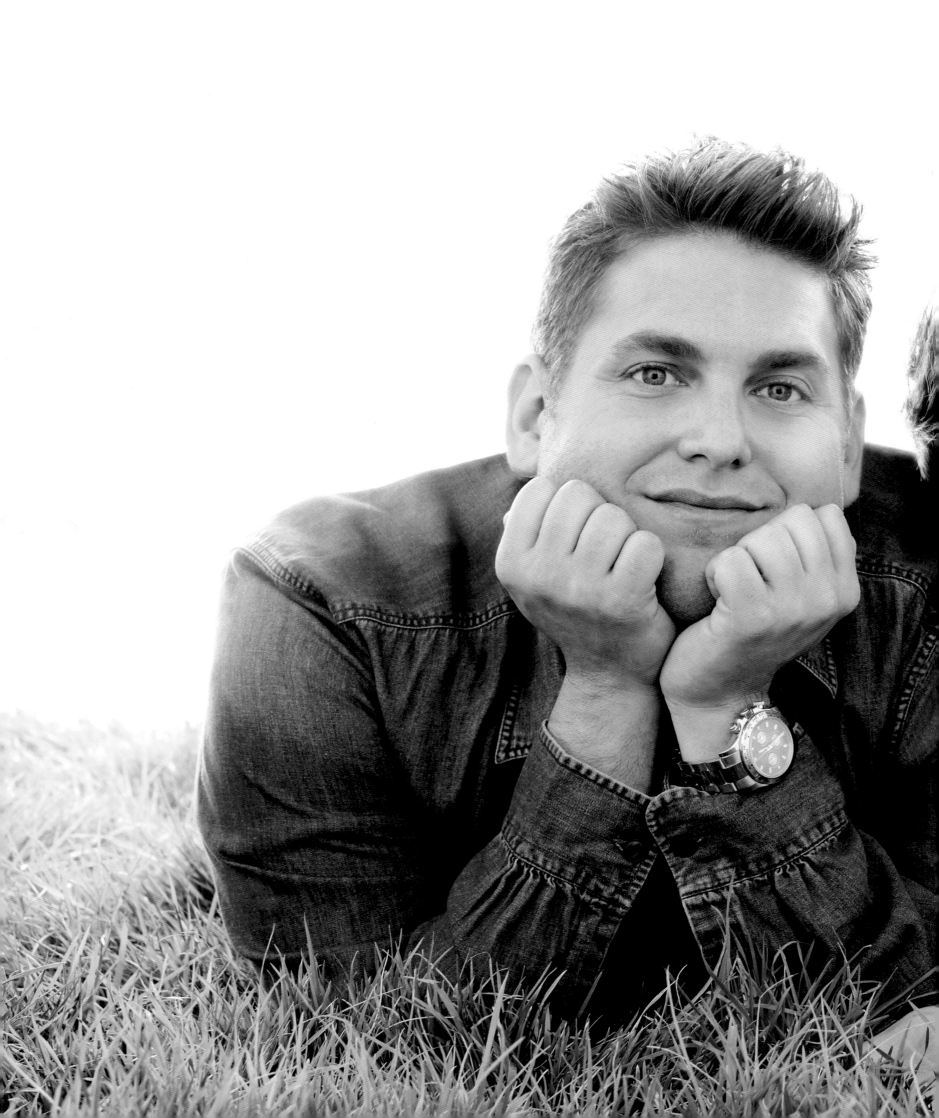

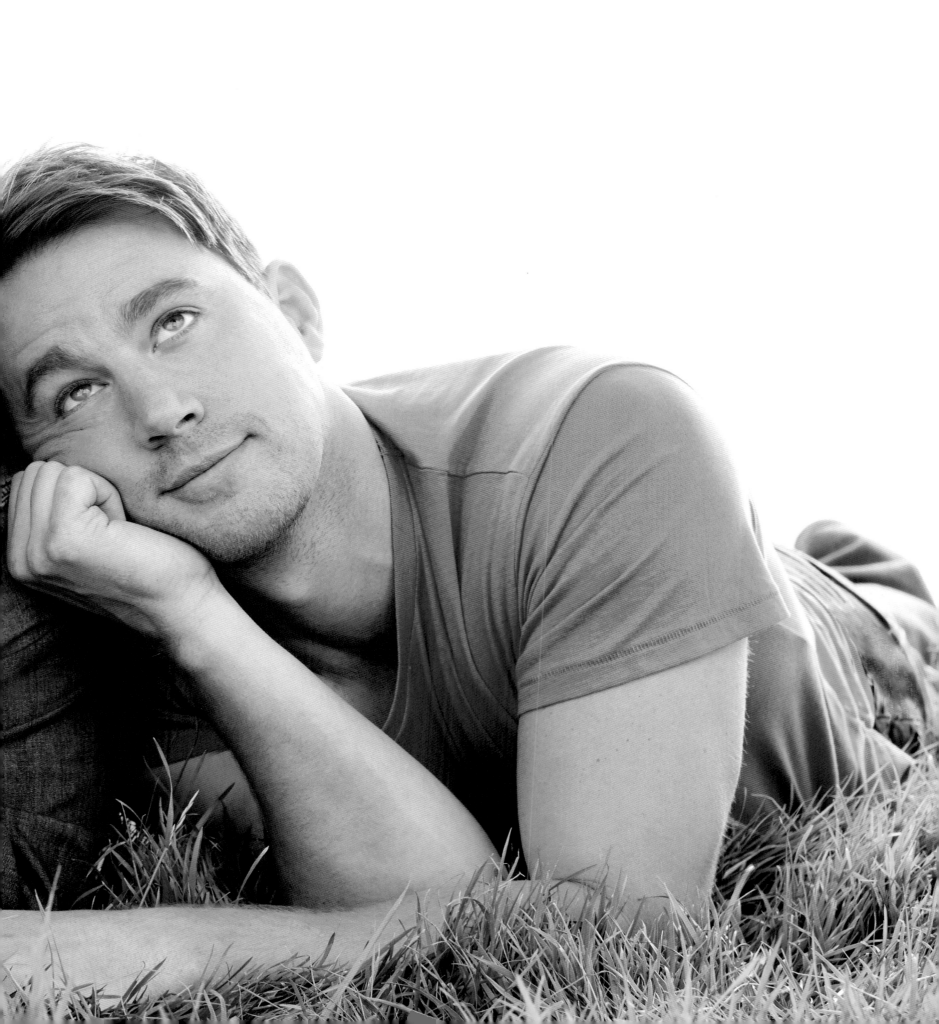

Dear Father,
Camp is ~~above~~ average.
Send me food (please). Also,
if you love me, ~~send~~ hide the
food in a tampon box. Don't ask.
Just do it. My elbow hurts so also
send me some advil.

Your Son,
Jackson

P.S. Tell mother I ~~hate her~~ say hi.

P.P.S. You are swell.

Here is a
photo of a
confused flowe

JACKSON FOX

2013

Letter from camp.

STEVE LAWRENCE and EYDIE GORMÉ

1997

Truly gifted vocalists on their own, they enjoyed their great success as a duo simply known as "Steve and Eydie." When I shot them I had never seen a couple make each other laugh so much — and they'd been married for over fifty years. I thought, *This must be the secret*. But then the *Vanity Fair* article accompanying my photo came out and I read Lawrence's quote: "I think the reason Eydie and I have been together this long, and been successful this long, is because for our entire relationship we have never had an in-depth conversation!"

(overleaf)

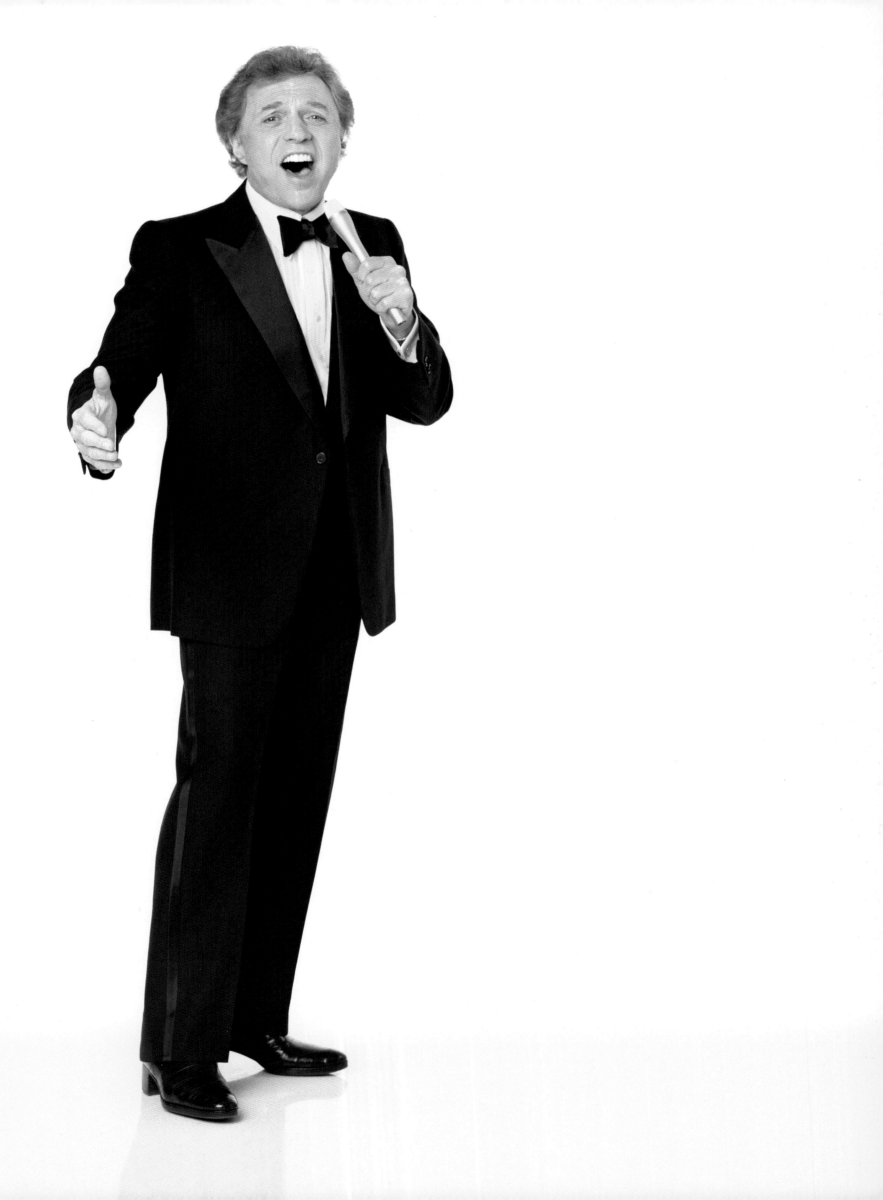

LOGAN PAUL

2015

Logan Paul pretty much did what people have
been doing since the dawn of the movie business:
he left his hometown (Westlake, Ohio) and headed
to Hollywood for fame and fortune. In a modern
twist, however, he already arrived a (social) media
star (Vine, Instagram). Now the movie roles
are coming in quickly, too. It's hard to say what'll
happen, things can turn on a dime, but he's
that perfect blend of affable, lovable goofiness
and muscle.

ELON MUSK

2012

I've shot Musk a few times—at home, playing
with his kids, making out with his wife, and
here, unveiling the (then) newest model of his
revolutionary Tesla automobile. I always want
to get done quickly so he can get back to work
shaping the future through his various endeavors
that include rockets to space, high-speed
transportation systems, artificial intelligence
research, solar power, and who the hell knows
what else. This is definitely the guy you want
to be stranded on a desert island with.

(page 204)

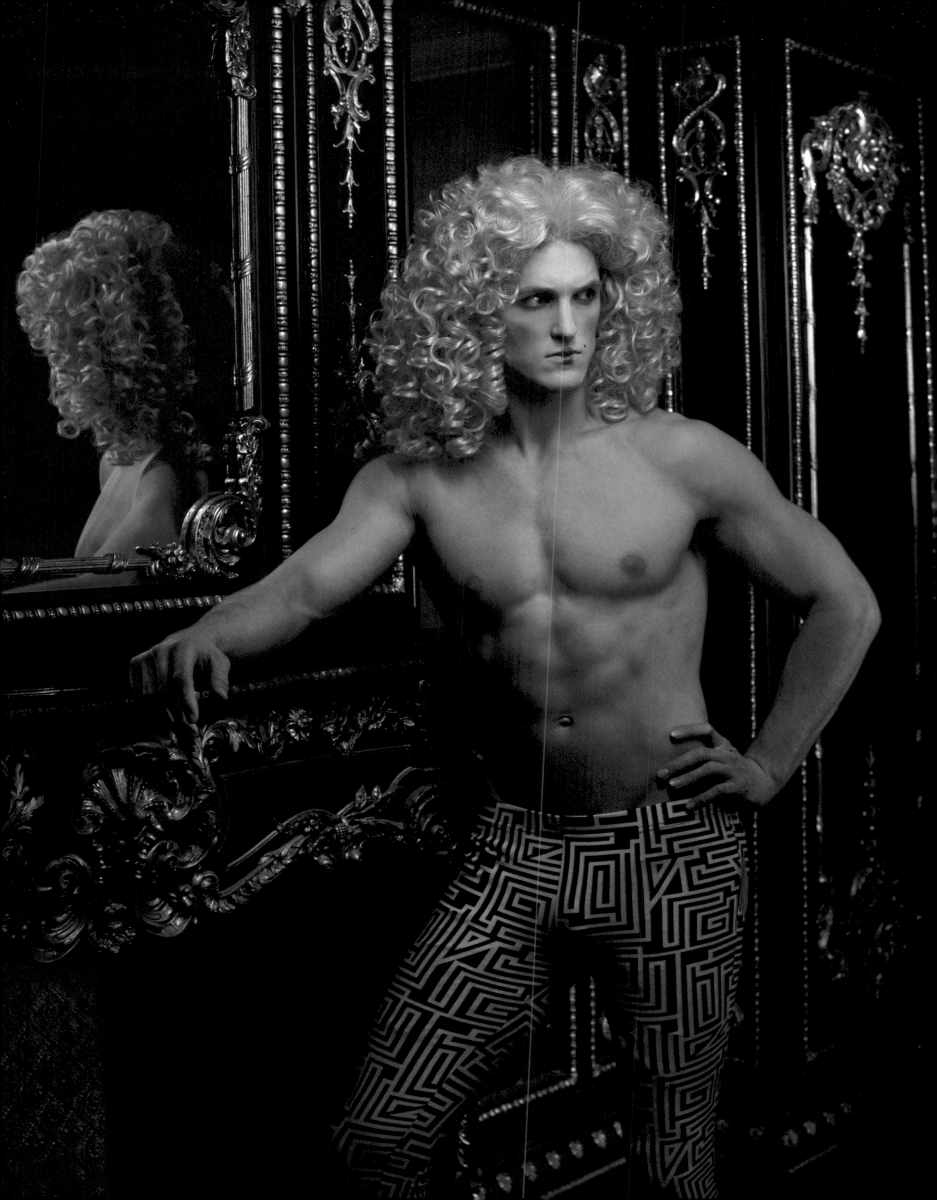

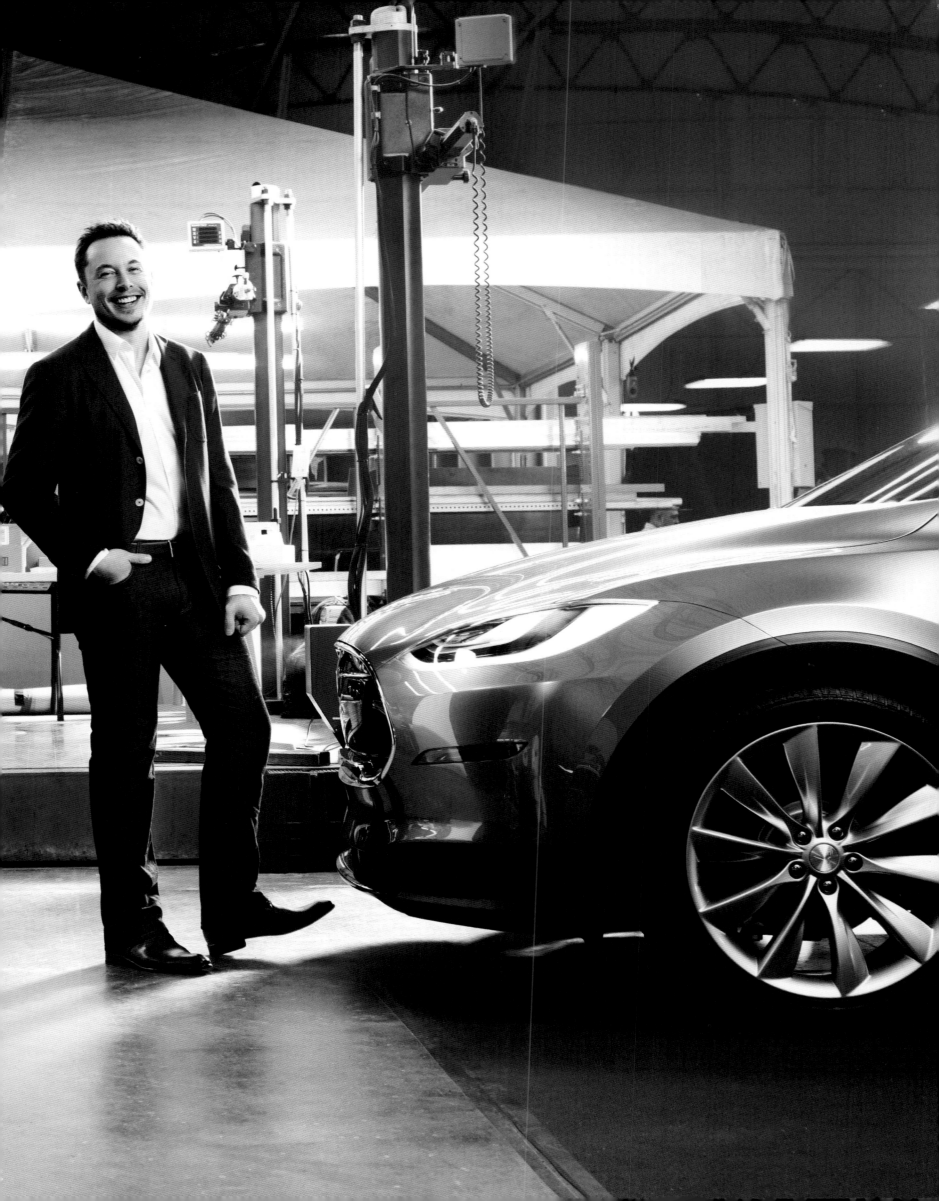

TONY WARD

2016

The survivor. Ward has been modeling for over thirty years. Conventionally pretty boys don't usually age well, but with a head like a Roman coin, Ward just keeps getting better and better.

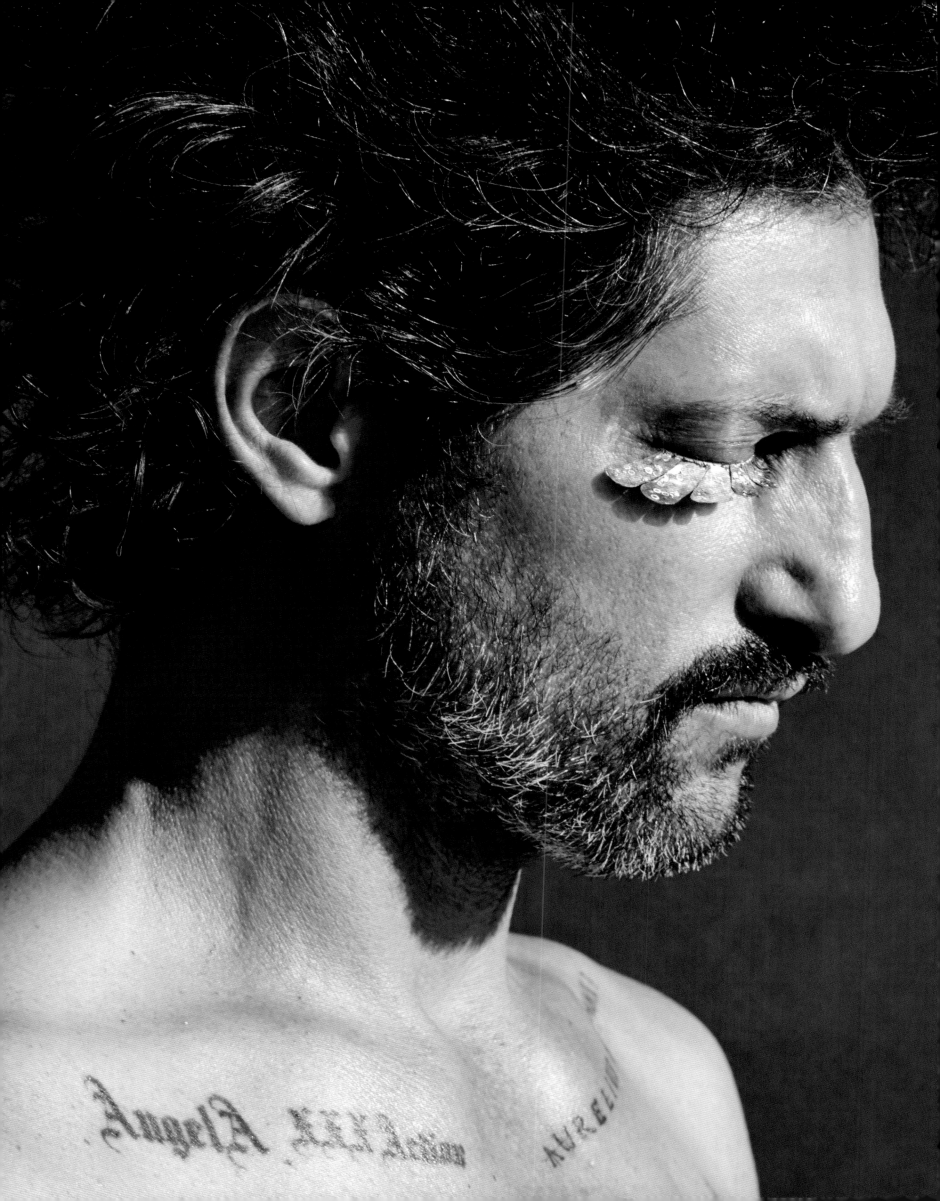

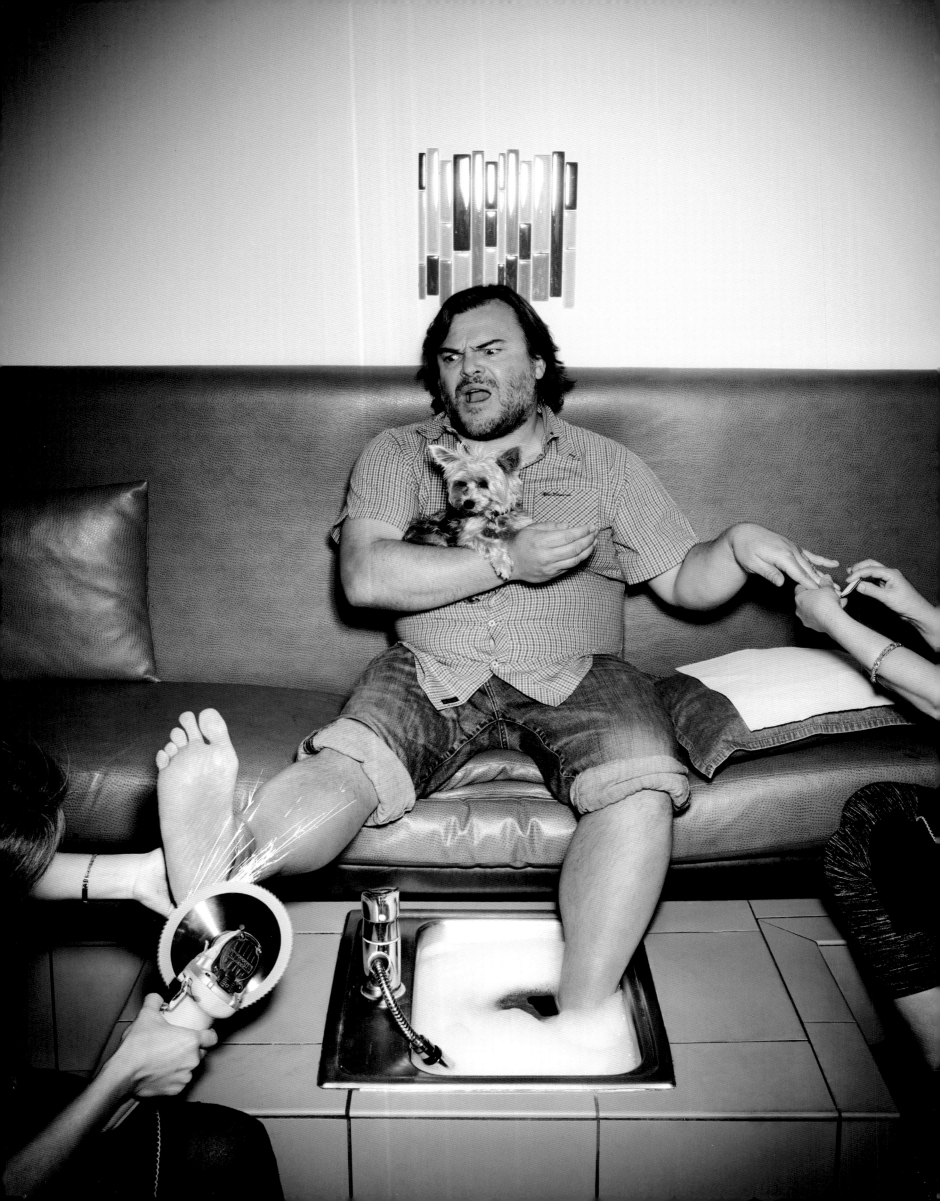

JACK BLACK
2016

CHRIS EVANS and
ROBERT DOWNEY JR.
2016

(overleaf)

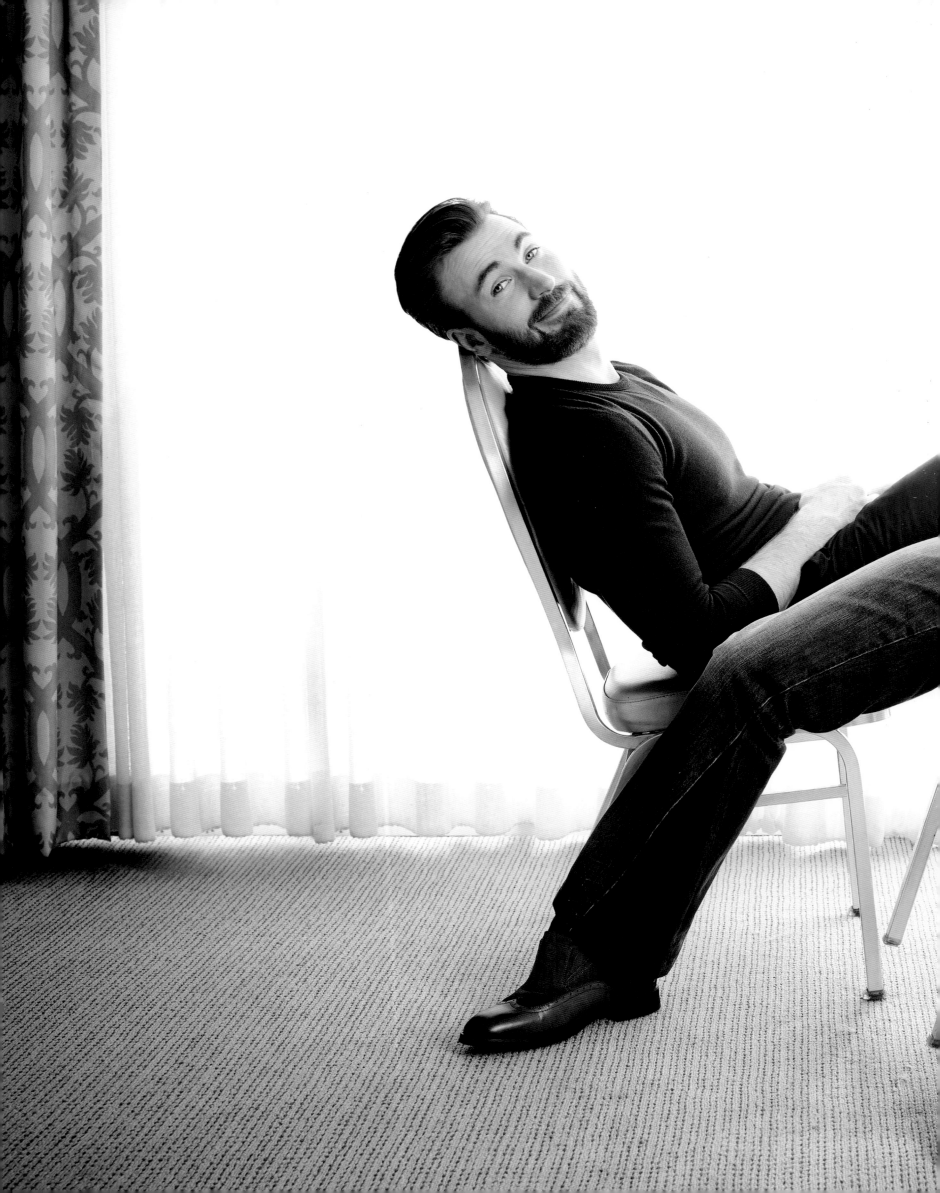

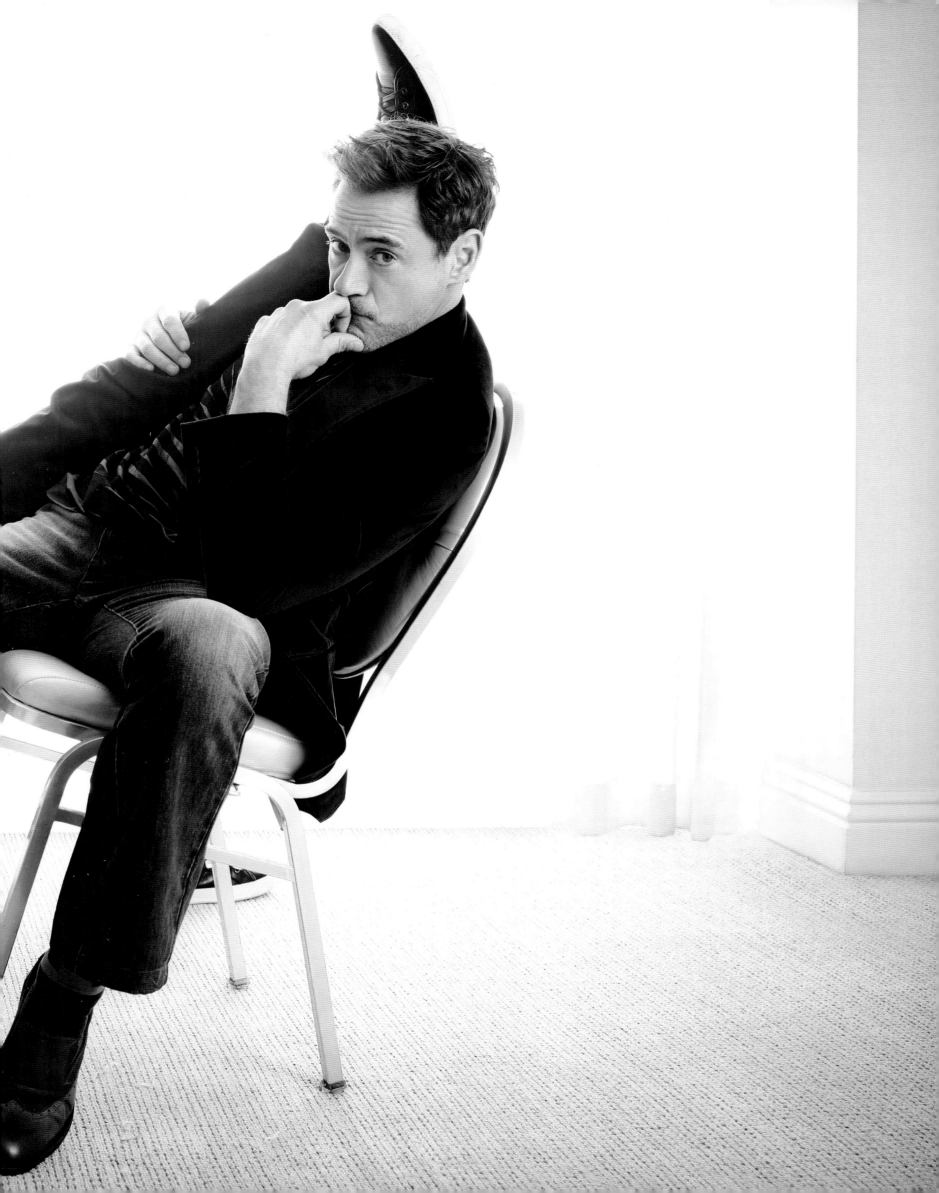

MEL BROOKS and CARL REINER

2001

What is there left to say about these two?
Only this: Their comedy emanates from history,
literature, music, theater, and art. It predates
irony and places the emphasis on, as Mel puts
it, "the human condition."

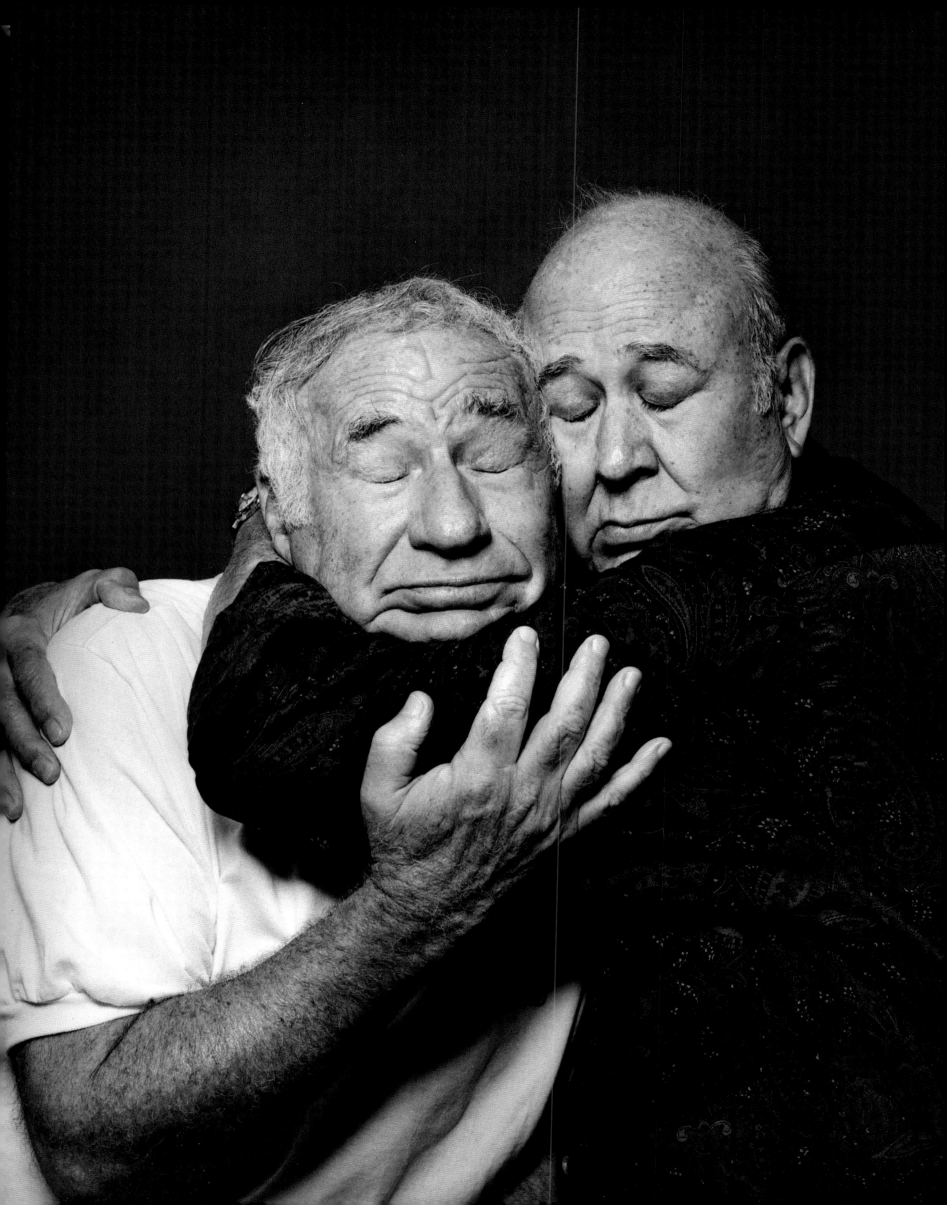

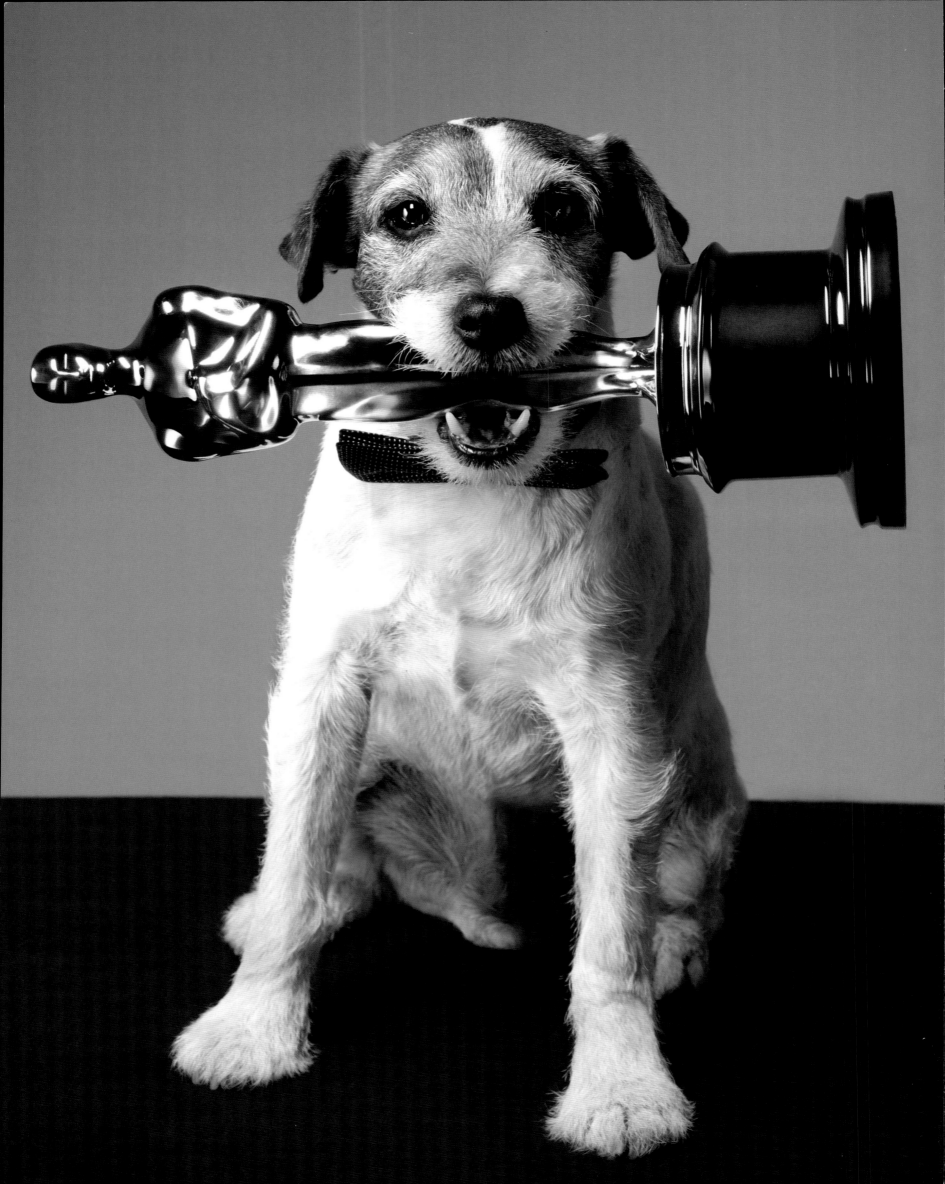

ACKNOWLEDGMENTS

In many cases, these photos were produced on assignment under extreme conditions. At times the caterer forgot to make the chicken breasts boneless or the DJ on set would play a song we had heard before. Once, we had to wait for a little bit while the valet ran down the hill to get our car. In other words, there's absolutely nothing to complain about—it's the best job in the world. I want to thank the following editors who put their faith in me to deliver the goods: Lisa Berman, Brenna Britton, Jessica Bryan, Robert Bryan, Jess Cagle, Alix Campbell, David Curcurito, Chris Dougherty, Deborah Dragon, Rose Fiorentino, Natalie Gialluca, Armin Harris, Michael Kochman, Richard Maltz, Quintin Nardi, Catriona Ni Aolain, Michael Norseng, Jodi Peckman, Krista Prestek, Gladees Prieur, Jody Quon, Michele Romero, Ilana Schweber, and Susan White.

Special thanks to Canon USA, Amy Kawadler, Shaun Murdock, Aly Cayer, and everyone at Milk Studios, as well as Donato Sepulveda at Quixote Studios. Without their generous support, this book would not have been possible.

The real muscle behind me consists primarily of this wonderful group of people: Seth Gundmunson, Marc Kelly, Nick Krasznai, Emmy Monzon, Brin Morris, Xavier Muniz, Byron Nickleberry, Dillon Padgette, Ward Robinson, Justin Schaefers, Drew Schwartz, Alex Themistocleous, Nick Tooman, and Marcelo Torok.

Thank you to my agent Giselle Keller for suggesting I do a "personal project," which became this book, and the wonderful group at Art Dept. including Bill McClure and Mary Jean Ribas. Thanks also to my literary agent Alice Martell for another great ride and to the team at Ten Speed Press: Lisa Westmoreland, Chloe Rawlins, and Natalie Mulford. Thanks also to

Donna Agajanian	Cathy Highland	Tina Robinson
Jennifer Allen	Brian Howard	Clariss Rubenstein
Eusebio Aynaga	Jim Johnson	Heidi Schaeffer
Meredith Benson	J.P. Weaver Co.	Amy Schireson
Ivy Bragin	Ofer Kamil	Nell Scovell
Carrie Byalick	Lewis Kay	Leslie Simitch
Liza Coggins	Mary Knobler	Charnelle Smith
CQ Home Decor	Matt Labov	Randy Smith
Peter Cury	Michael Lohr	Elizabeth Stewart
Anastasia Durasova	Tony Magner	Miho Suzuki
Debra Ferullo	Chris McMillan	Andrea Taylor
David Fox	Old Town Bar	Rosie Torres
Brittany Gilpin	Alla Plotkin	Ben Toth
Jodi Gottlieb	Matt Polk	Ina Treckiokas
Ken Greenblatt	James Reese	Peter Walsh
Jill Fritzo	Lynn Robb	Jeanne Yang
Kristin Heitkotter	Scott Roberts	Blaine Zuckerman

Finally, thanks to all my subjects for showing up showered and relatively on time.

All rights reserved.
Published in the United States by Amphoto Books, an imprint of the
Crown Publishing Group, a division of Penguin Random House LLC,
New York.
www.crownpublishing.com
www.amphotobooks.com

AMPHOTO BOOKS and the Amphoto Books logo are registered trademarks
of Penguin Random House LLC.

Library of Congress Cataloging-in-Publication Data
Names: Trachtenberg, Robert (Director), photographer.
Title: Red-blooded American male : photographs / by Robert Trachtenberg.
Description: First edition. | Berkeley, California : AmPhoto Books, an
 Imprint of the Crown Publishing Group, [2016]
Subjects: LCSH: Photography of men. | Actors—United States—Portraits. |
 Celebrities—United States—Portraits.
Classification: LCC TR681.M4 T73 2016 | DDC 779/.23ˆdc23 LC record
available at https://lccn.loc.gov/2016015153

Hardcover ISBN: 978-1-60774-966-0
eBook ISBN: 978-1-60774-967-7

Printed in China

Page ii: Matt LeBlanc, 2002
Page vi: Keegan-Michael Key and Jordan Peele, 2016
Page viii: Scott Eastwood, 2016
Page 214: Uggie, 2012

Design by Chloe Rawlins

10 9 8 7 6 5 4 3 2 1

First Edition